CW00827910

CROSSES

PORTRAITS OF CLERGY ABUSE
CARMINE GALASSO

With all my love, to my children:
Joe, Anthony, and Carla Galasso

CROSSES

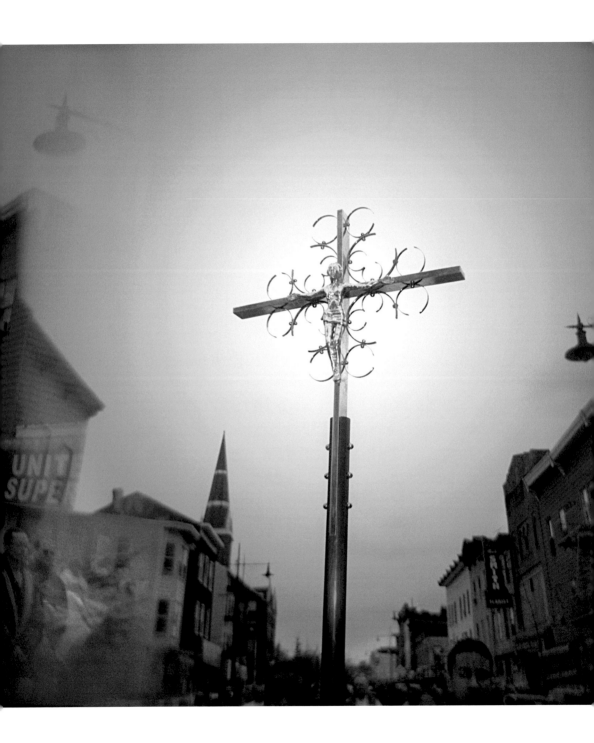

PREFACE

Carmine Galasso

"Crosses: Portraits of Clergy Abuse", is about survival – in varying degrees.
It's about a trust so deep, so pure, that the betrayal of that trust, sexual abuse of
children by clergy - often results in tragic life-paths involving depression, alcohol and
drug abuse, violence, and sometimes jail.

The people in this book spoke frankly about the unimaginable horrors they suffered as children and young adults at the hands of abusive Catholic priests and nuns. Some also discussed how their abuse was covered-up by Church hierarchy. Edited versions of the interviews - in the victims'/survivors' own words - are presented along with portraits of the people who were so unspeakably harmed. Some are photographed in environments that have significance, or give meaning, to their stories. Others are more abstract, but ultimately a common feeling of loss and betrayal is expressed in the victims' somber stares, and in their posture, and reaffirmed in the interview.

I had read many stories involving hundreds of victims, but I never really saw the faces behind them, and that's what ultimately interests me – to show the voiceless, the faceless, and let them tell their stories. Like Betty and Joe Robrecht, people with such strength and conviction, photographed at home holding a bag containing the ashes of their daughter, Mary, who was abused by a nun as a young girl, lived in torment into adulthood, and eventually committed suicide. Like Johnny Vega, who summoned up the strength to drive past the church reflected in his car window, where he was raped as a young boy. Or simply to show the headstone of Patrick McSorley, who lived the secret of his abuse for years and became an outspoken advocate for victims of clergy abuse. He was found dead by a friend, and according to the Chief Medical Examiner in Boston, was a victim of "polysubstance abuse".

This project has taken me across the United States over a three-year period. I am not a victim of abuse of any kind, but I have always been deeply interested in the way in which people cope, how they deal with all sorts of hardship, and how they live their lives despite the crosses they bear.

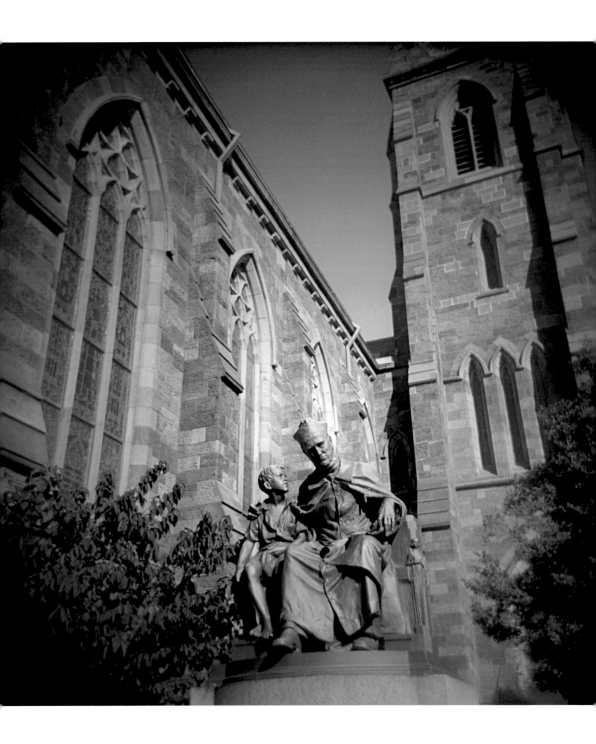

LOOK FIRST IN THEIR EYES

Mike Kelly

Look first in their eyes. As you scan the photographic portraits on these pages, notice the subtle hints of crushed self-esteem that frame so many random glances, the lingering fear that creeps around the edges of so many silent stares, the aching mistrust and doubt that never seems to disappear.

Now step back: Imagine that these are not the eyes of adult men and women in the photographs. Think of the eyes of children – and what so many children experienced so many years ago.

If you do that – if you turn back the clock and imagine what children felt – then you can begin to understand why the pain of Catholicism's sex abuse scandal is so deep and troublesome for so many victims. The abuse did not happen to adults. It happened to children.

The eyes of children captured the first terrible images of priests or nuns kissing them, often under the guise of a distorted vision of love. Those same eyes watched as representatives of God removed their clothes, then molested and raped their children's bodies. Like emotional cameras, those young eyes not only witnessed what took place in those vulnerable years, but sealed the abuse into children's memories. Often first hiding it under impenetrable layers of fear and humiliation, then releasing those images in the years ahead, as children became adults and began to ask adult questions. Why did so many men and women of God molest and rape so many children of God? Why did a Church that claims to represent God's goodness cover up so much evil in the name of God? Why are so many adult victims still suffering?

The victims of sexual abuse by Catholic priests and nuns do not fit neatly into a single demographic slot. They come from every point on the racial and ethnic compass, from poverty and wealth, from families broken and strong, from those who dropped out of school and those with graduate degrees.

Many victims, nevertheless, share a common legacy: The memory of what happened all those years ago still shapes their lives one way or another. There is no single template for what happens. But psychologists agree that the wounds of an abused childhood never really heal enough so that the scars disappear, especially if the abuser is a cleric or other religious representative. For many, the humiliating shame

of what happened and the residue of guilt from not fighting back or calling for help from parents or other relatives follows them each day like a shadow, shackling their psychological outlook in a way that the memory of battlefield carnage haunts soldiers for years afterward.

In their teenage years, some victims seek comfort in drugs and booze, never understanding why no narcotic seems capable of calming their unsettled souls. Others struggle for years with their own sexual identity. Are they gay? Straight? Still far too many never find authentic intimacy. For them, life becomes a lonely, meandering path of frayed relationships.

Perhaps the most common characteristic is the tendency of so many victims to bury the memory of their tarnished childhoods, mistakenly believing that if they don't think about what happened, then they can erase all the throbbing anguish from their memories. Initially, some fear what might happen if they tell parents or siblings what an otherwise friendly, smiling parish priest did to them behind closed doors. After all, they are just children. Who would believe them? Later, as teenagers and young adults, they simply can't face more humiliation. After all, it was one thing to be abused as a child. But to admit to it later? And so they remain silent, pretending it never happened.

The memory never disappears, however. Like an invisible electronic virus that slithers through a computer hard-drive, the memory of sexual abuse lurks in the dark corners of victims' hearts and souls, sometimes quiet through high school years, then college, then beyond. Eventually the memory returns, exploding suddenly in fits of anger or bouts of inconsolable depression that drain life from marriages, careers, and friendships.

Worse, the pain does not end in those incidental emotional outbursts. Perhaps the final punishment for victims is that many close themselves to religion and, ultimately, to God. The recollection of a priest or nun offering friendship or counsel and then violating their bodies looms as an insurmountable barrier of suspicion. Many never again let themselves feel the peace, wisdom, and comfort of an active spiritual life. For them, God has no meaning, no role, no place in their souls. God is essentially dead, killed off by the sick behavior of priests and nuns who lived a secret, sordid life – and were never held accountable even when Church officials discovered their hypocrisy. As one victim's counselor noted: "Boys and girls weren't just sexually molested. Their souls were raped."

Such spiritual emptiness – indeed, such wounded spirituality – often worms its way into the most mundane moments of ordinary life, leaving behind a sense of psychic rot that

is virtually impossible to repair. For example, many victims no longer find comfort or happiness in religious holidays. A priest's Christmas sermon about God's unconditional, eternal love holds little meaning to teenagers who struggle with seemingly endless feelings of being abandoned and unloved because another priest raped them only a few years before. The story of Jesus forgiving his executioners as he hung on the cross – a core message of the Good Friday gospel – has little meaning for young adults who feel incapable of forgiving a priest who once forced them to perform oral sex. And, finally, the essence of Christian theology, commemorated each year in Easter services – that Jesus' resurrection from death means that everyone is entitled to redemption and new life – seems like a cruel lie to victims who know they can never turn back the clock and redeem their tainted childhoods. Indeed, how can victims accept new spiritual life as adults when the souls of their childhood were stolen?

Simply going to church or seeing an ordinary religious icon can touch off haunting recollections. A cathedral's statue that depicts a priest seated with his arm around a little boy does not inspire consolation for victims; it invokes terror. Even the sight of worshippers leaving a church for a Good Friday procession weaving through a city's streets does not bring back happy memories for victims, but shame at themselves and anger at the hypocrisy of some priests. Most troubling of all perhaps is this question, asked all too often by victims: Where is God's justice when, for the most part, the molesters escaped, hiding behind the cloaks of their religious titles?

Many victims require years of intense psychological therapy to pick up the scattered pieces of their own emotional jigsaw puzzle. In a sense, they are not unlike an old graveyard statue of an angel who has lost a wing, perhaps when a tree limb fell in a winter's squall. A few find the anguish so severe and unrelenting that they turn to violence – against spouses or children or themselves. In the last five years alone researchers say several dozen victims have committed suicide.

Even for those who manage to move on – those who go to college and get good jobs and marry and have children and pay mortgages – the wounded reality of a damaged childhood is always there, ready to emerge. But to see – to understand – the fleeting traces of that damage, look first in their eyes.

Imagine what William Oberle saw.

When he was twelve, Oberle's parish priest in Roxbury, Massachusetts, took him for a sailboat ride and fondled him, the first of two dozen instances of molestation. As if that wasn't bad enough, Oberle has this additional memory seared into his soul, captured by

his own eyes: His brothers watched the abuse take place, but never intervened, never told his parents, never comforted Oberle afterwards. They saw, and did nothing.

Oberle tried to ignore what happened to him. The scarred memory seeped into his life in other ways though. He beat up his wife. After they divorced, Oberle's wife married a child abuser who, in turn, abused Oberle's daughter. Oberle turned to drugs and booze, then turned to crime, ending up in prison after a conviction for grand larceny.

Imagine what Rita Milla saw.

Before she was sixteen, Rita Milla of Carson, California, had been sexually assaulted by seven priests. She got pregnant and was sent to the Philippines to give birth to a baby girl – and keep quiet. She eventually found the strength to speak up, even submitting to DNA testing to determine which priest fathered her daughter, who is now twenty-one years old and photographed with her mother. But her attempt to hold her abuser-priest responsible fell short. He fled to Mexico, and Milla still finds herself handcuffed to a cycle of self-blame for what happened. "The whole thing felt like my fault," she says.

Imagine what Dontee Stokes saw – and what he still sees.

In Baltimore, Maryland, Dontee Stokes was thirteen when his parish priest – the priest who baptized him as a baby – began molesting him. The abuse continued, often during Bible study classes, until Stokes was seventeen. In his mid-twenties, Stokes confronted the priest. The two started to argue, then Stokes pulled out a pistol and shot him.

Stokes did not go to prison – charges of attempted murder against him were dropped. He was convicted of a less serious charge of gun possession and sentenced to eighteen months of house arrest at his aunt's home. Stokes knows he can never erase what he did when he picked up that gun. He can never erase the memory of what happened to him either as a boy or the realization that he never got as an adult what he wanted from the priest – an apology.

Imagine what Michael Johnson saw.

In Michigan, Michael Johnson never had the opportunity to ask for an apology. As a boy, Johnson's mother enrolled him in a Catholic military boarding school, hoping he would be safe. But at school, Johnson came face-to-face with a hidden danger – a sadistic nun who

routinely grabbed his genitals while he was taking a bath. As Johnson writhed in pain, the nun repeated a mantra that remained locked in his memory: "Little boys don't cry." Johnson ran away from the school, was caught by police and expelled. The fearful memories remained though. Even in his mid-50s, he slept the same way he did as a boy - with a blanket pulled up to his eyes, still imagining the nightly beatings by the nun. In January 2006, Johnson's pain and fear ended. He died suddenly. His girlfriend found him slumped over his computer. Did Johnson's broken heart from the shame of sex abuse ultimately cause his death? Who knows?

Such questions frame the lives of thousands of victims, shrouding key pieces of their lives in unrelenting mystery. Did a nine-year-old girl's rape by a priest drive a wedge into the intimacy of her marriage years later and bring about a divorce? Did the fondling of a ten-year-old boy cause him to become a cocaine addict when he turned eighteen? Did the homosexual rape of a twelve-year-old boy by a priest spark the anger that led to him being fired from job after job over the course of his working career? Who knows?

In a larger sense, other questions linger over Catholicism itself. Why did the abuse remain so secret? And even when other priests and Church officials learned of an abusive pastor or nun, why were police not called? And now that more stories have emerged, why is the Church so reluctant to open its files and tell the full story?

Father Thomas Doyle, a Dominican priest and canon lawyer, tried to sound an alarm to America's Catholic bishops in the mid-1980's about the growing problem of sexual abuse by priests. On the staff of the Vatican embassy in Washington, D.C., Doyle, an American who later became a military chaplain, found himself reading far too many reports of Catholic children being raped and fondled by priests and sometimes nuns. He even wrote a report on the potential problem.

Bishops ignored him, however, and for his years of trying to speak up, Doyle was recently told he can no longer preside at public Masses or any other Church service. He's still a priest, but he lives alone. "Hypocrites," he says of the bishops who run his Church. "I want nothing to do with them." Doyle's words are laced in anger – not surprisingly. Anger is the unfortunate by-product of almost two decades of attempts by Doyle and others who have tried to convince America's powerful Catholic bureaucracy to face the problem of sexual misconduct. While reports of sexually abusive priests first turned up in the fourth century – and even some pedophile priests were executed in Europe during the Middle Ages – America's problem remained hidden until 1985 when reports of an abusive priest in Louisiana began to trickle into the mainstream media.

The story of how Father Gilbert Gauthe molested possibly hundreds of Catholic children in the Diocese of Lafayette, Louisiana, might never have been known if not for the dogged work of journalist Jason Berry. But even Berry's diligent reporting of what happened to victims and how Church officials tried to cover up could not capture the attention of the national media. More than a few Catholic officials – and politicians and law enforcement officials too – were content to believe that this was just an isolated problem, an aberration, a storm that would pass.

The problem would not disappear, however. In 1992, the abusive secrets of Father James Porter unraveled. That same year, widespread sexual abuse was discovered at two Franciscan seminaries. Victims joined advocacy groups such as "The Linkup" and "SNAP." Conferences of victims and their supporters took place. More stories of abusive priests and nuns emerged – to the point that every American Catholic diocese, from Providence to Los Angeles, seemed to have at least one case of a priest who molested children.

The problem did not really capture the public's attention until 2002, when the Boston Globe not only reported on a number of chronic abuser-priests but published letters, reports, and other documents that proved that a cardinal, several bishops, and other Church officials systematically covered up for abuser-priests for years. No longer was this just a problem of priests sexually molesting children; this was a problem of Church officials keeping silent even when they had clear evidence of the damage done to young lives.

As more victims came forward, America's bishops – and even the Vatican – could no longer turn a deaf ear. Bishops met and issued statements, formed committees, established new rules. Perhaps most important, a research study was commissioned to answer a fundamental question: How big was this problem anyway?

In 2004, America was given a glimpse of the terrible truth. A study, commissioned by Catholic bishops and carried out by researchers for New York's John Jay College of Criminal Justice, reported that an astounding 10,667 Catholics had accused 4,392 priests of sexual abuse between 1950 and 2002, with most of the abuse taking place in the 1970s. In almost twenty-two percent of the cases, the abuse lasted one to two years. But that wasn't the worst. Twenty-eight percent of the victims said they were abused for two to four years and another ten percent between five and nine years.

As alarming as those figures are, they are considered a mere drop in the research bucket. The numbers only documented formal accusations of abuse. With so many

victims keeping silent, it was not much of a stretch to imagine a far more gruesome possibility – that the numbers of victims and abuser priests was much higher, possibly double or triple the number of documented cases, possibly even worse. Some advocates say it's not too much to say that 100,000 Catholic children may have been sexually assaulted in some way during the last half-century.

America is already seeing the first aftershocks from this social and spiritual earthquake. Mass attendance has dropped at many Catholic churches – to the point that some churches and schools are closing. At the same time, Catholic dioceses have been forced to pay more than $1 billion to settle victims' legal claims. For an institution that manages the nation's largest non-government network of hospitals and other social services for America's poor, this is not a good trend.

Such bureaucratic worries understandably dominate much of the planning now within the Catholic Church. But what of the victims? For many, it's far too early to talk about recovery. In the Bronx, Charlie Perez, the son of Cuban immigrants, still remembers what he was told as a boy: "What better friend can a child or a family have than a priest." But then he remembers the priest he saw first-hand, the one who fondled him when he was only thirteen, first in the rectory, then in a swimming pool. As Perez grew older, he sought refuge with a psychiatrist. But on two occasions, he tried suicide – and failed. He now takes medication daily to curb his paranoid schizophrenia.

And what does he see? What image dominates his memory? "This is the equivalent of homicide," he says of what he saw as a child but can't ignore as an adult."This is nothing more than homicide of the soul and the spirit and the mind of children. A stabbing in the back. A betrayal. Absolute betrayal." Like so many other victims, he continually asks himself a question: "How can this be?" And like so many, he is left with the same, unrelenting and painful answer: "I have nothing but anger and rage and wrath at the Church," he says. "And even at God Almighty." Like so many, he does not know when his anger will end. He just knows it is now part of his life, his memory, his soul.

Mike Kelly, an award-winning columnist for The Record newspaper in New Jersey, is the author of the critically acclaimed non-fiction books, COLOR LINES and FRESH JERSEY. He is currently researching a book on the sex abuse scandal in American Catholicism.

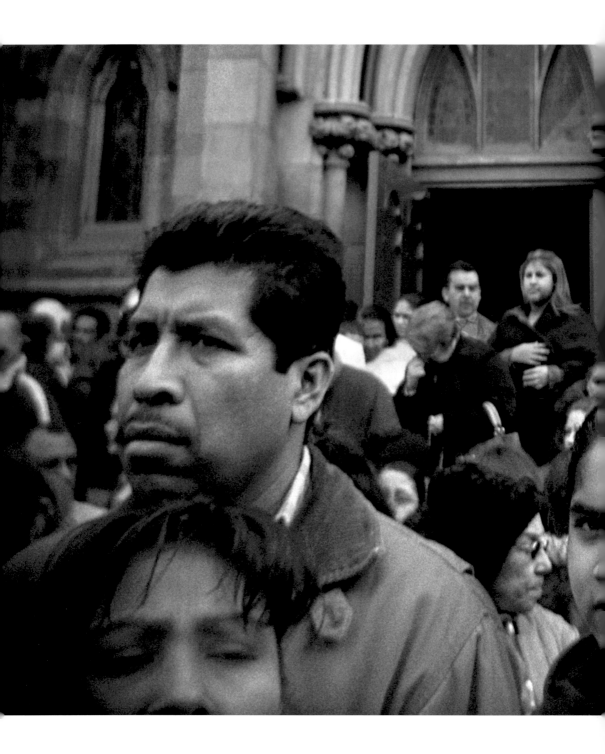

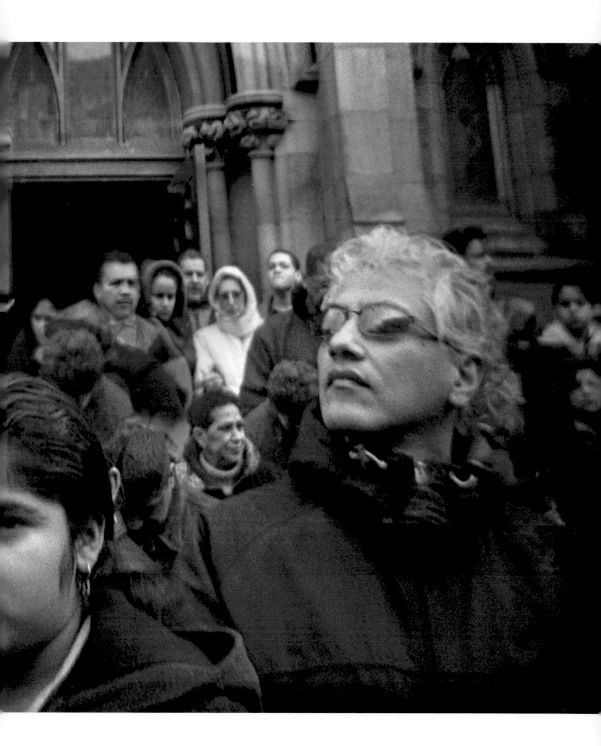

JOHNNY VEGA

I was raped by a priest and later by a deacon. When you come down to it, that's what it was – brutal rape.

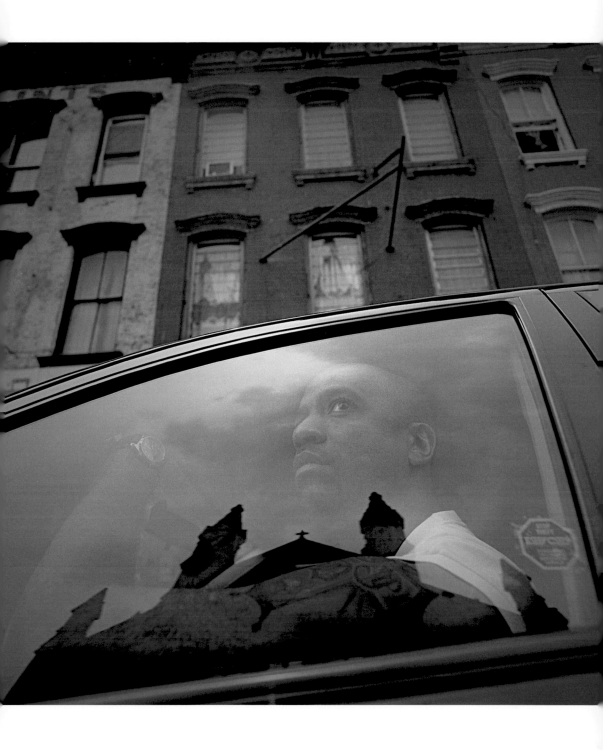

My name is Johnny Vega, I'm forty-one years old. I was born and raised in Paterson, New Jersey. I'm a Hispanic Puerto Rican. I was an altar boy, about eight or nine years old. I met him then. I don't recognize him as a father or a priest because of what he did to me. He was the first to sexually molest me when I was about ten to eleven years old. The real abuse didn't take place until after I moved, but he moved to the same church as me. The molestation and the things that he did to me was something that I did not expect from a priest. I didn't know anything about sex. I didn't know anything about touching or having the feelings of, you know, what it's like to be touched or anything like that. I always thought it was supposed to come from a female or a girl or a woman.

The first time he touched me he took me upstairs into this room where church classes were being held. He never turned down the light, it was still daylight, and you know, he stood behind me with his hands on my chest, as if, you know, like he was praying or something. I didn't know what he was up to, I didn't think of anything, I just stood there and waited for him to move. But then he began to rub my chest a little bit and I started feeling a little uncomfortable. He began to start feeling my legs and that's when I was getting real confused. I really didn't know what he was up to. He stopped there, by touching my legs and proceeded to go back down to the church. A few weeks later he began hugging and touching and doing the things that he started that first day. At that point I made sure that I had to try to avoid this man because he started to really scare me. Months went by and you know, he hadn't done anything to me and he announced to everyone that he was going to be moving over to another church. He was going to be the main priest, the pastor, so of course everyone followed him over there. I was still an altar boy with a lot of my friends and they had a special Mass to ordain us as altar boys and he was the priest who did the ceremony.

A year later it came to the point where we were able to sleep over, which I thought was something normal. I know a friend of mine used to stay over all the time, and his brothers and sometimes his cousins would sleep over. And even sometimes a couple friends would sleep over and hey, I thought it was exciting – on the weekends, whether it was a school night, a school week, or summer time, we always made it a point to sleep over. [The church] was the only place my parents let me stay for that matter. My parents were very strict, but fair. They only wanted the best for us. They had no idea what was being done to me because I didn't want to say anything, because I was too scared.

I was already being abused when I first began to sleep over. I remember sleeping with at least six or seven of us in one room, and one would always be picked by this

priest to sleep with him in his room. There was the big living room space. There was a bathroom in between the living room space and his bedroom. I never thought of why it was always one kid sleeping with him. He had plenty of guest rooms; he had plenty of other rooms that we could have slept in but I didn't think of it. I was very naïve back then. I just thought of it as fun, sleeping over with my friends and goofing off and doing all the kid stuff. When he picked me that one night to sleep with him I was expecting a separate bed, some kind of sleeping arrangement or a sleeping bag or something. I wasn't expecting to sleep in the same bed with him.

He was huge compared to me. To me he seemed like he was six feet one inch and he was like maybe three hundred pounds. And that's not even exaggerating. He was very strong. This was a priest that would really intimidate you. You know there were times when he would curse at you. I wasn't, you know, I wasn't used to that either.

When he first got me to sleep with him, you know I slept next to him, and in the middle of the night was when he began to do again what he had done at [the church] the first time, which was start touching my chest area and began touching my legs. And he moved his hands toward my butt and eventually touching my penis. I was aroused because I wasn't used to something like that, it wasn't something that I had enjoyed or was enjoying. I was scared and I couldn't move because of the size of this man compared to the way I was. I mean, I wasn't even five feet tall yet. So, that went on for several months until he actually began to start threatening me by saying that if I don't do what he asks me to do he would make sure that my parents would pay the price, that I would pay the price. He would take me away from my parents. He threatened to kill me if I said anything.

One weekend after another weekend of going through the same exact thing – six years this went on. I mean it got to a point where penetration was involved about a year-and-a-half after he began to start molesting me. I was very scared of what he was going to do; even at the age of sixteen I was scared that he would take me away from my own parents. But at that age I was furious about what was going on and I was getting self-destructive with myself.

When I was sixteen I bled so bad I actually thought that I was bleeding to death. I really panicked but I still couldn't scream, couldn't yell because my friends were in the other room. I had to run to the bathroom and hoped that the bleeding would stop. I was in so much pain I couldn't even go to the bathroom. I couldn't pee right because it hurt so much; I didn't know what the hell was going on. All I knew was I was bleeding from what he did to me and it hurt so much and he

didn't seem too worried at all; he just laid there wondering when I was going to be done so he could finish. And that's what happened. The bleeding eventually stopped, and I was relieved because the bleeding stopped, but I had no choice but to go back into that bedroom because my friends were still in the other room and they were sleeping.

He just didn't care and he would tell me not to cry, and he would cover my mouth with his hands real hard, and with a strong voice whispering, "Just be quiet." And you know he would basically just finish me off, and it would take me forever. It was obvious I wasn't into what he was doing, and it was taking very long. So I just, um, had to finish it myself just so that he could feel happy even though I wasn't. And after I was done he made me start finishing him off.

My life from that point on was simply to not go to church. My life got very self-destructive; I was a very angry person. By the time I was twenty years old I already had forgotten about everything. I had to. I had trained my mind to forget things because of my friends being around. I did not want to give them a hint of something that went on. So I already had my mind trained to forget so that my friends don't pick up on what happened, not knowing that they were doing the exact same thing. So by the time I was twenty years old I had to forget everything and I did and I blocked it so, so badly. But I was still angry. I tried to commit suicide several times, never wrote notes, because, not knowing what was happening to me…. I joined gangs…. And I think that these things wouldn't ever have happened because I was normally a shy person, quiet.

I used to go to the hospital because I thought I was having heart attacks. You know my wife didn't know that I had been abused like that, so you know these anxiety attacks started happening and I would go to the hospital thinking I was having a heart attack but that wasn't happening. I was just getting…. I mean it was anxiety. It wasn't heart attacks. I was just, you know, more afraid because eventually I would have to tell my wife, and we were just about at the verge of getting a divorce. We were having a lot of problems and she just couldn't take a lot of my actions anymore. And you know, it came to the one night where my son woke up in the middle of the night and I told him I got him, and I brought him over to the sofa and it was still dark and I didn't want to turn the light on or anything. I just wanted to rock him back asleep. And that's when I looked down at him and said I can't let this happen to him what happened to me, and I just lost it, just started crying. And him, so innocent just laying there and crying himself but trying to go back to sleep which he finally did. But I couldn't stop crying.

And finally around 2000 the Boston scandal began and I began thinking of my friends and wondering if they got abused. I didn't start remembering anything about myself yet; I was, like, wow, I can't believe that so many people in Boston have been abused by priests. And first time I actually heard the word sexual abuse by priests I actually thought of it as you know, sex. I didn't think of it as rape. As a matter of fact I didn't think about it as rape until a couple of weeks ago when one of the survivors that comes to my meetings says, you know, I was raped by a priest. And that's when it hit me – that I was raped.

Sexual abuse, especially by a priest, I don't think there's any worse sin in the world bigger than that.

The first time I was able to drive to the church was one of the most scariest moments because of what happened to me, the horror in there. I still get intimidated by that church. You go back to being that little kid. Even now I have dreams wondering if that door is going to open and see the priest. I just don't want to be near it.

PATRICIA ANNE CAHILL

My name is Patricia Anne Cahill, I'm fifty-two. Today I'm from Lancaster, Pennsylvania and I'm growing up.

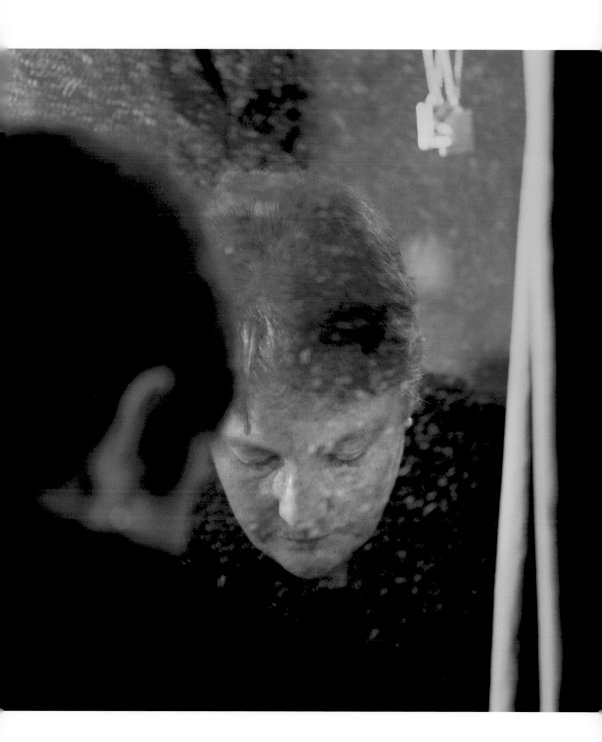

I froze. I froze. And crying the tears of the silent and the scared, I left my body that day. I've been trying to get back into my body ever since.

I learned how to dissociate, I learned how to abandon myself, and I learned how to please another person all at the expense of myself. It was my fault of course, I thought, everything was my fault; I was told it was my fault.

It was my fault that my priest/uncle raped me when I was five. It was my fault that I was too cute for him to ignore me; he told me that. It was my fault that my father was so violent and abusive, he told us day after day after day how in need we were of discipline and order, how spoiled we were.

My mother's drinking was my fault too. If only I had kept the house cleaner, the kids quieter, my father happier, then she would not have to drink. If only we were richer, or better connected, better behaved or better looking, she would not have to drink.

My sexual abuse by Catholic clergy started at age five and went on twelve years despite many attempts to get help. My first memory of the abuse is when I was young, five or six. He had this saying, he used to say, "How much do you love me?" and he would put his arms out and then we had to put our arms out as big as his and say, "Big as a mountain." That is what we had to do. And then we would sit on his lap; he would pull us up on his lap. And he was always in the black clothes, always in the collar.

The first time he abused me – this priest was also a family member of ours – I was sleeping at my grandmother's house and he came in, in the middle of the night. He had a key and he came into the room where I was sleeping with my cousin, my girl cousin, and he took me. He said, "Come inside with me and lay down for a little bit." I remember he reached up under the pajama top and I remember not knowing what to do. I didn't do anything. And over the months it just progressed and progressed until he had nothing on in bed except for his collar. He kept the white collar on.

He would punish me. He put me in a closet without clothes on. He removed my pajamas and put me in this closet and he made a real production of locking the closet door. It was very, very dark in the closet, and he would come back to the closet and through the keyhole he would say, "Are you ready to come back to bed with me?" I think I had a defiant streak way back then and I said, "No." Or I wouldn't answer him. I really don't remember answering him. And he came back several times – I don't know – six, seven, eight times and it was just that I was so cold that I finally said yes. I was really very cold. And he took me back into the bed and he was very rough with

me that night. He was very angry. I don't have distinct memories of penetration by him; I have mostly memories of his disgustingly huge body on top of mine, pushing and grinding, and forcing kisses on me, all over me, and I just remember feeling so dirty. Just really dirty; I felt so dirty.

I never thought to question that what was happening in bed at night, alone, or in the closet naked was really the worst hell I was ever going to go through – that there was nothing worse. I became very quiet. In fact, I remember the first sign of a problem was when I was about six or seven and I stopped speaking. And when I did speak I could not be understood. And then when I was eight my hair started to fall out and they brought me to the doctor and he said it was stress. I was eight. I didn't know what stress was. And then I started to have hives on my body. Welts would break out as if somebody scratched my arms, legs or stomach from the inside. And it would come out like scratches or welts on the outside. They were burning and itchy. My parents were told that it was stress.

He always had the white collar on. He stopped wearing pajamas to bed but he always had the white collar. And this next morning he put the stole around his neck in bed and he told me that as long as that stole was on his neck everything that happened here was not to be repeated or I would be committing a mortal sin. So as a little girl I would think it was either Heaven – with white clouds and people walking on them, and a benevolent God with a white beard and angels with wings and harps, and seraphs and being with all the people that you ever missed in your life that had died before you – or you go to Hell where you burn for eternity. It didn't seem to be a big choice.

If I had one day to do over in my life it would be the day I met the nun that raped me. She promised me so much and demanded payment in the form of my body and my soul. She promised me the world but she stole my spirit. She became my own personal savior, my own personal woman of the cloth with the promise of salvation and a better life and a more stable future. But she lied to me from the very start. It's true.

I want my life back. I want my childhood returned. I want my innocence back. I want to learn what it's like to feel alive. I've been dead for a long time.

She took a lot of things from me. She took from me the ability to feel spontaneous about anything. She made it very dangerous to feel at all. She made me into a Stepford nun, into a Barbie nun. And nobody stopped her. Not one other nun ever intervened on my behalf and in fact many joined in the abuse by keeping silent, turning a deaf ear and a blind eye.

I would be escorted into the back doors of convents and the nuns would literally turn their backs as I was brought up the back stairs. I was jailbait. Oh God, I feel like I lost my life to her, my soul to this woman of the cloth, this veiled threat. That's what she was to me, she was a veiled threat. "Touch me here," she said as she took my hand and pulled it in toward her body. I was scared and my stomach, I felt queasy, but I didn't want to upset her. I did not want to disappoint her. I couldn't risk losing the only person who was paying attention to me, albeit twisted attention. I resisted. I resisted. I pulled my hand out of hers but just as quickly she reached back and wrapped her hand around mine and with quiet silent deliberation she pulled my hand toward her body and placed it over her breast. I remember this like it was yesterday. My hand got caught up in the rosary beads that hung at her waist. I didn't have the vocabulary for effective resistance. I had already learned not to talk about anything that might make my parents uncomfortable.

She wore the perfume of nuns in a yellow bottle, that little mark over one of the letters making it French. The closer she pushed her body into mine, the more pungent the smell. The scent followed her as darkness follows light. It was like having an advanced warning that she was coming. I used to love the smell but I learned to hate it and her. It was a hard smell to ignore and she was a hard person to avoid.

One snowy winter afternoon she parked the car behind the church garage. She told me to wait in the car and that she would be back shortly. I wasn't dressed for the weather. Two hours later she came back for me. "Come on," she said, "no one's in the kitchen right now." She opened the back door. She ushered me up the back staircase to the second floor of the convent. My heart was pounding. Nobody gets to be on the second floor of a convent. "Touch me like this," she said as she unsnapped my pants and unzipped my jeans. "Touch me like this" and she slipped her fingers into my underpants and began to caress me in places I had never been myself. This was virgin territory for me but it was obviously a familiar landscape for her. I was mortified, humiliated, ashamed and afraid. Mostly I was afraid. I froze. I couldn't move. I couldn't breathe. My mind was swirling and I felt lightheaded and dizzy. I mumbled this to her, hoping that she would get me help. But she answered in a voice I came to recognize later as her pre-orgasmic tone of voice. Breathing heavy and quickly she whispered hoarsely, "In a second, little one." And then she collapsed onto the couch heaving and sweating with her hand still in my pants.

After all this, what do I see? Who do I see when I look into a mirror? When I look into a mirror I do not look into my eyes. I do not look at my face. I brush my teeth and comb my hair and I just keep on going. What do I see when I look inside of myself? I see

someone who has lost so much, someone who is so incredibly broken and wounded who has lost the people who have meant the most to her in her whole life.

My family, my siblings, they shun me. They do not allow me around my nieces and nephews. I'm not allowed around my nieces and nephews because of the relationship I had with the nun. My sisters in their compassion have determined that that makes me a lesbian. And in their Catholic compassion that means that I'm a pedophile because all homosexuals, gay women and men, are pedophiles in their heads. So since Sister sexually abused me as a child and the priest sexually abused me as a child, I, in their eyes, will sexually abuse their children. And when I started speaking about my uncle, my parents took me out of the will. So I have lost my entire family. I don't see them. I don't talk to them. I moved three and a half hours away from them to try and learn how to live again.

I am Patricia Anne Cahill.

WILLIAM OBERLE

My name is William Oberle and I'm forty-seven years old. My story starts back in 1969 when we moved to Boston from Illinois. My mother and father had just divorced. My mother was from Boston.

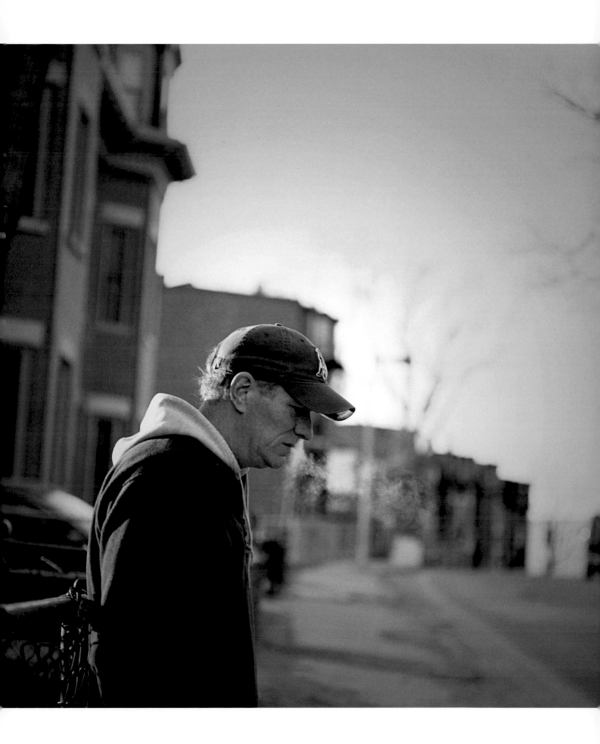

The incident with the victimization by the priest started on a sailboat in Marblehead Harbor. We were invited onto the sailboat by the priest after my mother had introduced ourselves at the end of Mass one Sunday. He said, "Well, sounds like your boys need a trip on a sailboat." We were all kinda gung-ho about it, 'cause my mother's family were some of the first lighthouse keepers on the Cape and we were introduced to sailing many years before. We were kind of psyched about it. At the time I was twelve years old.

We were approximately a mile or so off the beach when I had to use the bathroom. Having known sailboats and made my way around them pretty good, even at twelve years old, I proceeded into the cabin to use the head. And at that time the priest – I held him in such high regard – came in right behind me. I was trying to urinate and he spun me around and said, "You have to sit down on the sailboat to use the bathroom." He proceeded to pull my pants down, my underwear, [and] fondle me, and at that point I quickly sat down on the toilet – tried to end that situation.

To my brothers' astonishment, amazement, whatever the word, I can't find a word right now, but, um, they watched it happen from the fantail of the sailboat. To this day I can see the look on my brother's face when he saw what was happening. Mind you, this went untalked, unsaid. It was a non-event as far as my brothers and I ever, um, talking about it. It never happened.

There were subsequent occasions, dozen-and-a-half, maybe two dozen situations over the next year-and-a-half, two years. It's kind of a blur. When we were at scout trips I would have a recurring dream. You know, I knew it happened on a scout trip to Myles Standish State Forest with the troop, and, um, that's where this recurring dream was from. I was held down and he was trying to molest me and fondle me or, I don't know, [perform] oral sex on me. The priest was the leader of the troop.

I try not to think about [those incidents] but yeah, they do come to the surface sometimes and it's kind of scary. I get very depressed by it sometimes when it happens – self-conscious, you know. I can be on a train or something, and you know, some thought comes to my head. They're all looking at me. Maybe they recognize me from, you know, an interview I did, or the newspaper. I've been all over the world, in London newspapers, NPR, I mean, you name it.

A kinda dark feeling came over me. It was under wraps and, like I said, a non-event for years until 1997 when we were all together for a family reunion. It was about a week long, just my brothers and sisters and my father. It was the first time we'd

gotten together in thirteen years. My mother died in '84. So we're all in Dallas that week and one evening talking about this place and that place, this one and that one, and one of my sisters mentioned something about my cousin. And I says, "Yeah I know, he's a flamin' homosexual." She came back and says, "No, he was molested by a priest." At that point I sort of got all clammy and just, uh, a big flush feeling kinda came over me. A couple nights after that I asked my brothers if they remembered a sailing trip with a priest. And the reaction I got from those two boys – my brothers – was just … unbelievable! It was a kind of a scary thing to realize this had happened to me and my brothers. But it was that day in August of '97 that it came back to the surface and we didn't really talk about it that much at the time. We were probably set aback by the fact that it was a real happening thing, that it wasn't a dream or it wasn't a nightmare. It was a reality!

After leaving Texas, I came back to Boston and I shared it with my wife.

Some months after coming back to Boston, I picked up the Boston Herald to read an article about [the priest being] defrocked by the Archdiocese of Boston. It all started coming out. It all sort of opened up a floodgate of emotion and whatnot, and I ended up losing my wife to divorce because of this, because of the emotional duress. I wasn't as strong as I thought I was.

There were episodes of domestic abuse at my hands. Simple arguments turned into shoving matches. Um, I'd hit my wife on a couple of occasions. I had a lot of anger issues and emotional baggage. On holidays my mother's wondering what the hell is going on with her boys, what's wrong? We weren't tellin' my mother. Getting beat down [by the priest], that wasn't keeping us from saying anything. We just…. It's just…. It's such a hellacious, heinous thing to do to a kid. Who wants that stigma? You know, I mean thirty-something years ago in the neighborhood. I think everybody may have known that this priest was…. I think a lot of people knew about this guy and they just weren't saying. I mean he had a power. I'd seen my mother victimized by my father. You know, domestic abuse and, ah, you know, I guess subsequent to that I became an abuser as well. I realized I had a lot of baggage and didn't know how to deal with it. Drugs and alcohol became a factor for the longest time. I got involved with cocaine in the later years and that became the drug of choice. Subsequently my wife had a restraining order, protective order, put on me and we separated. I kind of went into a deeper depression.

In '97, '98, '99, yeah those were some really troubling years when I was trying to deal with the realization of what had happened to me. And it was at that point that I realized

what the drugs were doing to me. That's why I was going to the drugs – for the escape. I suffered from panic attacks, anxiety, and you know, if it wasn't for marijuana, for Chrissakes, I think I would have killed…. Been in state prison a long time ago for murder because it helped me, um, keep things in check. Never helped me escape my problems, just helped me escape the stress that, um, I was unable to control. When that kinda stuff wells up inside me it becomes a poison. It prevents me from seeing clearly and thinking clearly and acting clearly. And, uh, I'd be the one to decide when I'd had enough and not let outer forces control that.

But you know, I've had the rocky road. I, um, grew up on the mean streets of Boston, you know, Dorchester. Um, you're talking everything Catholic. It was…. It was a tough kind of neighborhood. Federal busing was just being instituted, and it made for a rough ride for everybody. Made it a very tough town. The neighborhoods were very tight. You had your Irish, your Italian – mainly Irish and Italian and, um, they were some tough kids. It was a tough town. I mean if someone didn't like you, you know, they'd hunt you down and kick your ass. With the molestation, I became a very tough little kid. I wasn't going to get picked on anymore. I wasn't going to take shit from anybody. And I got a name, you know? You just didn't mess with this kid. Leave him alone, he's quiet for a reason. And, um, you know, as a result of that, I'm this kind of gruff-looking streetwise kid today.

Then back in the '80s, um, I'd go into a bar and I'd just try to gain some solace and quiet, you know, [have] a couple of drinks, and someone come looking for trouble and they'd trip over me, and, you know….

I got stabbed in the neck in a bar, went to jail for a felonious breaking and entering I did with some friends and resulted in grand larceny.

I had gotten some professional help over the years. The Church has offered with their settlement to pay for counseling but I always thought that was too-little-too-late because at forty-seven years old I'm pretty much set in my ways and the damage is done. Not to say that there can't be any repair, but I'm responsible for my repair. I can't hold anybody responsible for what's happened to me although it was at the hands of an adult priest, and I was a child. But now I'm an adult, you know, I have to deal with it as an adult. I can't use that kind of crutch anymore. I was in denial a lot of times: "No, it didn't happen. Yes, it did." You know, I survived this. I don't know that I'll ever heal. How do you heal from something like that? It's just something you really have to go through to know it, and until you've been a victim, you really can't judge anybody on it, you know?

Even here today I've had second thoughts about wanting to do this many times. You know, you get saturated by it, and overwhelmed by it, and you know, it's hard to come up and do it again and again. It's hard for me to sit here now and try to get it in some chronological order. I'm kinda like splintered and fragmented.

I have one daughter, twenty-three years old, and she's the love of my life. If it wasn't for her I wouldn't be here right now. My daughter was born in '81. My mother died in '84. If my daughter wasn't here in my life when my mother died, we wouldn't be here talking today because I would have killed myself. That's the only thing that's kept me alive.

She had surgery – removed a tumor that was on her parotid gland. They removed it. Treated it with radiation therapy and chemotherapy and, you know, you're a cancer patient for five years anyway. You're a survivor after five, they say. So, um, she seems to be doing well, her hair is growing back from where they had the radiation. I'm very proud of her.

Her mother married a man who was twenty years her senior, and I come to find out that he's a child molester. And when I found that out, there wasn't anything left below the surface that had happened to me as a kid. That went out the window when I found out my daughter was molested by this guy. I stalked this man. I was basically on a tear, you know? I chased him around. I attacked him, and scared him so bad. I even tried using the courts to do the right thing – to no avail. He got scared. A good friend of mine had said something to this guy, and it scared him so bad he up and moved out of the state.

But, I've been trying to put my life back together now. I still have faith in God, I just don't believe in the Catholic Church and their doctrine. And, you know, it kind of shames me in some respects to be part of a Church that just didn't care about, um, the victims. They didn't care about the emotional … didn't care about any of it.

DONTEE STOKES

My name is Dontee Stokes. I am twenty-nine years of age. I first got acquainted with my abuser around the time of my birth. He's the man who baptized me.

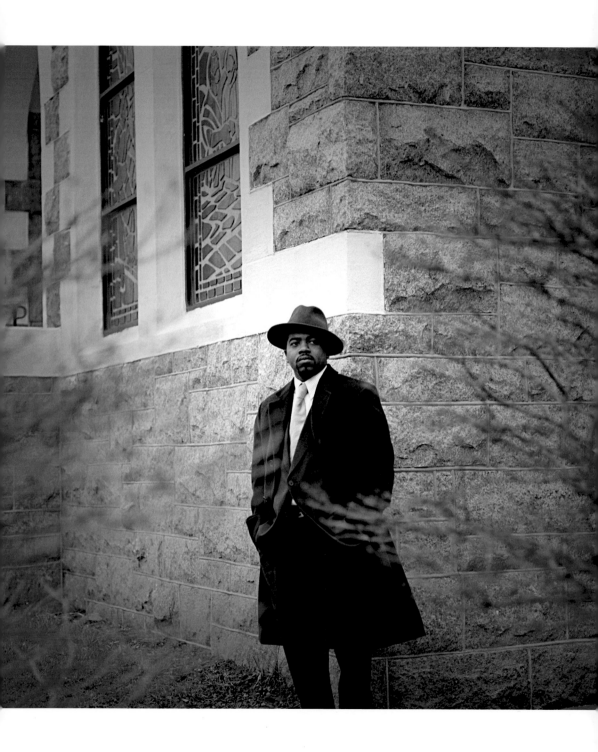

We developed a personal relationship around the time when I was twelve or thirteen. I saw him as somewhat of a role model. The church as a whole, with his headship, came from an African-American perspective.

I participated in a number of different things. I first started out with the youth group. I proceeded to be a member of the parish council. I participated in choir while I was there.

The touches went from casual embraces to things that just grew to a point where they were kind of unbearable. The casual pats on the head would lead to maybe him touching my ears, maybe putting his fingers across the back of my neck. These things occurred in a way that I couldn't say at the beginning it was overt. It always left me kind of questioning, "Did he just do what I think he did?" or "Was it done in a way that I should be alarmed?"

So I found myself at a crossroads in life – do I stop coming to the church, to stop being harassed and solicited and groped and touched by a priest? Or do I choose to fight for what I feel as though God has made right in my life? I guess it got to the point where I couldn't take it anymore. I couldn't take the touching.

I probably stopped coming to the church around the time I was fifteen or so. One day I found myself back there for one reason or another. I remember being in the church and being called to the rectory by one of the young people. I was expecting that maybe this man would want to apologize for the things that he had done. You try to give people the benefit of the doubt and you look for a sense of hope in individuals. He asked me to close the door and that's kind of when the worst of the things that have occurred between him and I occurred. That's when he attempted to rape me.

Physically, all I remember doing was bracing myself, at some points pushing him off of me. But for the most part I was just more hurt, shocked, really disgusted at the fact that I just didn't feel like he was human. He had no remorse.

I would see scary movies from time to time and, you know, you'd fuss at the screen or say, "Get up. How can you stand there and not move?" To really know how that feels, to be kind of in a state of shock, state of just being froze, it's a difficult thing to try to explain. The fact that he was more than a priest in my eyes; he was a close friend of the family.

That incident was the last situation where he put his hands on me, in the rectory, upstairs in his living quarters. It was the last time I saw him for a number of years.

That was the most serious of the attachments that I had with him, the most traumatic. I knew after that [that] I wasn't coming back to the church. Something re-connected with myself and I felt the strength to run out of the rectory. At that particular time, to the best of my understanding, he raped me.

I believe in the power of Christ. I hold on to the fact that Jesus has died for my sins. And that keeps me going day to day. It's only my belief and hope that tomorrow could be better that keeps me holding on.

Around the time when everything wound up hitting the news again, with the Catholic priests being accused of child molestation and so forth, I remember at a certain point just not being able to deal with it, and having to really fall to my knees and pray to God to kind of keep me together. I remember praying to find peace in that situation.

I remember being in the house. The day of the shooting came about on May 13, 2002, I believe. I got up and had a strange feeling because my daughter had awakened with me. She just grabbed onto my waist real tight and stared at me, you know, just kept looking up at me. And we sat there on the corner of the bed for probably about an hour, didn't say much of anything. She just kept looking up at me with a strange type of look. I don't know, I kind of woke up feeling like this might be the last day I'd ever see her, or something.

So, I got up that day and took my daughter's mom to work, and I had my daughter. I allowed my aunt and her children to move in that day.

I remember having a gun in my room and – as I came to the house – that I needed to take the gun from out the room. And that's what I did; I grabbed the gun, put it in my book bag. As I went to my job I dropped my daughter off, grabbed my bag, put the bag in the car, and proceeded around the corner to the store to get something to drink that day.

I went around the corner, the same block where the priest lives. In '93 they put him out of the church, and he moved into his mom's house, which is around the corner. I see these people standing outside of his home, and I'm thinking to myself, "Maybe they're going to do something with him." I've never seen really anyone outside of his house. I noticed that he was standing, talking to a cousin of mine. When the allegations first came up in '93, the first person who came to my home [concerned about] those allegations was my cousin.

I thought to myself, "Hmm, this would be a good time to go and talk to him." I took it as an opportunity. There were enough people to witness whatever would occur between him and I, whatever conversation. I decided to approach him that day.

So I pulled up in front of his house and attempted to have a conversation with him. I sat there for about a minute and finally I just beeped the horn, looking at him, waving my hand, telling him to come towards me, I'd like to talk to him. And he looks at me and says, "Why don't you go the fuck on up the street?" And he points with his hands, like to "go the fuck on about your business, leave me the fuck alone." I'm not sure exactly what his words were, I couldn't hear him, but I could see that he was saying "fuck."

The truth of the matter is that I went there kind of hoping to resolve the situation. I'm kind of going there, kind of putting my heart on my sleeve. And when he reacted that way, it did something to me. It wasn't so much as the disrespect then, it just felt like I'm putting my heart on a plate and presenting it towards you, and you take that plate and knock it out of my hand and, you know, stomp and spit on my heart.

I remember at that time noticing the gun sitting there. Seeing everyone standing around, and thinking about my daughter. I kept seeing her face. I kept thinking to myself, "I'm not going to jail for the rest of my life and miss being able to be involved in my child's life for this asshole." And saying to myself, "God, give me the strength to drive off."

I notice a bright light, as bright as the sun but kind of white like the moon. This light came down towards me and for the most part entered me. And when this light came forward, it was so bright that once it got very close, I couldn't keep my eyes open. There were points where I could see my hand and see the shooting, see my hand and see the gun, and kind of see him. I was struggling to regain control of myself, or regain control of my body. And I remember hearing, like, hearing the first shot go off and reaching – feeling myself, like, my soul trying to reach into my body and stop the shooting from going on. I kind of felt like I was fighting with whatever was inside my body, and I felt like that light was now in my body and my soul had left. And I remember just reaching in and trying to stop what was going on, 'cause my last thought, my last moment was saying to myself, "Drive off, drive off," you know. And that's what I did.

I know that three shots were fired. I can't say that I could feel what was going on physically. Once I gained control, saying to myself "Motherfucker," just thinking to myself, "God damn, here it is now, and look what the fu--. Look what has happened, and I know I am going to jail for the rest of my life. I know this man is probably dead, here on the ground."

I drove to give my daughter's mother her car. Then I just began to walk up Park Heights, and I found this church that was having service at the time. I decided to walk into the church, and they were having a revival service, and I just went in there and began to pray. I guess at some points I opened my eyes, and noticed that I was the only person standing. It was almost as if everything became black. No one else was around, and I was just praying, you know, between myself and God. When the service was over, I had a discussion with the preacher. I told him what just happened, and that I was planning to go turn myself in, and he said he would accompany me.

So we did.

I had the gun with me. I took the gun in the bag and had stuffed it in a tree. The police took custody of me. I was booked and processed and stayed in jail for about a week or so before I got bail. Then from there I went to my aunt's house. I was on house arrest for about a year and a half while awaiting trial.

I was charged with attempted murder in the first and second degree, attempted assault first and second degree, three handgun violations. So when people ask, well, how did he get off doing what he did, it was because of one question: Did I, or did I not, have the intention to do the crime that I was charged with? I was left with just three charges, the handgun charges. And they were all misdemeanors.

The priest wound up being charged due to the actions of my attorney. I didn't want to tell anyone about the fact that he raped me, or to put that out there. My attorney felt that it wasn't fair that I didn't, that I was in a position where I needed to come forward and be more candid about what happened. He went outside on the courthouse steps with a bullhorn and demanded that they bring charges against him.

I'm very spiritual. I'm very in tune with God. I believe in the power of Christ. I hold on to the fact that Jesus has died for my sins. And that keeps me going day to day. It's only my belief and hope that tomorrow could be better that keeps me holding on.

RITA MILLA

I'm Rita Milla. I'm forty-three, and I'm in Carson, California. I knew that I would not be good enough to go to heaven.

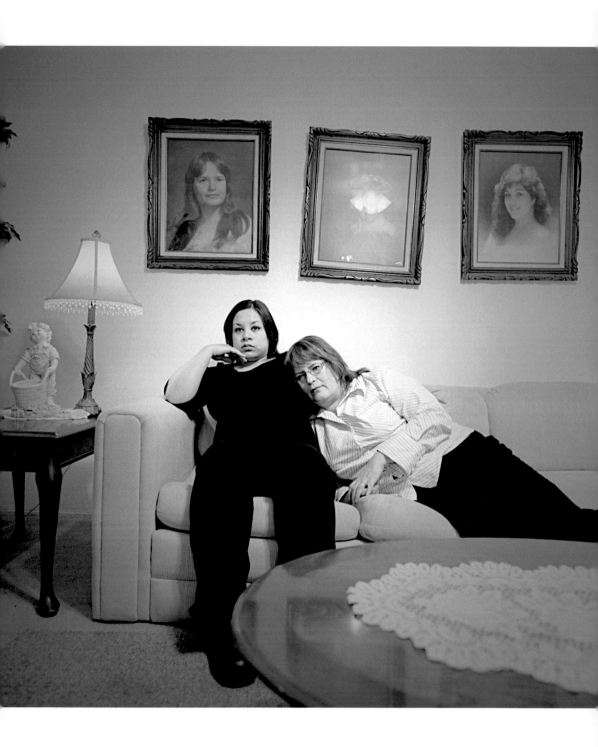

I was terrified of Hell. Elementary school I would stay up all night worrying about dying, thinking about eternity, thinking about going to Hell. And one day I got the idea that the only place where the devil would not get me would be if I lived in church. Going to church on Sunday was not enough; I would have my mother take me during the week. If we were out on vacation we'd have my parents look for a church so that we could go to Mass or go to Confession. I had no interest in boys. I wore no makeup. I purposely made myself look boring and I didn't want to be noticed. I only had a few friends. I guess I was suffering from depression. I had been abused at the age of three by a neighbor. And I always felt that I was weird in that way and I guess that's where the fear of Hell came from. I knew these nasty things that I knew I shouldn't have known. And then I was afraid of being punished for them so I wanted to be as sexless as possible.

I spent a lot of time at church in Carson, and that's where I met Father T. and I would clean up the altar, what they used in Mass.

One time right after Mass I was in the sacristy and Father T. pushed me against the wall. He was grabbing my breast. I blamed myself for the way I dressed. I blamed myself for being a girl actually – I hated that I was a female. He used to touch me during Confession. It didn't matter, it didn't matter to him. It was a nightmare. I didn't know how to make him stop and he was getting worse and worse in the abuse. He would put his fingers inside of me. He was rough about it. And it was painful and embarrassing.

One day I finally told a catechism teacher what was happening, and she confronted him about what was happening and he denied everything. He became angry at me. He ignored me. He wouldn't even look at me. It was weird that that hurt. The catechism teacher thought she could help me by teaching me Bible verses but I couldn't remember any of them. I guess finally she gave up.

Eventually Father T. starting talking to me again and one day he took me to his brother's house. He brought another priest with him, an older priest. He was about fifty or something, and that's when Father T. had intercourse with me. The other priest I guess was in the living room. When he finished he told me to wait there for Father C. I did not imagine Father C. was going to do the same thing so I fixed up my clothes and I tried to look like nothing happened, and Father C. came into the room. He wanted to know why I wasn't undressed. And he said, "Well, you did for Father T." and then he started undressing. I didn't want to undress although he pulled my pants down. I did not let him take them down completely but he was still able to have intercourse with me.

Shortly after that first time Father T. invited a couple other priests to have intercourse with me too. And it just continued like that. What was scary was that I never knew when I met a priest if I was going to have sex with him or not. I never felt I had a right to say yes or no. It didn't feel like I had a choice.

Altogether there were seven priests and this continued until I was twenty. The seventh priest was the one who got me pregnant. They had all used condoms before that. This was the only one that didn't.

Father T. said the best for me was to leave. He decided I should go to the Philippines. He told me if I didn't, everyone would know it was a priest who got me pregnant because I didn't have boyfriends and it would be a big scandal to the Church. He said that I could not do that to the Church. I really loved the Church back then and I did not want to hurt the Church at all or him even. So I agreed. The plane landed in Manila. I was met there by Father T.'s brother, who is a doctor. And he drove me to this little town. It was, like, eight hours drive. It was a bumpy road through mostly jungle. I felt so out of place, like a freak. And the more pregnant I got, the freakier I looked.

I was becoming very suicidal during this time, too. There were times when I just could not get out of bed. And I was just lying there trying not to move because of the heat. If I just moved a little bit it just made things a lot hotter. I would just lay there thinking about ways to kill myself. And then I could feel the baby moving inside and I knew I could not kill her. That's the only thing that kept me from doing it. Then eventually thoughts of killing myself turned into thoughts of anger with Father T. I started wondering what if he had started doing this to someone else? I knew I had to stop him!

I wrote to one of my friends and I didn't tell him I was pregnant but I told him that I was sick and I thought I was dying and I explained how I wanted my funeral to be. And then I wrote to my sister and I told her I was sick and I don't remember writing to her but she said I did. And she told my mother and they both flew out to the Philippines.

It's a good thing my mother was there because I went to sleep with a big headache that wouldn't go away one night. And the next morning, that's what they told me I was having – convulsions. Had they not been there I would have died because usually no one would have checked up on me until, like, noon or something to see if I wanted lunch but this happened about eight in the morning. So my mother got an ambulance and took me to a hospital. So they had to do an emergency C-section. They saved us both. My daughter was born dead. And they had to do CPR on her to bring her

back. The doctor said she was so out of oxygen that she had gone beyond blue; she was turning black. But they gave her that CPR and they brought her back. And I was in a coma.

After I got home, it was weird. I thought I'd be glad to be home but things got worse. I went into a rage easily. I, um, spent a lot of time crying and, um, it was just horrible. My mom finally told me I had to go get psychological help. I didn't want to but she made me go. During this time my mom had no idea how many priests were involved. She thought that it was just one and that Father T., being that priest's friend, was trying to help him and cover for him. She didn't realize that Father T. was covering for himself, too.

While I was in the Philippines at the hospital, I spoke to the bishop there, too, and told him what had happened and the bishop told me to keep it a secret. Later on he came to California from the Philippines and I saw him. The bishop told me, you know, these priests are getting tired of you threatening them. Why don't you just stop complaining? You know, don't go to the bishop here. Just don't talk about this anymore. And that got me madder! He goes, "Promise me that you won't talk about it." I was, like, yeah, right! And he tried to blame me, too! He said, "Well you know they didn't do this on their own. You know it's your fault, too." I had carried enough guilt. I wasn't about to let him do that, too.

After he left the room this lady came into the room with me. She wanted to see the baby because I had the baby with me. And she says, "What a cute baby. She looks Filipino." I go, "Yeah, she's half-Filipino." And the lady goes, "Who's the daddy?" And I was, like, "Screw the bishop for making me promise him." I was, like, "It's one of the priests." And she's, like, "What?" And I go, "Yeah but, um, I promised that I wouldn't tell so you shouldn't tell either." And she just had this look like she was dying to tell everybody. She got out of there really fast.

I did go to the bishop in Los Angeles. I made an appointment with him. My parents went with me but they would not let them in the room. They took me to this big room with this big shining wood table. There were monsignors or priests and bishops all sitting there. And they all started questioning me. They wanted to know all of the names of the priests. They wanted to know if I were really sure that it was a priest that was the father. If I had any other boyfriends. What kind of birth control? It was a whole bunch of questions. And then they said they would investigate and see what happened. And I went away very confident that they were going to investigate this, that they were going to be outraged and that they were going to punish these guys.

Months went by and the bishop would tell me, "Oh, we still need to talk to some more priests. They're on vacation, they're dragging it on and dragging it on."

And finally he said, "Oh, yes I spoke to them. They said what you said is true." I was, like, cool! "And there is nothing we can do about it."

And that was more devastating than what the priest had done. And that night I broke down and I just cried. It was like the bishop had just killed me. The part that believed in God, you know, the part that had all of this faith was dead.

And that was the last time I prayed to God. I didn't want anything to do with Him anymore. That's when I realized I wasn't Catholic. I didn't know who the hell I was. My whole identity was wrapped up in being Catholic. Before, I didn't even say I was Mexican or Honduran, but I'm Catholic. I'm so proud! I was nothing.

One of the most upsetting things about the whole thing was my daughter Jackie. She was the only innocent thing in all of this. I was not a good mother to her. My mom raised her mostly. I was just so depressed. I did not want to deal with anybody or anything.

It's sad because she really tried to be lovable. I felt like, if I had paid more attention to her.... She didn't have the most mentally stable mother. I was so zombied out.

She had a lot of questions, about her father, the DNA test – when I found out that he was actually the dad. I couldn't even look at Jackie. I didn't hold anything back. I think it's getting better. We're getting therapy together to work on that.

I wish I could have been a happy, positive mother to her.

LANDA MAURIELLO-VERNON

My name is Landa Mauriello-Vernon. I'm thirty-one years old. When I was seventeen years old I attended a private all-girls academy in Connecticut.

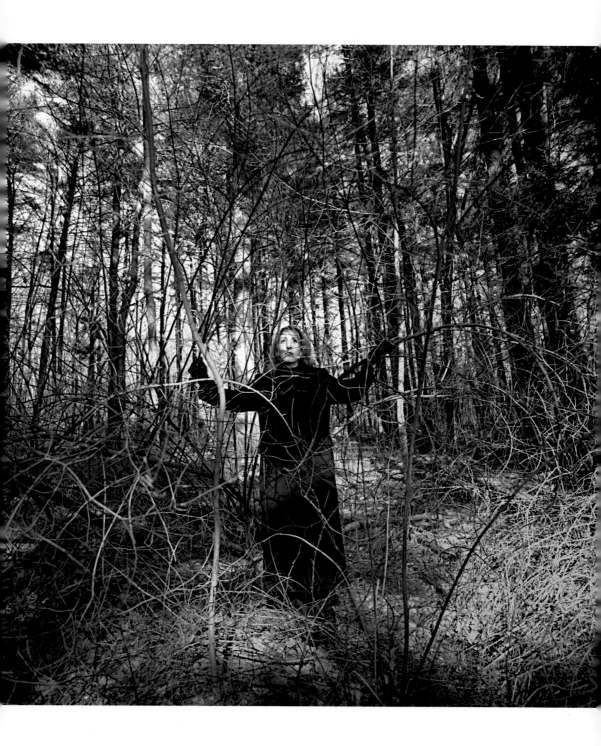

During my senior year I was sexually assaulted by one of the nuns, who was my religion and morals teacher. It started the summer before my senior year when this nun took us on a trip to Greensburg, Pennsylvania to work at a camp that the sisters ran for children with disabilities. She talked to me a lot about what I was going to do with the rest of my life. She had convinced me at that point that maybe entering the convent was for me. I'd just broken up with a boyfriend and when you're seventeen and had your heart broken, it's pretty easy to convince you that a life of celibacy and working with everyone's children would be better than a life outside the convent walls. It seemed very safe. She did warn me not to tell my parents that I had decided to do this. I called them from Pennsylvania and told them and my mom said, "Over my dead body."

It was at that moment that she was right and my parents became wrong. She was very good. She knew that would be the reaction of my parents and she knew that would cause a wedge. And it did. She would give me books to read about how to raise my self-esteem and how to become a better person because she told me how weak I was, and that I needed help. It was this constant game of mind-twisting that she did that enabled her within weeks to start using sex against me. She had isolated me from my friends and my family at that point.

She became my best friend.

I don't know how the actual abuse started. The sex part of it anyway. She would take me into a conference room that was right outside her classroom – in a very isolated part of the school. And so no one was there. It would happen during school hours, after school hours. It didn't matter. But we would go into this conference room to talk about one of the books that she'd given me, um, and then one day she just started wrestling me. And I ended up on the ground with her on top of me. And she would just, she would just stay on top of me until she eventually would orgasm. And she had. I was pinned down, I couldn't move, and that's pretty shocking. Especially for me because I was seventeen, um, but seventeen, even in 1972 was different than now where sex wasn't talked about very much. And I wasn't very aware, I guess, of different types of sexual behavior. I had no idea what was going on. I had no idea. I just knew that I didn't want anyone else to know about it.

And I never spoke of it. Ever. And she didn't speak of it either. She would just get up and go either on with the conversation or right out the door to go to prayers.

Once-a-week, twice-a-week, four-times-a-week…. It just depended on her mood, and on my mood, I guess. She was very good at reading if I started to feel strong. She was able to quickly knock that down.

My parents; of course that relationship continued to go down hill, because I would become more sullen and more angry at them. I would go into this deep stare sometimes.

During the time of the abuse I started actually cutting myself with my nails; I would … and I usually did it on my upper legs where no one could see. But I would just pinch, or scratch or dig holes into my legs. And, you know, my mom at one point noticed and sent me to the doctor because I had given myself a staph infection. But no one could figure out, you know, no one could figure out how I got these holes in my legs, and I never, ever told anyone.

My parents tried really hard. They went to the principal of the school, another nun. My dad went over and over. Five, six, I don't know how many times and said, "We want her kept away from our daughter. She's brainwashing her."

My parents actually went to the provincial of the order. And they said, "Look, we're not signing the papers. We want you to keep this nun away from our daughter." And the provincial looked at my mom and said, "Why don't you just let her enter the convent and we'll take care of her from here?" And I think my mom looked at her and said, you know, "Over my dead body."

I did not enter the convent. My parents would not sign the papers.

They sent me to Eastern Connecticut State University.

I called every night, crying. I didn't know how to live outside of the abuse anymore. When I didn't want to feel things I would make myself bleed; I would pinch myself till I had holes on my legs, on my face. I destroyed my body.

I would drive to the school and then I would sit in the parking lot because I was having panic attacks at that point. I just couldn't walk into a classroom without, I mean, feeling like I was actually having a heart attack. And so I dropped out. I just couldn't do it.

I was able to get a job waitressing at a country club. I knew I wasn't going into the convent and at that point I had no relationship with the woman who abused me. I met two girls and I remember one of them saying, "We're going to be really great friends." I remember thinking, "Oh I just don't think so." I didn't want to be great friends with anyone.

They saved my life.

I started to understand what it was like to have friends my own age again and started to meet guys again. They started teaching me how to be normal and I was – for a while.

I had gone to therapy and I thought I had kicked whatever the depression was. And it sounds silly but I just thought, "Well, you know, I'm depressed, I have headaches." I never thought to say, "For a year of my life there was a woman in a habit on top of me, um, using me for her sexual pleasure." I didn't deal with it.

In January of '94, I went back to college and that's where I met my husband, Brent.

I think anytime you have a boyfriend, girls start to lose weight. But at that point I really started to lose weight and I started to lose very fast; and that was when I started to deal with my eating disorder. And I think I went from a size twelve to a size six in six months.

In my engagement pictures, I mean, I'm a size four, and my hair was falling out. But I was still looking to lose weight! I actually thought that I was being healthy. I thought I was doing something good for myself, losing weight. And you know, I think I could have gotten to a size zero and still thought I needed to lose weight.

We moved a lot in the first few years of our marriage. Just kind of following his job. And that was miserable for me. I started to put weight on again. My daughter, Alea was born in May of 2000. And that was pretty much when all hell started to break loose. I missed my family. Just panic. So we moved to Rhode Island because we felt that was close enough. And, um, I don't know, Alea was almost two at the same time that the scandal was hitting in Boston. Cardinal Law was the big topic of conversation and that's when I just was devastated by the effects of my own abuse – sitting on the kitchen floor just crying and knowing I wasn't going to survive it anymore.

I knew that I had to get help that day. Or that Alea would grow up without a mom. I started therapy in Rhode Island. I just felt so ashamed, like, why didn't I say "No?" Why didn't I walk away? Why did I keep going back to that classroom? And you actually have to know in your head, you have to learn it – that it wasn't your fault. And as much as I would say to anyone else who told me a story of abuse, "Oh my God, you could have never … it wasn't your fault." But when it's your story, you're, like, "Yeah, but I should have known." I mean, how did I miss that? How did I? How did I let that happen?

The fact is that there was no way our power was equal. She was a teacher. She was a nun. She used to say that she would represent the avenue that I could get to God.

She was going to help me become my best self. I mean I grew up with anyone wearing a habit or a collar as just holy! You never, ever, questioned.

The next step was telling my family what had happened.

I remember the look on my mother's face – my dad's face was just agony. You know, my parents were victims of this, too. And my sister. And now my husband. The kids.

What bothers me about the whole thing is not really the abuse because you'll never stop people from becoming sexual perpetrators. We'll never stop that. But the worst thing about the whole thing is when a leader knew and they did nothing. We need to listen to our kids. We need to watch for signs. And now we know. What we didn't know ten, fifteen, twenty, thirty years ago, we do know now. And there's no excuse for not calling people out on what they've done.

The girl that was best friends with her before me entered the convent; the girl who was best friends after me entered the convent, and I just don't think that in the early nineties you had that many girls going into a very small convent in Hamden, Connecticut that weren't pressured.

And still to this day, where I consider myself you know, in full recovery, every once in a while you think, "Why didn't I see it?"

Why didn't I know it? Why didn't I just knock the crap out of her and walk out of the room?

CHARLIE PEREZ

My legal name is Carlos Perez. I am now forty-three. Practically since the day I was born in The Bronx [New York] I've been named Charlie. That's been my nickname in order not to confuse myself with my father, who's also named Carlos. My parents are immigrants from Cuba.

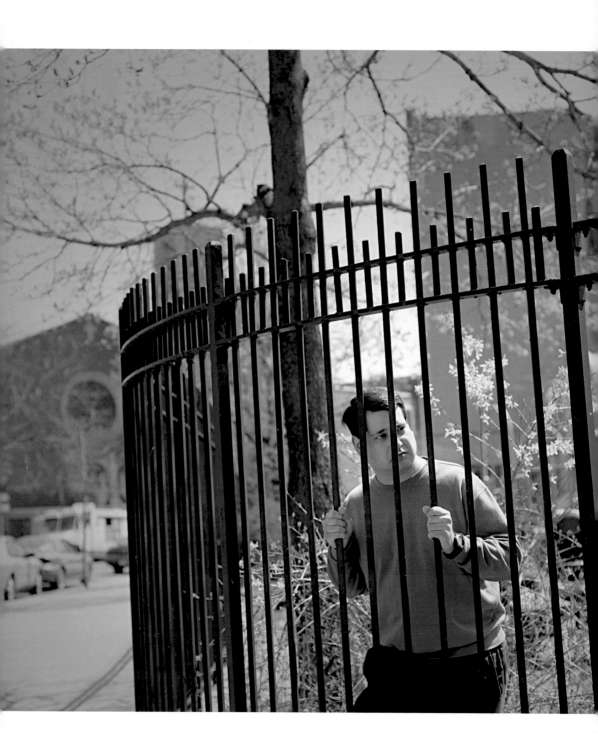

Around the fourth grade, I decided to volunteer my services to the Parish and to the community as an altar boy. I was about nine years old. I would celebrate Masses, daily Masses in the morning, at the church. I would celebrate for funerals and special occasions and of course for Holy Week, and other special Masses and holy days of obligation and all of that.

One morning, during a school day, I was in the sacristy of the church, preparing to celebrate Mass with two other altar boys. I was standing right in the doorway that separates the sacristy and the rectory, where the priest resides. And suddenly this huge fat man with long hair and beard flung open the door – wide open – and as soon as he opened the door, he suddenly froze. He stood like a zombie in a trance, stiff as a board, and he had this odd look in his face – this stare, this glare, and he was directly looking at me. His eyes were sort of like glassy-eyed, and he had this very ominous look in his face. For a second, I was stunned. But then he, like, instantly snapped out of this trance, this zombie-like state, and he immediately approached me and befriended me. He immediately, like, crossed my boundaries. He started asking a lot of personal questions like what is my name, what grade I'm at, where do I live, my telephone number and this and that. And I thought nothing much of it. Hey, you know, it's a priest. He's just being friendly. That's how we started our friendship, just like that. I was about nine years old.

In the beginning we started taking car rides alone in his own automobile. I guess he was just trying to get acquainted with me, slowly, deliberately trying to lower my guard, drop my defences. He was, like, encroaching himself on me, like, grooming me, preparing me, the same profile these pedophiles conduct. He was setting me up from the age of nine when he first set eyes on me until he finally got me in December of 1975 at the age of thirteen.

I received a phone call telling me that he would like to invite me to a trip to Bethlehem, Pennsylvania for a Christmas party. I said sure. And my parents, they didn't object. They saw nothing wrong that I would be going alone with this priest all the way to Pennsylvania. And we left for a weekend. It was, like, a Friday afternoon. We drove all the way from the Bronx, across New Jersey, and we finally arrived in Pennsylvania, in the Lehigh Valley of Pennsylvania, and there was this family there, a gentleman and his wife and two older sons. They were expecting other guests to arrive for this Christmas party, and of course, I was fascinated by all of this because I never celebrated Christmas in an actual house. It was always usually in an apartment in the Bronx, you know. And they had a nice beautiful Christmas tree, and the town was beautifully decorated with lights.

And this family that owned this house, they welcomed me to their home, and they treated me so kindly and respectfully, and it was an honor to be there. When the festivities were over, we decided to go outside and go Christmas caroling. First time in my life I ever did that because in the Bronx, you know, people don't usually go Christmas caroling. So, it was a very blessed, joyful moment in my life that, hey, this friend/priest of mine, he really cares about me. I looked up to him like a father figure and my best friend. And even more than that, he was like God to me. When I was with him, I thought I was in the presence of God Almighty Himself. And, you know, what could go wrong anyway, we thought in those days.

It was time to leave. We left in the middle of the night. And along the route, I fell asleep. Instead of taking me directly home, which is what he should have done, he drove directly to the church. He got out of his car. He was leading me directly into his bedroom, into his living quarters. He never said a word. He was like a zombie. He immediately went into his private bathroom and took a shower, and I was just sitting there, wondering, you know, "What the hell am I doing there? What is he doing? He's taking off his clothes. He's taking a shower. He has the door open." He came out of the bathroom, totally in the nude, naked, and he walked up to me and I was at eye level to his genitalia, to his penis. And he kept pressuring me and coercing me to take off my clothes and take a shower. And I was sitting there, you know, frightened to death. I didn't know what to do.

So, I remove all my clothes. I went into his shower stall. I was taking a shower. And as soon as I came out, he grabbed a towel, and he began drying me. He got down on one knee. With his left hand he pulled back the foreskin of my penis, and with the other hand he had the tip of his fingers covered with a towel, and he immediately rubbed the tip of my penis so hard, like it had never been done before. And it was so painful. I didn't scream. I didn't shout. I didn't push him away. I didn't, like, punch him in the nose. I didn't see anything wrong that he was doing. I just allowed him to continue with this obvious indecent behavior because I still had respect for the man. Because he was a priest!

Since he could not arouse me, he could not have me have an erection, he let me go. He led me into his bed, which was a twin bed – a bed built for one, and he immediately crawled into bed right behind me, totally naked, completely naked. And him and I slept throughout the whole night that way. I was in his pajamas. He was naked. I turned my back on him and I slept the entire night with my back towards him. But during the course of the night, he made no attempt to sodomize me, to penetrate me; I don't know why he didn't go all the way. That still is a mystery to me.

After that incident in the rectory, I stopped going to the church, and I stopped offering my services to the church as an altar boy. I kept silent. I repressed the memory of this incident for twelve years from the age of thirteen to about the age of twenty-five. And now, after many years, the real reason why I was struck with mental illness was due to the fact that I was sexually abused and assaulted.

A year and one month after the incident, my behavior, my personality, my demeanor, everything changed so radically. I started to withdraw, I isolated myself. I would stay in my room. I was avoiding my friends from the neighborhood. My friends were asking me constantly, "Hey Charlie, why aren't you coming outside? Where are you? You don't come outside anymore?"

I was initially diagnosed as a paranoid schizophrenic. I had all the symptoms of hallucinations, delusions of persecution, paranoia, but now that has been changed. I am now considered "schizoid-affective disorder" with "post-traumatic stress disorder." What used to be called "Post Vietnam Stress Syndrome." I have very low self-esteem. I'm unable to be employed. I can't hold onto a job. I'm very dependent on my family.

I'd like to state for the record that before and after I recovered the memory of this incident I attempted suicide twice. I attempted to kill myself twice because I just couldn't go on living like this any longer, with all this uncertainty and having my life and my future ruined. Totally destroyed, tragically obliterated.

No, I don't go to Mass anymore. I don't believe in the Sacraments. I don't go to Confession. My faith in the Roman Catholic Church has been decimated. These bishops and cardinals and popes and archbishops and even priests have violated their solemn vows before God to serve, protect and defend the flock, and they have failed very miserably, very miserably. They have violated the laws and commandments of God and the teachings of Jesus Christ in this matter, and they have committed very serious grave and mortal sins and abominations and atrocities. They don't deserve any forgiveness. May the wrath of God fall upon the Catholic Church. I really seriously mean that.

The Church is nothing more than a mafia. It's a corrupt institution. It's like an organized crime syndicate.

I had blind faith for the Church because, in those days, in the Seventies, priests and even nuns were so highly respected and were members of the community, and we welcomed them into our homes. And it was an honor to have a priest come into your family and become welcome as a member of the family.

But now, since these revelations came out of Boston, and when a judge signed a court order for the Archdiocese of New York to open up all of its confidentiality files, the truth has finally come out. That was the biggest break I ever had after so many years of struggling with this. And I think finally my prayers have been answered. After praying and suffering and crying, and pleading, "Oh God, help me," this was the biggest break, not only I had but many other victims like me. Because I thought at the very beginning that these were just isolated incidents. We now know better, that these were not just isolated incidents, that the hierarchy of the Church and even the Church itself was behind this all along, and we now know the truth. They decided not to do a goddamn thing about it. And it's absolutely atrocious, and abominable, and despicable and disgusting, and disgraceful and degenerate, and dastardly and diabolical and demonic, and even hypocritical.

Let justice take its course. I let the law take its course. God has been with me all along. I have prayed deeply and prayed whole-heartedly to God, "Please send me your divine providence, your intervention, your inspiration." I pray for divine inspiration, divine intervention and divine providence every day, every day, for God to help me in this matter and to finally see justice and compensation for as long as it takes.

These bishops and priests and cardinals and archbishops, to me they are nothing more than traitors and subversives. And they have been caught red-handed, literally with their pants down. And you know what? They deserve it. They goddamn well deserve it. They are, totally, you know, an affront to God, an affront to the Scriptures, and an affront to Jesus Himself, totally anti-Christ. I call them Antichrists – hypocrites. Their only allegiance and loyalties are to both Rome and the Bishop of Rome, and not to the United States of America, and not to the people of the United States of America, and to its citizenry. They are nothing but hypocrites, fake, phony, frauds, fiendish, foul, filthy, felonious and fucking goddamn hypocrites as well. I have no love for them at all. And may they all go to hell.

JAIME ROMO

My name is Jaime Romo. I'm forty-five. For me to be here, soaking in the sun – being where I am – is a miracle. It's a lot of miracles because I died when I was young. And only now I'm starting to find what has been lost for so long.

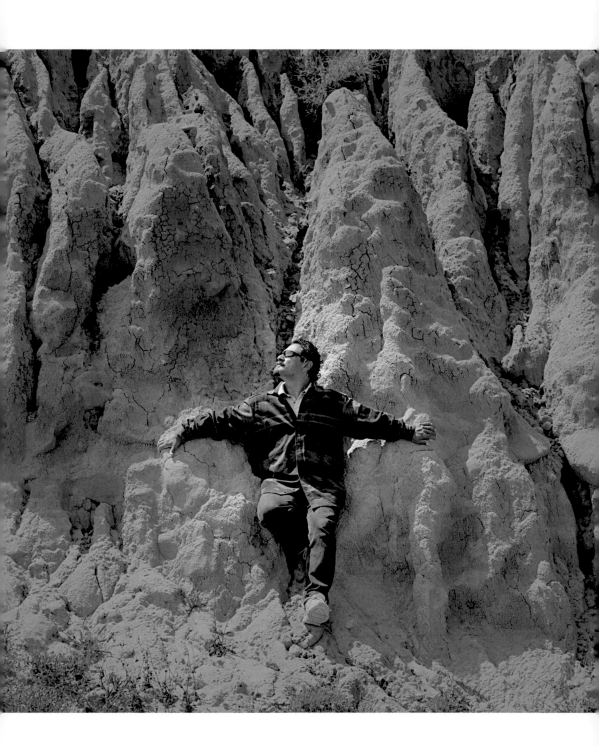

I grew up in Northeast L.A., in Cypress Park, with my five brothers and sisters in this very, very tiny house that was really cockroach infested and always in need of some kind of repair. I grew up very hungry in a lot of ways. I mean hungry certainly for food, but also for some safety; my dad was a violent alcoholic. So we grew up with a lot of violence in our home and a lot of secrecy about how miserable and dangerous a lot of our home life was.

Church for me was hope. Church – somehow God – was this big Santa Claus in the sky, and that every once in a while you'd get some good things.

We all went to the Catholic school where we were the core bedrock family and very, very involved in everything.

My mom got to know the Monsignor, who was the person who molested me. She was his best friend, she was his right hand, you know, connected him to everybody in the parish and translated the bulletin and was his adviser and confidante.

So I think my first job was there in the rectory, answering phones. It was quite a contrast going from my home to the parish; nice carpet and nice furniture and all this crystal and stuff. So for me to work there and have a chance to have lunch or sometimes even dinner, there was really a big change. I mean, to have food was a big deal.

I was a good student. I worked real hard to be the perfect kid so that I wouldn't upset Dad and start a new wave of violence, that maybe somehow magically my being good enough, being perfect, would stop or minimize his drinking and violence. And I think that's exactly what made me kind of the trophy for this guy, you know. In a lot of ways, I became his date, I became his, you know, friend to go places and travel with and keep him company. Little by little he started buying birthday presents and other kinds of presents. My mom was thrilled and I felt honored. I didn't have anybody really in the family that spent that kind of attention or, certainly, that had those kinds of resources.

He had a beach house in San Clemente that he started to take me to when I was in high school. That's where he started getting me drunk, little by little, just introducing me to different drinks. My dad had a violent alcohol problem and so I never wanted to – around my house, you know – connect with any alcohol use or anything. But given who I was with, this was somehow responsible drinking and elegant even. There was part of me that liked and felt flattered and liked that kind of intoxication.

I don't remember exactly when the first time was that he started being genitally sexual with me. He started more and more just to kiss me all the time, like he was happy to see me. It was this sloppy kind of kiss. I didn't know, I mean I didn't kiss people. He'd take me to dinner and order different drinks, lots of different drinks, and then we'd go back and he'd offer to take a sauna 'cause he had a sauna in his little bedroom. I remember this rich, thick carpet that he had throughout his place. So that's where the massages started. That's where the showers started and that's where sleeping in the same bed, nude, started. Some of the times I remember him groping me and washing me and grabbing me and trying to masturbate me. A lot of my response that I remember was me pulling away and, you know, if we were in bed, trying to pretend I was asleep, and roll up in a fetal position.

I remember one time I was a junior in high school and I was at a soccer game. I was a pretty decent athlete. I think part of what made me a decent athlete was that I could run and kick and slide and work out my rage in a socially appropriate way. I pulled a groin muscle. So after that, Mom dropped me off at his rectory. And you know, going to dinner and getting a little bit drunk, and he was really massaging me [and] doing this kind of quasi-treatment. I got an erection and I was really embarrassed and mad, and he kind of joked about, "Oh, you're just embarrassed cause you got a hard-on," like it was normal for any man to be massaging this kid's groin. And I remember really not knowing how to respond to somebody who apparently knew a lot about the world, knew a lot about whatever, sports medicine, or.... So that was one of the last times I remember him pawing me in the night, and I uh – actually this is one of the first times I'm remembering – having an ejaculation. This is kind of why I don't want to remember a lot of things.

Someone asked if I remember, you know, did he sodomize me? Did he do other things? And when I think of that, I find, despite my therapy and recovery that this is a part that I don't want to remember. There's a part for me that goes dead when I think about the [molestation] with him in bed.

The first time that I really even remembered anything, even though it wasn't very clear, was when my now current wife was my fiancée. We went, as I've discovered that a lot of survivors do – at least a lot of survivors that I've talked with – back to the Monsignor so he would marry us and we would have his blessing. So there's this Stockholm effect, you know, of like I was just still very loyal even though I really didn't have anything much to do with him anymore. And in short, he ignored and showed his disapproval for Filomena. And something happened.... It was another one of those flash moments where I wanted to hurt him. I told him he couldn't be a part of the wedding,

he couldn't show up. I un-invited him. And then a couple days later, my mom called me. She was so heartbroken! He was so heartbroken! She didn't understand – and he didn't understand – why he couldn't be a part of the wedding. He loved me so much, and on and on. I told her – the first time I told anybody – that he had molested me. And she was just in shock. Uh, I don't remember what she said, but I know that she kept in touch with him as, again, his daily kind of confidante, friend. And she continued to do things with him, and that was the end of my relationship with her.

All this stuff came up a few years ago. It was like as if all those experiences and memories that I had, I had compressed and pushed way down in my consciousness. And so when the stuff started coming up, I guess it was like compressed air, you know, when it comes up and it expands, it messed up everything that I had organized in my head. All of a sudden I couldn't remember and I couldn't function well. I was upset, it was very unsettling. I felt stupid and incapable and confused and scared. All kinds of things.

I was really miserable. I was having anxiety attacks; I was having flashbacks and nightmares. I mean my sleep had always been limited. For the last year of my dissertation I only slept three hours a night well. I figured that's what people do when they get a dissertation done. I later became an administrator. I didn't want to go to bed. I didn't want to lay down in a bed. I mean I was losing my mind, I was blanking out in class in the middle of lectures. I was becoming forgetful and just clumsy in my teaching. I'm a great teacher! I have been at different times a really, really great teacher and all of a sudden, I was miserable and I couldn't remember things, and students would bring up things for me that were about authority, and I was lost.

As I did more therapy and actually started to admit that I'd been depressed for a long time, and started to ask for help, I started to feel a little bit freer and a little bit clearer sometimes. I started to have some boundaries that I never used to have. When I think about a lot of survivors, our boundaries have been so broken down and messed up, so screwed up. No wonder I didn't know where I ended and other people began. I was always taking care of other people because I didn't know how to hold on to myself and my own experience.

I think a lot of my life has been everyone thinking I'm fine. A year ago, I told one of my most trusted colleagues that I had been diagnosed with [post-traumatic stress disorder] and that I couldn't remember things, couldn't read or concentrate. She said, "You know, a lot of people might just think you're a little spacey because you compensate so well...."

When I started to take action it forced a lot of learning. I recognize that in a lot of areas I've been an advocate for others, for kids, poor kids who don't get seen as smart. I started to use my own experience as something not that was going to be poison for me but something that I could process and make public. So I started to develop a language for my own recovery.

I brought my family with me in my experience of abuse, letting them know what was going on, making connections to maybe why in some cases I was so upset about certain things or protective about my kids.

One day I saw my younger son, who physically is very much like me. He was laying across my bed asleep, taking a nap in the afternoon, just wearing shorts, not wearing a shirt, and I had a flashback of me at his age. So it's not been an option for me to not take action because action has been the method for me to recover.

I take my therapy seriously. I take my support serious. I take my work to bring change as part of what helps me to be happier.

I don't go to Catholic church. That was a big leap for me. The place that I go is really involved in social justice as a core, a principal foundation.

I imagine a million-survivor march in the future with not just priest and nun survivors but domestic abuse, and war, and poverty, violence, and all kinds of things that people really survive. I imagine that this work, directly related to clergy abuse, is akin to Martin Luther bringing a discourse about deep systemic corruption and abuse of power to the table in a way that made sense in his time.

The beach has always been a safe place for me. It's one of the things that is significant, being here near the beach. In fact in my childhood it's one of the few places that was really fun, that was always really, really freeing. So it's no coincidence for me that now I make an effort to go to our family beach house where it's also safe and also, you know, is a place where I can connect with another part of my identity.

RICHARD SPRINGER

The most painful state of being is remembering the future; particularly when it is
one you can never have. I sit here and I look at these drawings....
I think about what I might have been if it hadn't been for what he did to me.

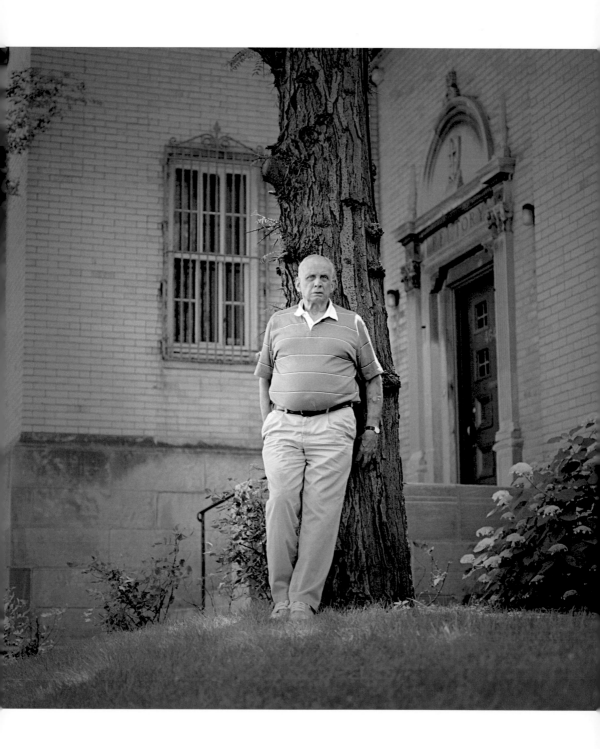

My name is Richard Springer. I'm sixty-eight years old and I live in Chicago, Illinois. When I was a kid growing up – I wasn't born Catholic; my family was Lutheran but they really didn't practice much in the way of religion so I was kind of a free-wheeling kid. I was pretty wild, it was a time of excitement for me, and I had a lot of talents and I was very artistically inclined, as well as athletically inclined. My father was an Olympic swimmer. I came from a long line of athletes as well as artists and architects, and that sort of thing, and so it appeared that I had a pretty good future. I was a go-getter, probably the fastest kid in my block, I could out-swim everybody; one kid once told me many, many years later that I had the makings of a triathlon athlete.

When my parents broke up in 1946, I desperately needed something for solace, so to speak. About a year or so after that, my best friend took me to my very first Catholic Mass, and I can tell you that it was a magic show that really impressed me. I embraced that religion right then and there. I really felt that Jesus was right there in that church with those people singing the hymns in Latin. The priest was changing water and wine into the blood of Christ, and the bread into the body of Christ, and all the other happy horseshit.

Around this time it was determined that my mother could no longer keep us at home so the family decided that we would have to go to boarding school. I ensured that we would go to a Catholic boarding school. We were received very well and the nuns were very good and kind with us. I had a lot of things to overcome when I went in there and my goal was to become a Catholic.

I was baptized a Catholic in eighth grade. I got my first Holy Communion, I went to my first confession, and I began to serve as an altar boy. About that same time, I determined that I had the calling to become a priest.

I believe I was thirteen when I entered the seminary. At first, everything was new; I was really into this religion thing and I was really very excited about becoming a priest. I was also very attracted to girls. Well, you can't overcome impure thoughts when you're going into puberty and I found myself in confession more than any other place, confessing my sins over and over again.

I was beginning to have doubts about my so-called vocation as well. I was very uptight, a train-wreck at the ripe old age of fourteen. There was a church down the street from where I lived, about two blocks away, and I started going to confession there. I poured out my sins in the most graphic detail and eventually this priest told me that he could help me better by coming to see him in the rectory. We made an appointment and I

remember leaving the house that morning. I was full of hope that this priest was going to magically take away my evil thoughts, and I would be free from them forever. I went there and I knocked on the door. The Father answered the door and took me upstairs to this tiny room.

He heard my confession. I remember I was kneeling before him on that hard floor, and he was sitting in this chair, listening. When we were through with the confession, he absolved me. He said, "I want to demonstrate something with you. I want to see if you are holy enough in the eyes of God." He told me to take my pants down and I obeyed. I just obeyed. He took his thing out, and he began to rub my penis with his, and telling me, asking me, didn't that feel good? Didn't it give me pleasure?

It was horrible, but I had to say it was pleasurable. He wanted me to stroke him, and I refused. I couldn't do it. So he continued to stroke me, and finally he got down on his knees and he began to suck on my penis and, I don't even know how to describe how I felt. It's almost like I was up on the ceiling and I was looking down. This can't be happening, but it is happening, and it can't be, but he's a priest, and I can't say no, yet I know it's wrong, and yet he's a priest, and it was just back and forth, and it was horrible. I was fourteen when it happened. And when he finished, he stood up and he pronounced my body holy enough to go on to study to be a priest. And then he said that he would want to see me again, and then we would do some more counseling.

I was condemned to hell!

I knew that my confessions and graphic descriptions of my fantasies had caused this priest to fall.

It was my fault!

When I left that rectory and went down those stairs and back down the street to my home, I was a totally different person from what I was when I walked there, less than a half-hour before. And from that moment on, my life was destroyed. Absolutely destroyed.

I couldn't tell anybody at home what happened. I had to keep it inside of myself. I think that what sustained me was that I knew that when I got back to the seminary, I could tell a priest there, and he'd know what to do. I think that's one thing that kept me going. I just prayed to God that I wouldn't be struck by lightning. I prayed for forgiveness and all these other things, but I avoided that church like the plague.

When I went to see the Father at seminary I was crying. I was just crying my eyes out, and I said I had to talk to him about something that happened. He was profoundly shocked at what I was saying, just a huge sigh came out of him. He tried his damnedest to tell me that this was not my fault, that the priest had committed a grave sin, and that I was not at fault. It was of some solace, but I was convinced I was going to hell.

He went to the bishop and the decision was made that I should be counseled and that there was not much they could do, because, believe it or not, if it had happened before the confession, we could go after the priest and we could do something. Since it happened afterwards, [he said] it's a different situation and it might be bad for the child if we had him go to the cardinal in Chicago and repeat his story. It might re-victimize that child, so we better not do that. So, essentially, the decision was made that I should be counseled.

At first I tried to stay in the seminary. Eventually Father told me that I would have to leave, that I probably was not good priest material. It seemed to be that because I was abused, I was essentially radioactive material. That was a big blow to me. I remember crying and asking him, "What's going to happen to me now?" and Father said, "I'll pray for you."

In school my grades just went down the toilet. I couldn't study, I couldn't concentrate very well. I was not a good student. I was either drunk or hung over and I acted out an awful lot in angry bursts of rage. There was something inside of me, that, I always had this horrible fear that I might be homosexual. So I would make every effort to prove to myself that I wasn't and that meant girls, which was not a problem because I was strongly attracted to girls anyway. So, I, uh, you might say I was almost like a sex addict. But I couldn't sustain a relationship. There was just no way a relationship was going to last long in my emotional state.

By the time I got to my new school, I believe the memory of the abuse was repressed. My parents didn't know that I was abused. Nobody in my family knew. My repressed memory syndrome kicked in within a week or two after I left the seminary. I had to do something about this memory and it seemed like the only thing I could do was to just shut it out, just squeeze it out of my head.

Although I had no memory of what the abuse had done to me, the residual effects of it were devastating. There was a sense that I was doomed, and even though I had no memory of the abuse, there was something in the back of my head saying, "You're doomed, you might as well just live it out as long as you can."

It's an interesting dynamic that happens to people when they're abused. Some will come right out, and they're absolute, they're raging maniacs and they can do great

wonderful things right off the bat. And there are others of us, like myself, we're just terrified. We're just too frightened. Fear absolutely dominated my life in every area. I knew I was going to be rejected. The fear of rejection was very high in all areas of my life, from girlfriends to jobs to friendships.

I got drafted in 1960 and I went to Korea. My drinking even got worse when I was in the army overseas. I never was court-martialed for some of the idiotic things I did, and the outbursts that I had against authority. Which was another thing in my life – authority figures.

In 1979 my life really began to unravel. I just loved my job at that time, but I lost it because of booze. Shortly after that, the booze really took over and I became unemployable. By May of 1981 I was homeless and I was drunk almost around the clock. I would have seizures. On the day before Thanksgiving of 1981, I had my last drink and I went into a detox center. I've been sober ever since.

And one night, in October of 1983, when I was on the verge of a nervous breakdown, or going back to drinking or killing myself, I had the flashback of what the priest had done to me back in 1952. It was just devastating! But I remember, when I had the flashback, the first thing that came to my mind was – "So that's what's wrong with my life! That's what's wrong!" That one moment of revelation seemed to explain everything that was wrong with my life. The fucker took everything away from me. He took everything away from my family, I mean, not just me – he just ruined it for everybody. My mother, my father, they never knew what the fuck was wrong with their son.

I never married; never had any kids. I'm sixty-eight years old now, and the chance of ever being married or any of that, any of those perks that everybody else has, there's nothing there. And that's why I keep going back to that quote that I mentioned in the beginning about the future I never had. That's the most painful part about my life today, knowing the potential that I had and what I could have been if I had not been abused.

ALEXA MACPHERSON

My name is Alexa MacPherson and right now I'm thirty. I'm the youngest of eight children and was raised in Dorchester, Massachussetts.

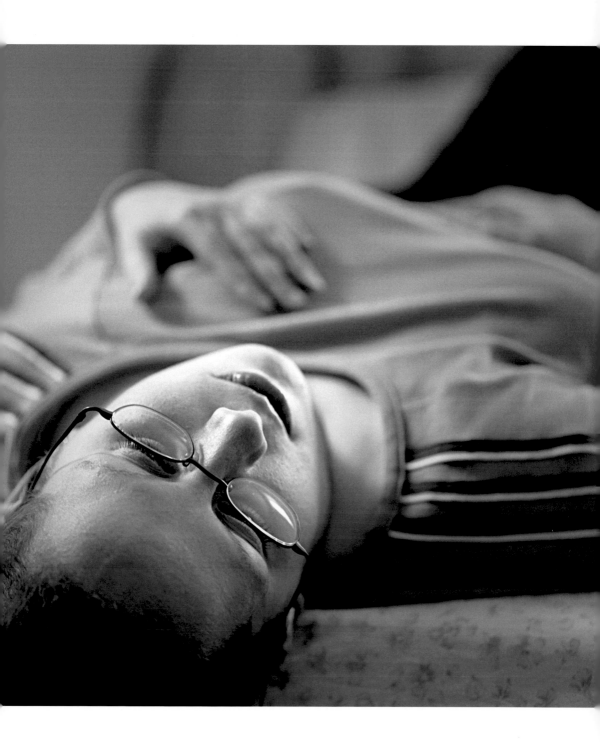

He would come around all the time. He was like a light fixture in my house. Always there, like the bulb that never went out. I mean he was there, breakfast, lunch, dinner. I'd be sitting at the kitchen table. I liked to color and paint and draw and all kinds of stuff. I'd have my crayons and my paints and everything out. He would pick me up and sit down in the chair I was in and then sit me on top of his lap. I would feel him get hard underneath me, but I didn't know what it was. Me being little, I would think it's like a candy bar or a pack of Lifesavers or something, but what it was, was him getting an erection. And then he would gyrate me on his lap, like swirl me around and be moving all around himself and you know, I wanted to just get away. I didn't want him holding me, I didn't want him touching me, and you know, he would hold me even tighter and hold me there. Then a lot of times, I would all of a sudden feel something wet and warm under me, and he would ejaculate in his pants. And I would yell out, "Mommy, Mommy," and she, like, I don't know, wouldn't notice or whatever.

My mother was always busy 'cause she was taking care of a household of nine people, and so she would constantly be doing laundry, and having to cook and prepare food and clean the house.

Right after that he would put me down, and he would go in the bathroom and spend a little bit of time in there and come back and have a cup of tea and some crackers or cookies or whatever, like nothing was wrong, like nothing even happened.

The house was old, and it had those great big old-fashioned radiators, so I would, like, put a blanket from the radiator over the chairs and the table and, like, really build myself these cool little forts. I would take my game boards, like Chutes and Ladders and Candy Land and stuff like that, make this cool floor pattern and have all these colors and set up my dolls or whatever. He would come over and interrupt and he would crawl underneath and he had his fly open. He took his penis out and he was masturbating himself and he ejaculated all over my boards. I remember being all grossed out and I was, like, "Eeewwww," and I told him. He spit all over it or something like that, and I had to, like, jump up and go to the bathroom and get all these tissues and wipe it away. I wish to this day though that I had saved that board, because you know, that DNA evidence would be so strong in a court case right now, but unfortunately I don't have it.

I can't say that I know for a fact that he ever fully raped me. I know that he used to touch me over [my] clothes and under the clothes. I know, for a long time, I would tell my mother, "my pee-pee hurt, my pee-pee hurt"! It would always be red and inflamed looking, and you know, she never took me to a doctor or nothing. She had

this medicine that was in this big white container, and she would always put that on my vagina, you know, after I took a bath and stuff. She couldn't figure out why I was so red down there all the time, and so swollen looking, and she just figured, you know, maybe it was from my pants or underwear or shorts or whatever. She just never put two and two together.

All's I know is that if anybody ever did anything like that to my daughter – I have a six-month-old daughter, her name is Heavenne – and I saw her personality changing and she was saying things like I was saying, the first place I would be taking her is to a hospital to get checked out to make sure she's OK, and then to a police station.

How I was in a household with all those people, and nobody ever picked up on it, just stuns me to this day.

My parents found out about the abuse while my grandmother was in the hospital and my mother had to go and see her so my dad drove her into Boston. I want to say August 17 was the date, and it was in 1984. I was home with my older sister. I don't remember if he rang the bell or not. I think he probably just walked in the way that he usually did. I was just sitting there and watching my cartoons and eating chips and stuff, and my sister was sunning herself at the pool and had the radio going and stuff, and the next thing I know, he was on top of me, and he was taking off my little shirt that I had on, and then he was getting my pants down, and he, you know, already had his fly down per usual. He had me, like, pinned with his elbow, like, on my shoulder. He was forcibly trying to rape me that day, on the living room couch. I was only nine. I was yelling and screaming and stuff, you know, "Get off of me!" and "Help!" and everything, and my sister couldn't hear me because the radio was on and the pool filter was on, and that drowns out even more noise. He was trying to get me fully undressed and, you know, he had his pants down and his penis out and ready, and then all of a sudden my father just walked in.

He literally threw him off me. And then he somehow got him out the front door and my father, like, picked him up and threw him down the four front steps. My father threw him so hard and fierce that he bumped the gate, and knocked the gate out, you know, toward the street. My father was throwing the shoes at him and telling him to get the "F" out, and just screaming and swearing at him. I was on the porch and I was hysterical, crying and screaming.

My mother came home, and we had a great big discussion. We went to the police station. The detectives came to us, and we ended up going to court for it. But,

we didn't go to trial. My mother wanted to keep it out of the papers and all that stuff. They asked me over and over and over again, you know, was that the first time, was that the only time, what happened. Yak, yak, yak, yak, yak. I was so scared, I kept thinking about him always telling me if I ever told, my parents wouldn't love me; they'll send me away; they'll send my brother away. You know, they'll kill my cats; they'll kill my dog; he'll hurt me, and all kinds of stuff, so I denied it. I denied that anything else had ever happened, which, you know, wasn't the case, because he abused and molested me almost every day of my childhood. Until I was fifteen, almost sixteen years old, my parents never knew that that wasn't the only incident.

So we went to court and we went in front of a clerk-magistrate, and he was put on probation for a year and ordered into psychiatric therapy and counseling. He had already been suspended from the priesthood the year previous, but we didn't know that. I actually didn't find that information out until just a couple of years ago when I got my hands on the internal Church documents. Up until I was twelve, thirteen, fourteen years old, I would still see him in his clerical clothing. He would be driving down the street and I would see him, and I would freak out 'cause he was still in his priest's costume!

When his probation finished, he ended up working at a treatment facility dealing with mentally handicapped and schizophrenic children. Why didn't the court system stop that from happening? Why didn't the Church stop it from happening?

I've actually been fighting with the D.A. since, like, 1994 to get him prosecuted criminally. Our whole intention was to prosecute him criminally. He just – he wouldn't leave us alone. He just was always around – always in the area. I remember one time, I was walking home from Patty's Pantry, a sub shop not far from where I live, probably about five blocks away. I had a pizza under my hand and I saw him, and he was pulling over towards me, and I got so scared and freaked out I dropped the pizza and I ran home, screaming the whole way. I ran upstairs to my room and I locked myself in my closet and I was just screaming. My father's yelling at me, "Where's the pizza, where's the pizza?" and then he realized that I had seen the priest. He went out and he found the pizza or whatever. But I don't even remember, I think it was my sister that was comforting me, because my mother wasn't home. I was just freaked out. I couldn't sleep. I just kept crying. I was, like, "He's after me, he's coming to get me." They called the police, 'cause they didn't know if he was trying to follow me or what, and you know, I had to talk to the police and stuff 'cause we had a restraining order against him.

After two years of whatever they were doing – hogwash in my opinion – [the D.A.] came to me and said, "Oh, you know what? We have a problem with your case. We found a statute of limitation problem with your case, and we have to drop it although we would love to be able to prosecute him and we think it's prosecutable crimes and everything. We can't because, you know, your statute of limitations ran out."

Not a single one of them take any accountability for what happened. Not a single one of them. From the priest who abused and molested me and all that stuff, right up the line to his pastor and supervisor. All the way up to the cardinals and the bishops and the Pope, there's been no apology to us. They think that by handing us over a check that we're going to, you know, shut up and go away and everything's going to be all better and we're going to forget about it. I'm one of the people that that ain't happening. I'm still here, flappin' my yapper and, you know, doing what I need to do to make a true change in the system. Until I see that day come, I'm not gonna rest.

I have no religion now, I don't go to church, I don't believe in the Church. I don't believe any of the crap that they say. It's just I think it's a bunch of bull at this point.

To tell you the truth, I'm really surprised that somebody hasn't gone nuts and really tried, you know, taking out priests and the bishops and all that stuff when they have their big little ho-hum get-togethers and stuff like that.

I'm really honestly stunned that nobody got, you know, an Uzi or whatever and just came in and shot down the whole lot of them. I really expected something like that to happen, and I partly still do. It just stuns me that there's no other form of punishment that these people are going to get.

JIM H.

My name is Jim H., and I am forty-one years old. I live in Hamden, Connecticut. I was born and raised in Hamden. My parents were not bible bangers or anything like that. We did go to church on Sundays, major holidays and all that good stuff.

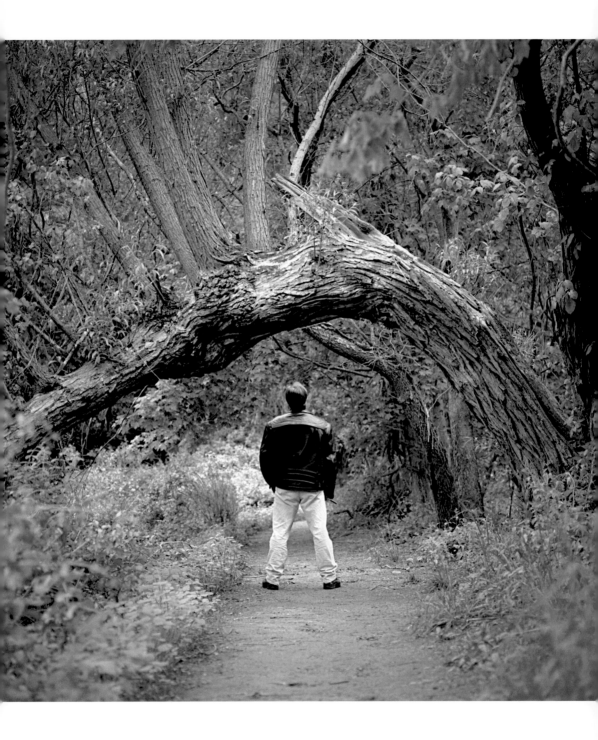

I went to public grammar school up through sixth grade, and at the end of sixth grade I was acting as safety guard when I met someone who introduced himself – Father P. He was the new priest at our parish [and] found out that I was going to be going to the junior high school at the parish. He suggested that I might want to become an altar boy, said it was a lot of fun. He would take the kids to the amusement park once a year. Occasionally, he would take some of the guys out to the movies and stuff. He kind of enticed me into wanting to kind of join the crew, so I did.

Around the fall or winter of '76 was the first incident of abuse. He and I were alone in the basement of the rectory. He was teaching me how to shoot pool and while I was bending over to take a shot, he came up behind me and started to tickle me. And the tickling eventually turned into a wrestling match on the couch and eventually that turned into him holding me down. He laid on top of me, and with one hand he held my two hands together underneath me, fondled my nipple, and dry humped my buttocks until he had an orgasm.

At the time, I knew it was wrong and I was thinking that I should scream out. I don't know why I just laid there in silence, shocked. And I don't remember much after that, like whether he took me home or I walked home myself or anything. I do know of two other instances of his abuse with a similar M.O. – starting with tickling, then wrestling. Then he would always say, "These are wrestling moves I'm teaching you. You'll need to know this if you're on the wrestling team," and I knew it was bullshit. It was pretty obvious this wasn't how you wrestled.

The final time that it happened we were in the school itself and he said he had to go into the principal's office for something. I was in the area just outside the principal's office, where the receptionist was. And again starting with the tickling and wrestling right in the hallway in front of the principal's office.

He had me down on the ground, doing his stuff. At that point I just screamed out, "Stop it!" And um, he knew then he no longer had a willing partner. So he stopped.

After that third instance I went to my father and I asked him about what kind of things homosexuals do. My parents were pretty open as far as sex and stuff. And he gave me some of the basics about the stuff that homosexuals would do to each other, and then he asked me if I knew anybody that was homosexual. At that point I broke down and started to cry and I told my father [Father P.] was. I told him about what had been happening. He spoke to my mother and they went to talk to the pastor at the parish

and the first response out of him was, "Is he still doing that stuff? I told him not to bring kids in here." The guy had a history of it!

The pastor said, "Well, probably best if Jim drops out of being an altar boy. And since the school year has a couple of weeks left, if he can just get through that, next year we'll make sure that [Father P.] stays away from him." At that time we just basically wanted to keep things quiet. We did not want to make a big deal out of it. It was still a time where priests were looked up to. And you know, who's going to believe you?

Do you really want to make a big stink about a priest and stuff like that? It's tough enough being a twelve, thirteen-year old kid in junior high school! The last thing you want is a black cloud – of you doing homo stuff with the priest – hanging over you. That was the way we decided to handle it.

The following September, when I went back to school, I was sitting in my religion class waiting to see who my new teacher would be and in walks Father P. So I went home pretty upset and told my parents, and they went to the principal, who was a nun. My father explained that he would like me transferred out of [Father P.'s] class and she wanted to know why. He said it was personal. She said, well, I can't just move him because you say it's a personal reason. So he suggested she go and speak with the pastor. Within a day my parents got the phone call that I would be moved to a different religion class.

However, they still kept him as a gym teacher for that whole year in eighth grade. When gym class was over, they would send him into the boys locker room to keep an eye … to make sure there was no horseplay. And I would have to go and shower in front of this guy while he'd sit there with a glazed look in his eye, looking at all of the little boys soap themselves up. That, in and of itself, was pretty demeaning.

This is at a point in my life where I went from being the All-American kid playing hockey, doing good in school. I wanted to grow up and be a cop, to help people, ya know. New kid in school, I would always be the first one to approach the priests and welcome them. After the abuse I just turned. Started out with cigarettes and getting involved with marijuana – just a very bitter, angry kid hating the world, rejecting authority, doing lousy at school and not caring about it. Went from A's, B's and C's down to D's and F's, and didn't care.

A lot of the nights while I was going to sleep, I would lay in bed and I would fantasize about different ways I could kill Father P. Hide in the bushes with a baseball bat and

wait until he got home from taking kids to the movies and just bash his brains in from behind or, take a steak knife from the house and jump him and stab him. Here I am, twelve-, thirteen-years old trying to plot a murder of somebody, when just a few months before, I was "Dudley Do-Right." I wanted to do the right thing all the time, so it was a real turn of events.

The fact that I was abused I do not blame directly on the Church. What I do blame on the Church is the way they handled it or didn't handle it. They knew he was an abuser before he came. After we outed him, they certainly knew! And they didn't even have sense enough to make sure that he wasn't my teacher. I had to walk around that school for the whole following year – taking a shower in front of this guy and having to see him on a daily basis in hallways and so forth.

They certainly did nothing to protect the innocent in that case.

In 2002, the news came out. I was sitting there at 10:30 at night watching Fox News, a national news station. And there it is – his name and his picture, and I said, "Holy shit. He's out, they got him." I told my wife about it immediately. I mean, she had known about the abuse. Then I said to her, "I think I need to come forward."

I thought about it for a couple of weeks, and I mean it was just very consuming and a lot of the anger that I had felt at twelve and thirteen-years old, when I was going through the initial abuse had come back again. I was having sleepless nights; I mean it had come back like a tidal wave! There were times when I was alone and I would break down and cry because at this point in my life, here I am with two little girls and I can't imagine doing that shit to a child. And I really did not comprehend the full extent of the manipulation – the way he befriended me, the sole aspect of him taking advantage of me for his sexual pleasures and how degrading that all is. And it really hit home at that point, being an adult now, having children and knowing what that guy did.

I decided to go to a SNAP [Survivors' Network of Those Abused by Priests] meeting and it was very eye-opening to be in a room full of people who'd been through what I had been through. It really hits home! I heard people say things and describe things, and I knew exactly what they were saying. But I had never been able to put a finger on exactly what it was before.

All kinds of doors opened, and all kinds of lights went on, and I felt an immediate bond with this roomful of people. After listening to a few of them talk, I opened up and I told my story publicly to strangers for the first time.

I feel I've healed myself a majority of the way. I was always tightly wound. If things didn't go my way I'd get pissed off at the drop of a hat. And these days I tend to let shit roll off my back. I'm finally becoming a peaceful person.

As far as my work goes, nobody knows here. What I'm planning to do is, when I get the word from my lawyer that – you know – this is going to be in the news in the next day or two, then I would gather my immediate supervisor and probably his immediate supervisor just to let them know, "You'll probably be seeing me in the news."

I'd like to remain anonymous at this point because of the civil litigation that's ongoing. The way it's going now, there would probably be a settlement out of court but, I mean, you never know. I might have to go in front of a jury someday and, I'd hate to have to explain something that I might have said incorrectly and then get misquoted, or you know, misconstrued in some way or another that could hurt my case.

I'm certainly going to be there to do a press conference with SNAP and I'm going to come out and use my face at that point to let people know that this happened to me, by this man, in this town! And I know in my heart that other kids were abused by him. I know kids that were a couple of years younger than me that thought he was great; they played basketball and he was the basketball coach, and all of a sudden one day they don't want anything to do with him. I know why that happened.

I want people to know this man was an abuser, and he did it more than once. And the Church covered up for him and then sent him into the inner city to deal with young children after they knew about it.

On October 31, 2005, at a press conference announcing a multi-million dollar settlement with the Archdiocese of Hartford on behalf of forty-three clergy sex abuse survivors, one of them, Jim Hackett, came out publicly for the first time and stated, "I was a victim of childhood sexual abuse."

DAVID CARNEY

David Carney, age thirty-eight, Scituate, Massachussetts. I grew up in Dedham, Massachusetts. I went to a Catholic high school.

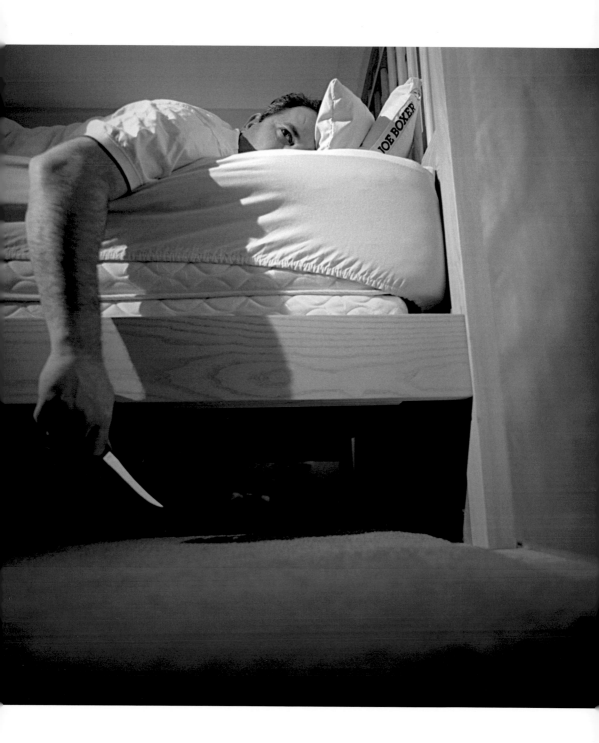

I was a freshman there. I got recruited there to play hockey with the outlook of becoming a pro hockey player. I also made the varsity football team as a freshman, as a field goal kicker. I was doing pretty well in school.

My family life was decent, but my mother was, uh, she had her problems. She used to drive me to school and pick me up, but sometimes she wouldn't pick me up. So, after practice one day, Father R. saw me standing there waiting, and everyone had been gone by now. I was still waiting for my ride, and he offered to give me a ride home, and you know, of course, I accepted it.

About a week down the road, I was in another situation where I was waiting for a ride, and uh, he said to me, "Why don't we go out to dinner tomorrow night?" And I says, "Yeah, that sounds good." So we went to this restaurant in Boston.

He had ordered wine and it actually came in a Coke bottle, for me. So I drank the wine, you know, I was fourteen, and I figured hey, why not, if he's allowing me to do it. Who is higher in this world than him? If he wasn't God to me I don't know who was. I was feeling good, and we left the restaurant. Along the way we had spoken about my hockey career. He had said to me, if you want to come back to where he lived at the Chancery, "I have a lot of memorabilia." I'll never forget. The big garage door opened, and I went in. He offered me a beer, and I said, "Absolutely." We walked into his room. There was a big desk and everywhere you looked were pictures of boys. Not naked boys or anything, but there were pictures of boys, thousands of pictures everywhere you looked. He offered me another beer and I took that. Now that I think of it, whether I was born an alcoholic or not, I wanted more, I wanted to drink.

And he said to me, "Do you want me to take a picture of you?" His big thing was "The Thinker." Now, I'm fourteen years old. I didn't know what "The Thinker" was. So he came over and adjusted me to pose like "The Thinker." And as he was doing that he slipped his hands in my shorts. I jumped, and I just looked at him. He said, "Oh, I'm sorry." To this day I know he wasn't sorry. He didn't have me drunk enough yet....

Back then, if you had a tattoo you were kind of a tough kid. He said he'd take me. I was gonna bring a friend of mine who was probably one of the toughest kids around town. So we drive down to Rhode Island. We go to the tattoo parlor, and I wanted the sports figure, and he wanted me to have the devil on my leg. The devil with diapers on. And I think I would have put Mickey Mouse on my leg as long as I had a tattoo.

Right after we got the tattoo, there was a liquor store across the street. So, we went and he bought a twelve-pack of beer and a bottle of wine for himself. He had rented a room, unbeknownst to us; it was right up the street from the tattoo parlor. So we all walked up to the place, and we got a bag of potato chips, and that was the only thing we'd eaten. And we were drinking. The TV had an AM-FM on it, so we had the music on. He was drinking his wine and summons me into the bathroom.

He wanted to check my tattoo 'cause there was a bandage on it. As he did do that, I walk in and he was sitting on the toilet. He was clothed, but he had the toilet seat – and, uh, this is maybe an hour or two into it – we'd been sucking down beer and he did the same thing…. Now this time he started giving me oral sex, and I was so afraid of my friend coming in. So I says, "You motherfucker!" and I pulled away, and I remember the anger. It wasn't murderous anger, but I knew that there was a part of me coming up that I could kill this fucker.

So I ran back out there, and we started partying. And all of a sudden my friend passed out. To this day, we think he was drugged, because he was a big kid and I know he could hold his liquor. So he had passed out, and I kept drinking with [the priest]. Then he wanted to lay down, and I, you know, wanted to keep drinking. So I was drinking and drinking, and I opened the chips up because I started to get, you know, if anybody drinks, you start getting a little drunk at that age, you know. I knew I was drinking now for a reason, because of what we had done in the bathroom. So I wanted to sober up a little so I could keep drinking, so I decided to take a shower. When I took the shower and walked into the bathroom, those two were sleeping. I kept my leg out of the curtain, so [the bandage] didn't get wet. And all of a sudden, I had my leg out, and the curtain just opens up, and it's the fuckin' devil. It's him. I'm, like, "What the fuck." I'll never forget the feeling, 'cause I'm, like, embarrassed as all hell if [my friend] walks in here. He just looked at me, said "Stay right there," and started giving me oral sex, then he masturbated me, and then he just went back in the room. Now I don't know how long I stayed in that bathroom, but I stayed in there quite a while, and I just fucking cried. I felt like the biggest, dirtiest fuck in the world. When I came out, he was fuckin' sleeping, and I was gonna get him, I was gonna kill him. I had to pee so I fuckin' pissed all over him and he never woke up. I looked at his wine bottle. That's how I was gonna slice his throat. So I urinated all over him, and I took the potato chips and I put them all around his body, and I just sat there and I was, like, "You're gonna fuckin' die." So about maybe an hour went by, and I was still fuckin' drinking, and I had to piss again, so I fuckin' pissed all over him, and as I was peeing on him [my friend] woke up.

"Carney, what the fuck are you doing? He's a priest." And I said, "Fuck him for what he did," and we both looked at each other. We didn't have to say anything 'cause I think we both knew that something happened that shouldn't have happened.

I said, "Let's kill him," and he says, "How the fuck are you gonna get rid of the body?" I said, "We'll throw it into the fuckin' car." So he's, like, "But how are we gonna get the body to the car?" We just couldn't figure out how to get the body to the car. We just sat in the room and fuckin' pissed on him, and at one point we laid down on the bed, me and [my friend], and went to sleep. And we woke up, it was morning, and he still wasn't awake. And then he rolled over and it was, like, the fuckin' devil rolling on potato chips and piss all over him, and he's got a fuckin' hangover and a half, but he don't even know how lucky he is to be alive, you know. He was minutes, seconds to getting his throat slashed.

I can honestly say that from that day on I've probably been the angriest person in this world. The angriest! And a lot of it was anger at myself, but I'm gonna have to deal with that…. He would call my house, and I would tell him, "Listen you motherfucker, if you ever call my house again, I'm telling. If you ever come near me again, I'm gonna fuckin' kill you, and that's a promise." And you know, that guy never bothered me again. And it's weird because the bathroom for many years at my parents' house is where I used to hide and just cry.

Christmas was the worst day of the year. I don't know why. Everyone was happy, and I was crying – for many years.

Subsequently I left that school; I didn't leave on my own. I got thrown out. I flunked everything, you know. Hockey. I didn't want to play hockey. I didn't want to do anything.

I just didn't have any more drive left in life, and I didn't go to college. I ended up being a union laborer, which isn't a bad thing but my outlook wasn't supposed to be there. I was supposed to do all the things in life. Whether that would have happened – a pro hockey player or not. But I didn't think I was supposed to be a drunk for twenty-three years of my life, and just a shit bum person.

Ended up going to prison, jail for nine months. Just a lot of infractions over the years. My record, it's three pages long and it's all alcohol abuse, impersonating an officer, just crazy, fighting, fighting, fighting. It soiled me. He soiled my soul. He put evil in me.

The nightmares are there quite often. It would just be horrific things that he would be doing to me. It's not much for me to see somebody with the bald head and glasses

and want to go after him, 'cause that's what he looked like. Like right now, I'm picturing his face, and just the anger inside of me is just getting – it just gets to the point where you want to murder. There are many days when I want to drive there and kill him. Actually one of my friends attempted that, and he was foiled, thank God, by the state police.

They say you gotta walk through pain to grow. Well, I should be seven hundred feet tall because there's a lot of pain there. I go to a mental hospital once a week to get some help. The past two or three months I separated from my fiancée. We broke up, due to my [post traumatic stress disorder]. The night sweats, sleeping with a knife, thinking he was coming after me. I couldn't live with it, she couldn't live with it. Nobody should have to live with somebody who sleeps with a knife.

I worry about the littlest things. I'm just so fearful. I look at my little boy now about things, you know, how protective I am about him. It's things that nobody should have to go through – worrying about a day-care lady wiping your son's butt. My mind just does not stop protecting myself of everything.

I had my tattoo cut off my leg. It's literally sitting in a bottle of formaldehyde in my lawyer's office. So, not only did this guy take my soul, he took a piece of my flesh, too. There are scars all over me, inside and out.

I'm just figuring out who I am. From what my doctor says, I'm still sixteen or fourteen years old. I'm just growing up now. But from what people tell me, you know, I know that David Carney is a good person.

MANUEL VEGA

My name is Manuel Vega. I'm thirty-nine. I live in Oxnard, California. My dad met my mother in Mexico. They fell in love and eventually started a family. Everybody was born in Mexico except for me. He came to the Oxnard Plains in the 1950s as a *bracero* – basically a hired working hand – and he worked the fields throughout the United States. The family eventually settled here in 1964/65, in the projects – primarily a Hispanic barrio.

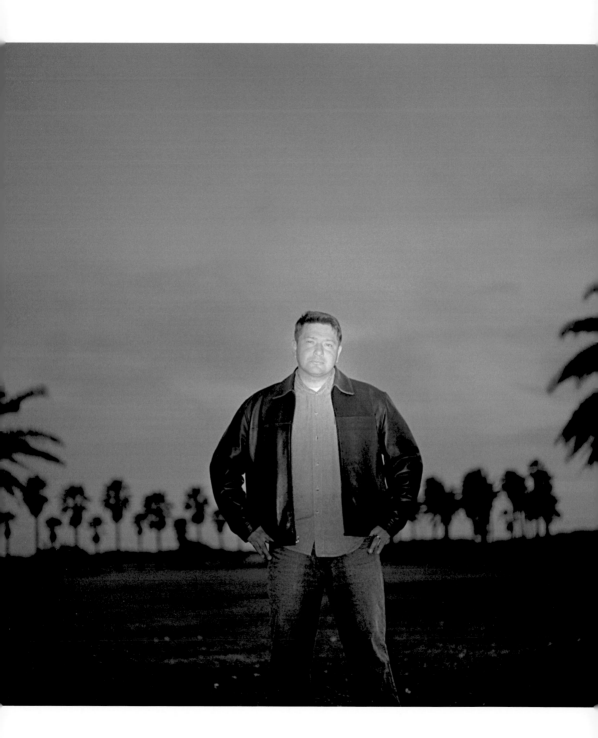

That's where I come into the picture. I kind of grew up in a family not quite assimilated into American culture. And the strong ties that the Catholic Church and the Hispanic, the Mexican, Latino culture have, obviously make the church a magnet for us.

I remember wanting to be an altar boy in the second grade because, obviously, who doesn't want to be closer to God? And by being up there next to the priest, what greater honor could you bestow on your parents than being close to God? In my culture there is a hierarchy of power: First you have God, then you have the priest and then you have your parents. That's how I was raised – to fear God. Not so much to love God.

I remember working with the priests during Mass and washing their hands – always looking at their hands. And they weren't working hands, not like the hands my dad had that were all rough and beat-up. And I guess sometimes when I look at my hands I start seeing them become soft and kinda non-working-like hands – it bothers me. So I always make sure my hands are roughed up.

I guess I was a regular kid growing up. I still remember making my first basket in second grade. I thought that was the greatest thing. I shot the ball and it went in there. I could still remember that extraordinary feeling. You gotta remember I came from immigrant parents. It's not their fault but it's just you know, circumstances.

But I remember in the sixth grade is when Father F. came…. That's when I met him. And it's kind of interesting, now that I look back at the circumstances that led to my abuse, how he fooled everybody. And how these abusive incidents continued.

What happened was my parish had a bunch of old worn out priests. These guys who delivered the same sermons, the same mundane monotone voices…. We were just kind of following the motions, not really praying. So when Father F. came along with Father D., they were definitely a breath of fresh air and were immediately accepted with open arms into the congregation without any questions as to who they were, where they came from or what they had done in the past, other than wearing the Roman collar. That was kind of like a free pass. It's incredible, everybody was looking at them with the glazed-over Catholic look. And immediately because of their age – they were very young, probably late twenties – people thought that was even greater because these guys committed themselves early to God.

Father F. was put in charge of the altar boys and immediately was trusted with the most precious things that the parish had – the children. And I was one of them.

And I mean, God, when you talk about a wolf in sheep's clothing, that was him. And he fooled everybody.

And my abuse began when I began to confide in him as to marital problems my parents were having, and how that was tearing our little family apart. And how my brother had sided with my mother. And how my brother would go where my mother went.

And I on the other hand said no, that's not fair to my dad. My dad can't live a lonely life. What I didn't understand was that my dad had issues only a grownup could understand. He needed to come to terms with what he was doing in life. Not because my dad did not love me, it was because my dad didn't have his shit together. And eventually he said, "Hey I gotta split too." He up and left.

I didn't like my dad out there by himself so I ran away. I went looking for my dad. I found my dad and I told him that he needed me to be with him. And this is a silly kid telling an older man he needed to get his act together. And what father would say "no" to his son? And so my dad said, "Come on board." And I still remember looking at the house and how empty it was without my mom and my brother being there. There was a lot missing. So my father and I got closer to the Church because that was our surrogate family. And when my dad was trying to get his act together, I would go from school to the rectory and spend time doing homework there. It was kind of a refuge for me but at the same time I was suffering because of the separation in my family.

Father F. began to notice me – that's when the grooming started.

At one point my dad wanted to go to Mexico to take care of business – what business to this day I don't know – and that I needed to go back to my mother. He probably needed time by himself. I told him that I would run away again. That's when he asked the pastor if I could stay at the rectory. Basically the cook and the housekeeper took care of me.

Father F. would come over, try to comfort me in my pain. We would pray together. I began to trust him and, little did I know, what he saw in me was weakness – and he exploited the weakness. I guess that's where things started to change for me. I looked at him, I don't want to say as a father figure, but as an older brother who would take care of me. He always comforted me and complimented me. He told me I could go up to his bedroom and take a shower. I was always in amazement at all the neat stuff that hung on the walls, the books, the paintings, the drawings…. One in particular of a hand, a very detailed labor-looking hand, not like his.

One time I had a fever. I went upstairs and told him that I couldn't serve Mass and he felt my forehead and said, "Well, mijo, you're really sick." And he put his hand on my forehead, but then he said he could "tell how sick you are by touching your testicles." And to me that was odd because I had never had anybody touch my testicles. He started looking at my penis tracing it with his fingers, and there was nothing that I felt was wrong because I trusted him. There was no fight-or-flight syndrome going on. But that small [scrotum] seam is what he keyed on. And he would say to me – and this happened on more than one occasion – that this is where God decided to make you either a man or a woman. And so he would follow it down to my anus.

Bizarre things began to happen like that. He would say, "Hey, do you guys want to go to the beach and see some nude women?" and we're, like, "Yes!" Then we walk down these cliffs and at these private little beaches were all these naked men. And I couldn't figure out where the hell all the women were. And he would say, "Hey, when in Rome, do as the Romans do." And so we did as the Romans do. We took our clothes off.

He would, uh, take us there quite often. And, uh, later on I learned that this is where he abused a lot of my friends.

There was a time he was painting a Rising Christ, and it was a very large portrait. And I remember I told him that I wanted to model for this painting. I have no idea why I wanted to please this man…. So I clearly remember one day being taken out of school sent over to the rectory, and from the rectory to the upstairs sacristy to the rear of the church and seeing the painting for the first time. I remember him telling me that I needed to take my clothes off.

I was standing naked in the upstairs sacristy. What a very unusual place to be! He was no longer sketching me but now was taking pictures of me as if I was Jesus being crucified on the cross, and he was posing me not so much in Jesus-like poses but more compromising poses that I couldn't understand. And somewhere along the line he stuck his finger in my anus. He made it seem as though it was a natural thing to do, and he continued to encourage me to masturbate until I ejaculated, and at that point I felt like, I guess, dirty. I felt sick. I felt disgusted. I felt like a rape victim! And I remember it was recess because I could hear all the kids playing, the basketballs bouncing, and the laughter. I was in shock. I ran. I never told anybody about this, not until years and years and years later.

And so the abuse went on. And I remember asking him to be my confirmation sponsor because I wanted him for whatever sick reason to acknowledge me and I also wanted his attention.

But high school saved me, I think, from further abuse because I got into sports, into girls, cars, surfing, all kinds of crazy stuff. Things that, you know, your typical little Mexican-American boy who grew up in the barrio wouldn't do. And as I got deeper into high school I got further away from church.

At the age of seventeen I wanted to join the Marine Corps, and he told me that I would never become anything. I remember going to boot camp and leaving Oxnard, feeling some sense of relief that I am taking over my life.

I eventually fell in love and told my fiancée how important it was to have him marry me – he was my padrino. He had to do this marriage. I tracked him down and found him somewhere off Wilshire Boulevard and I saw a very different Father F. My fiancée, Amy, now my wife, said, "There's no fucking way that he's going to marry us."

I suppressed those memories until 1997 when at my mother-in-law's she began to talk about abuse. Without thinking, I said, "I have also been abused." And that is when I began to talk about it. I explained to them what had happened, the abuse that I had suffered.

Fast forward to 2001. I had to do something. I realized that the only thing that's going to make the Catholic Church change is the monetary threat – losing a shitload of money and enacting safeguards.

I saw this as a challenge and I put all my effort into it.

Now that I reflect on it, with the lifting of the statute of limitations, 900-plus cases have been filed against numerous archdioceses within the state of California.

And that old cliché that if you can only make a difference in one person's life, then your life has been fulfilled. I think I've made a difference in hundreds if not thousands of lives.

I was born a Catholic, I'll die a Catholic. I believe that the day that I walk away from my faith is the day that I lose my voice.

The whereabouts of Father F., as of April 26, 2005, is unknown.

It's as if the earth has opened up and swallowed him. He's disappeared.

FATHER ROBERT GREENE

This is where the spiritual and physical rape took place.

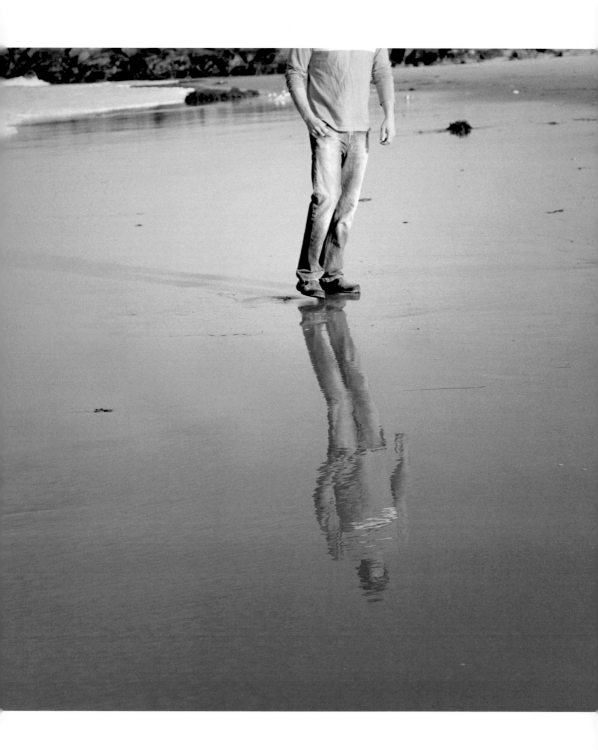

My name is Bob Greene. I live in San Pedro, California. I'm a California native, fifty-one years old.

It's a very painful journey for me, being here at Playa del Rey beach in the Los Angeles basin this morning. I feel a great sense of violation, especially when I walked on the beach. And, being up here....

He offered to be my spiritual adviser, hear my confession. He wanted me to do a general life's confession, where I confessed every sin that I've ever committed. In retrospect, both from a priest's point of view because I am an Anglican clergyman – my family converted to Roman Catholicism when I was ten years old – and what I know about other survivors, he was getting a data-dump. And he was able to use the information that he obtained to attempt to manipulate me.

Afterwards, about a week or two after this initial meeting, we had the confession and he took me out to lunch afterwards and started in with the wine. And after that the use of wine was a regular occurrence at our time together. First it included some spiritual event like a Mass or a confession, then wine and then going on to be touchy-feely.

He would get me drunk on the beach and then he would take the venue to one of the local streets where it was abandoned near LAX and continue to ply me with wine, talk to me, and attempt to caress my hair, rub my back. That's the sort of thing he started with. And then he would go into the lower pelvic area, all the while saying how attracted he was to me. I asked him to stop on several occasions, that I really wasn't into this, and that I didn't feel comfortable with the fact that he was a priest and my spiritual director. Then he would stop. He would absent himself for a couple of weeks and then he would call me back up and repeat the whole process again.

Thereupon, my mother started noticing, at age seventeen, and later on at seminary, that I was coming home drunk. My mother was recovering from alcoholism at that time so she picked up on it and she started asking questions. She started questioning the local clergy. Subsequently the priest was asked to produce his paperwork that allowed him to celebrate, it's called a celebret, it's a Latin term for "he may celebrate." It's a permission from his bishop to celebrate in the Archdiocese of Los Angeles. He refused to produce it.

Because of this, he was asked to leave the parish. However, he continued to see me while the investigation was being performed on an archdiocesan level. The results of the investigation were kept secret from me because my mother was afraid that I would leave the Roman Catholic Church. I was informed that if I talked about this

publicly, the Church would disavow me and not allow me to come back to my church or study to be a priest.

I was very addicted to his pep talks. He made me feel very special, very wanted, very bright, and very intelligent. He also used all of this information to manipulate you and get what he wanted. So when he left there was a mixture of sadness and happiness. Happiness because the abuse and the craziness was exposed for what it was worth, including his fraudulent status. There was sadness because I lost a sense of some of the pep talks he would provide, and I walked away from the Church. I fell into quite a bit of alcoholism in my college years. It was only later, after a period of healing and time that I was able to walk into something spiritual again.

I think the greatest experience that I've had as a result of what happened was an abiding lack of trust in people. My closest relationships are not close simply because I don't let people in. I have a real problem opening up to people and trusting people. I've experienced a lot of addictive behavior including a fair amount of alcohol abuse when I was in college and afterwards. A lot of it came from my lack of self-esteem – that I was really not worthy to be considered for a relationship and that I was worth just being lied to and played with.

I deal constantly with self-image issues, with lack of self-confidence. I feel that the abuse spoke directly to that. I felt that I was set up. He knew that I came from a vulnerable situation and he used my situation in my family to exploit me.

I have a real problem sometimes with my faith in God. I do believe that there is a God. I believe He cares. But I sometimes feel that He's asleep at the switch. I felt that if He really understood and knew the affairs of humankind that He would respond to the pain in the world, including the pain that I went through. I thought that He wouldn't allow His servants to misuse their authority.

I continue to have quite a bit of anger, especially at the Roman Catholic Church's position, on their denial. All it would have taken was their apologies. All it would have taken is, "Bob, we screwed up." I can accept the fact that they screwed up. What I couldn't accept was being threatened, being silenced, and being lied to about this man's status. It's also very difficult for me to accept the fact that they allowed an unlicensed man in – to function as a priest.

Even though I was having a lot of doubts about God, I never really lost my desire to function in that capacity. I had a family, and priesthood doesn't pay an awful lot, so what I did was that I opted to become what's known as a "non-stipendiary" priest, a

priest who is only paid by the job, basically. And I worked at the behest of my bishop, and he would assign me to churches and I would fill in.

During both my marriage and my priesthood, I continued to struggle with my own doubts about myself, and doubts about God. I started doubting the goodness of the Church. I thought that the Church was not worthy of me.

I spent some time away from the priesthood. Walking on the beach and relaxing. Trying to figure things out. If it weren't for the love and support of some people who felt that I was needed in the Church, I would have not returned. But it is because of their love and support I can continue to minister and try to work through my issues.

At this point I think in a very real sense God blessed me with a real dislike for Church politics. And any time I see that element in the Church, there is a sense of outrage and anger that wells up inside of me. That connects to that little boy that got molested.

Consequently I alienated some of my superiors in the Church. They tolerated me. I think the real burning out for me happened in the late 1990s. I sat in on a meeting that closed a church down; it was not my decision.

And that's when I was really in touch with some of my anger. And after that, I know that I was just ready to walk out. I mean, they're not moving forward on even apologizing, basically. You know, if they came forward and said, "Look, you know, we're going to work out the money in a little bit, but we want to start the apologies now." If they brought people in and said, "Look, we want to give you an apology," they may find that a lot of us have an open heart to that.

There needs to be penance.

"Putative Unction"

No recompense
above the stars
can salve a despondent heart.
No words ever
Spoken in Oracles
...no matter how supernal
Can soothe a fractured soul.

"Bind up the wounds and Heal!"
...so you push your words at me!
No unction, so highly blessed
can provide enough healing.
Go, pour out your unguent balms
ablaze with fragrant graces;
they are but a momentary respite.
Ah, the tragedy of a White Dove
with broken wing:
Unable to fly in a universe
a creation made for her flight.
She weeps in silence,
bestowing her sadness
in measured sighs
too soft for the
hardened ear to hear.
Thus ever drones on
the endless sad din:
a requiem for lost faith
a requiem for broken trust.
a requiem for a dying soul.

By Father Robert Greene

SISTER CLAIRE FRANCES SMITH OSU

My name is Claire Frances Smith, and I am a sixty-seven year old Ursuline nun. I had another name – John of the Cross – like I don't exist anymore. This was part of the spirituality at the time.

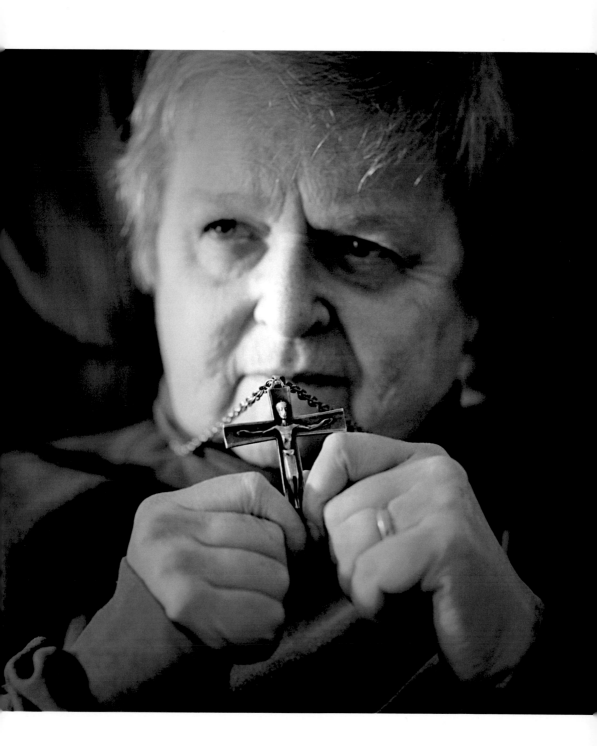

I was born in the South Bronx by Yankee Stadium in a very conservative, loving Irish Catholic family and the parish was a very important place for all of us. At that time, when people asked you where you came from, you didn't say the Bronx, you said what parish.

A year after my sister, my older sister, had been killed by a car that ran off the road, this parish priest, wanting to be somewhat of a grief counselor, took up with me in the sense that he paid attention to me. I thought I was practically "Queen for a Day" because the parish priest was taking notice of me and priests were regarded as saints, you know, without any blemish or sin.

I was eleven years old when my sister was killed. And the parish priest really noticed me more than he noticed my other two sisters. For some reason he was very attracted to me. My sisters began to wonder why he was paying such attention to me because they didn't think I was particularly that good. He would take the three of us to plays and movies and he always managed to sit next to me and would be very affectionate toward me during the play. He would hold my hand, put his arm around my shoulder. It was a kind of closeness that I thought was terrific because my mother and my father were emotionally absent after the death of my sister.

So this filled in a gap – that somebody was interested in me, and would want to hear about school, what was going on, and that kind of thing. This lasted through high school. And then I thought: Here I am in high school sitting in front of the nuns that were trying to teach me French and algebra; they would have had cardiac arrest if they knew what I was involved in.

You know how some girls began to talk about their boyfriends? It was like I had one. The priest!

I was very immature because, first of all, I was chronologically younger than they were; but in my immaturity I had no idea that there was something wrong with this.

In eleventh and twelfth grade it became more sexual in the way he held me and held his body close to me. I was very naïve, and so I didn't even know until I was with him what a male body would even look or feel like, where he expressed his physical manhood to me.

He sexually abused me in the sense of him getting his relief, or whatever, in holding me close to him, in which I felt parts of his body. When that happened I thought it was terrific. Then when I got to first year in college I said, "Uh-oh, there's something

wrong here. There's something wrong here!" But I didn't have the wherewithal to confront him about that.

He would do this in the rectory. he would ask me when he was on duty alone. He would get me behind the curtain on the stage – so that nobody saw us – and just hug me, and it was like, he always wanted some part of me for some part of himself, figuratively and physically. I was so passive because I was this conservative Catholic girl who would not even dream that this priest was relieving himself of some emotional lack.

I boarded in college, which was not too far from my house, a half an hour or so. He would continue to call me; and some of the conversation the girls would overhear. They'd say, "Is that your boyfriend?" I did date in college. But as I dated, when this priest saw them, he'd kind of make fun of them; he downgraded them.

My sophomore year I was so attracted to the order that taught in my college, high school and grade school. They were women who were so ministry-orientated. They weren't just do-gooders; they had a purpose and they had an intellectual awareness about them. I thought seriously about becoming part of that Ursuline group.

And then at some point I also thought, "I'm damaged goods. I'm used goods." And so, who would have me?

I was led on to believe that I was very loved by this priest, and very important to him. At one point he said to me that there were things going wrong at the parish that he was in. And he said, "I would have thrown myself out the window if it wasn't knowing that you were there for me." There is something in me that is such an enabler, and a do-gooder, that I felt that I was almost obliged to continue to keep in touch with him because here I was, keeping him from throwing himself out the window! He was a good manipulator, but the bigger part was that he was into alcohol and was very depressed. He wasn't getting along with his parishioners but I think at one point I was glad that he wasn't getting along with them, because I was the one and only!

And I thought, even at that time, "What an awful burden to pin on an eighteen-year old!" Even then I knew that wasn't fair. It wasn't fair for an adult to pin it onto anybody. If I had ever told my mother and father, my father would have killed him. Absolutely. I remember one time my father was fixing his car and the priest came along, and he was talking to my father. My father said to me, "I don't like that guy, I don't like that guy!" That should have given me a clue, but when he said it, I was still

in the midst of being in a relationship with this priest and I thought, "Oh, Daddy, don't do that!" My mother was teaching in the school that he was, and she would see him every day. He would make sure he saw her every day, ask her how we were, and all of that. And I would ask her, "You like him, don't you?" She said, "He's OK."

In my psychotherapy, I would learn the difference between abuse and criminality. He stole my selfhood as I was growing up. He stole it! My young adult life was stolen and at the same time he abused me. The only way I can describe it is like a hum situated in the back of my head. And I then uncovered the hum, realizing it was the secret I had been carrying for so long. So there is shame and that is the heart of the abuse. Abusive shame and then toxic shame. And this was definitely toxic.

I realized this in my mid-forties. This was way before the stories came out in the paper about the abuse that priests had given to boys and girls. I said to myself, "You're not going to go around with this burden, you are going to speak about it!" My road to freedom would be saying the truth. I first said it to my best friend in the Ursuline order and she went with me up to the nursing home that he was in. I was ready to speak to him about what had come to me in my studies and in my awareness of the burden I was carrying. And when I got to the nursing home, I saw that he was a rather confused man. He kind of fumbled for my name. After seeing him like that, I decided that I knew enough and that I'm not going to let him carry that burden into heaven.

Emotional experience, emotional abuse, psychological abuse, physical abuse, or whatever the kind of abuse it is, it's abuse. So, it isn't only physical or sexual. I think we make that error in thinking, if it wasn't sexual it was nothing because you can't imagine…. I have received so many phone calls and so many letters from people who have had the similar experience. I think sometimes we can just lump everything into abuse, and it might have been emotional abuse but that's as strong as physical abuse!

I decided. I called the Archdiocese of New York. It hadn't come out in the papers. One of the things that happened was, I was asking for remuneration for the therapy I was receiving, and I was going to go public with this. And this was long before Boston, or Providence, Rhode Island, or any of those places that eventually came out public. And then when they did come out public, I said, "At last, at last! Because I knew there were other people who were abused.

Another time, when I talked to some of the priests, it was like I could infer what they were saying by their tonality, and also by a couple questions they asked me. Like what

I did as an eleven-year old to seduce this priest. Which is totally insane. That was so demeaning! And it is such a statement of the low level that women are held by the clergy. It's as if the clergy are at the top of the pyramid....

I mean, I was eleven going on eight at the time. I couldn't have done it! So what I have done is to help people learn how to speak the words – how to try to eliminate the burden that you carry because you always carry that burden, that hum in the back of your head that something happened, and what was your involvement in it, your complicity in it? That question will go into heaven with me: What was your involvement? At some time in my teens I thought I was complicit with it. So I changed the pronoun from I to the priest because he was the abuser and the thief who stole my selfhood.

One of the awarenesses that came to me in regard to "The Church" is that I am the Church, we are the Church. The hierarchy and clergy are not the Church. We no longer have that esoteric pyramid that we always thought of – the Pope, the bishops, the priests, and then somewhere down below were us laypeople. I am the Church, you are the Church, we all are the Church, so one of the things that has enabled me to dismantle my idea that the clergy is the Church is the experience I have gone through in realizing that he is as limited and beautiful as I am. Every one of us is beautiful, and limited. There's nobody greater, and we have made them God-like, and that is such untruth. We are the cloud of witnesses with each other...

FATHER ROBERT HOATSON

My name is Robert M. Hoatson. I am fifty-three years old and I am a Catholic priest. I was born February 15, 1952 and raised in New Jersey. We're in Rockaway Beach, New York. I went to Catholic elementary school and Catholic high school and three Catholic colleges. So I am a Catholic school trained person from birth.

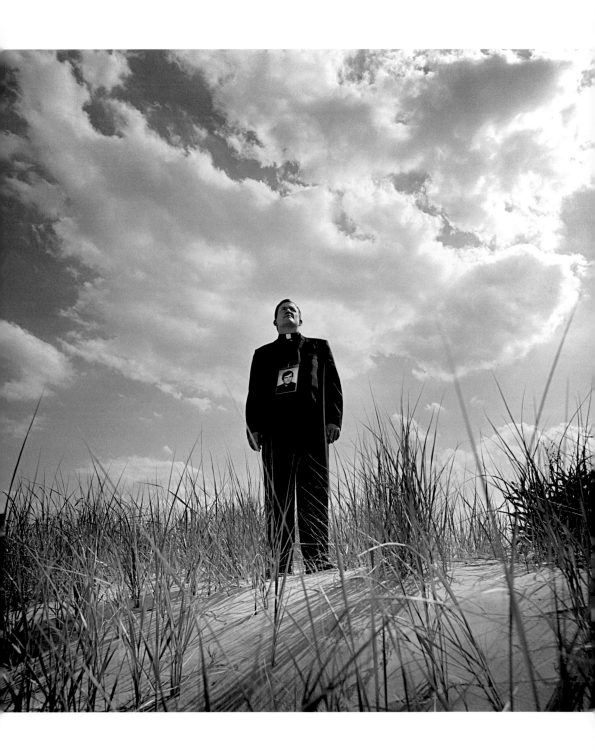

In 1966 I entered a Catholic high school where the congregation of Christian Brothers were missioned. It was during my late junior year that a Christian Brother approached me and told me that I was going to be moved into his senior honors English class. I always wondered why he had asked me to do that and I objected to it; I told him that I was doing just fine where I was. I was a good student and I was getting good grades and I just wanted to stay where I was in the regular classes. He insisted and had me transferred into his senior honors English class. That Christian Brother later became perhaps the most serial pedophile in the order.

Nothing happened to me that year, but that was the beginning of the grooming process that led me to be abused by two different Christian Brothers at several different times. When I joined the Irish Christian Brothers in 1970 I moved into the postulancy, which is the first year of training for the Brothers. It was at that point that I was introduced to my first superior. And during the first conference I had with him he told me that I was "a very cold person" and that I needed to be "warmed up." When he told me that, it sounded very foreign to me and I wondered what he meant. I didn't realize at the time that he was talking about sexual abuse. He did all that he could to try and lure me into some kind of sexual relationship.

I was told later on, at the end of that year, that I was practically thrown out of the order the first year and that I was not going to be passed on to the novitiate – which is the year you learn the spiritual life – by this first superior. Well, when I got to the novitiate, I met the novice master. He was a hail fellow, well met, but he was a serious alcoholic. And he was another abuser. He continued to tell me what the first superior had told me, that I was a cold person and I needed to be warmed up. And at the end of each conference he would stand and have me stand. Then he would put his two arms around me and hug me while he rubbed his cheek up and down my beard.

I become so anxiety-prone in that novitiate year that I left the order in February of that year. It was during seminary that several other things occurred. First of all, it was very sexually active in terms of homosexuality. I heard many, many stories of seminarians sleeping with other seminarians, with professors, etc. Besides that, there was a culture of homosexuality in that seminary that was very disconcerting. For example, at meals I learned that most of these professors in the seminary were referred to by their female names. They were ascribed female names! For example, someone whose name was Joe Smith, they were given a female name like Kitty or Katie, so seminarians would refer to him by that name. Like, "Oh yeah, I was in her class this morning with Katie Smith." The entire culture was feminine; people were referred to as being feminine. "Did you see what she was wearing today?" "Did you see what she

said to so-and-so today?" One of my classmates who asked me to teach him to play golf said to me one day in his room in the seminary, "Bob if you want to be my friend, you'll have to be my bitch." When I told him that it was very unusual for a friend to say that to another friend, he said, "What are you going to do, think I'm a homo now?" It was at that point that we kind of went our separate ways. There was a culture of homosexuality and femininity in the seminary that was very disconcerting.

I came back about a year and a half later and re-entered the order and got through the novitiate and I took my first vows at the end of that first year. The group that I was part of [was located at] the Jersey shore and a classmate and myself were rooming together. One night he pulled his chair up to the side of my bed and, claiming that he wanted to talk, he began to stroke my body up and down. I froze in place and the thought that went through my mind was: I wonder if that's what that first superior meant by being cold and needing warming? And I said this must be the way it is in religious life, you have to be gay in order to be religious. That abuse went on for about four and half years with that classmate.

I was on the verge of a breakdown. I had severe anxiety and panic attacks; I was just a mess. My parents were about to have me hospitalized at one point. At that time I decided enough was enough, and I confided in a superior of mine that I had lived with. I told him the whole story. He reassured me that I wasn't gay, that I was abused, that people were grooming me for these kinds of things and I let out such a sigh of relief at the end of that day that I can still recall it.

At the end of that conversation we drove to my parents' home in New Jersey and my parents invited this man to spend the night in their house because it was late. During that night I felt something coming into bed with me, a person climbing into bed. The man to whom I had just told the entire story of the first abuse climbed into my bed while I was asleep and began to stroke my body exactly the same way I had described to him a few hours earlier. Once again I froze in place, and I can recall the words in my head: "Oh shit, not again!"

For some reason pedophiles have a nose for vulnerable people and they try and size the kids up and then they make the kill. The grooming process is the process before the assault. For example, in my case, the first superior was trying to gauge my vulnerability. Fortunately he did not succeed that first year, but the novice master then continued it, and that led up to the first assault by my classmate. By the way, my classmate and the first superior I had were involved in a sexual relationship. I have a feeling I was kind of being groomed to be a sort of ménage a trois with these other

two people. But their grooming succeeded because eventually they did succeed in sexually assaulting me too.

His abuse lasted about two years, at which point I was home for Easter vacation from my assignment in Boston in 1982. My parents had become so concerned about my condition, with the depression, anxiety, panic, that they were going to admit me to a hospital. I told them that I didn't think I was that bad and that I would return to Boston. I began to see a psychiatrist when I returned. I decided then that enough was enough and that I would never have anything to do again with this person. That's when the abuse ended in 1982.

I have been in therapy, on and off, probably for the past twenty-five to thirty years, and my therapy really began intensively around 1982, once the abuse ended. I still had not really recognized what had happened to me as abuse, psychologically speaking, so I stayed in therapy until 2002 when the Boston scandal hit. Two of my former students in Boston went public. I immediately phoned them and offered my assistance. I got very involved in their cases and my therapist at one point said to me, "Bob, how come you're so interested in your former students?" And I said because a former priest abused them and I wanted to help them. Well, he then said to me in this session, "Well what about yourself?" So I said to him, "Are you saying that I'm maybe so interested in their abuse because I was abused?" And he said, "Precisely." It was at that point that I went public, and as a result of my going public – I testified before the New York State Legislature on May 20, 2003 – I called for the resignation of anybody who has covered up sexual abuse by clergy, including bishops.

Three days later, on May 23, 2003, I was fired.

I was called into the Chancery of the Archdiocese of Newark, New Jersey and fired by my archbishop. I then decided that what God was calling me to do was to help other survivors and so I requested permission to work full time with survivors of clergy sexual abuse. I was told that I would not be allowed to do that, but if I took chaplaincy of Catholic Charities for the archdiocese I could do that kind of work.

So that is what I have been doing ever since, and just a few weeks ago I started a national organization called Rescue and Recovery International Inc. Its mission is to give direct services – financial, spiritual, medical, psychological – to help people to recover from the ravages of clergy sexual abuse. When someone is abused by a cleric, a religious, a brother or a nun, that person suffers some unique symptoms because of the fact that the person who has abused them represents God. So, it is as if God

abused the person. So it essentially takes all hope away from the person, at least initially. It's as if the person thinks he or she is so bad that God allowed this to happen to them. They believe they have been abandoned by God, too. So, in order to recover from this, the people need to be walked through it and walked side by side because it is so devastating and the effects linger and linger and linger and linger. As a matter of fact, it's my opinion that the effects will always be with these people. They will just always be in various degrees of seriousness. The effects of clergy abuse are so devastating and so unique that I think it almost takes a survivor of abuse to kind of understand the damage and what people are going through.

Celibacy has created conditions around which people can act out sexually. It's not healthy. So, mandatory celibacy has been a problem. I'm not saying celibacy is the reason for the crisis. I think pedophiles and homosexuals found safe haven in religious life and the priesthood.

SUSAN RENEHAN

My name is Susan Renehan. I'm fifty-six years old and I live in Southbridge,
Massachusetts. Originally I'm from the Jersey Shore, it's called the Irish Riviera.
I was the fifth child out of seven so I was pretty much on my own.

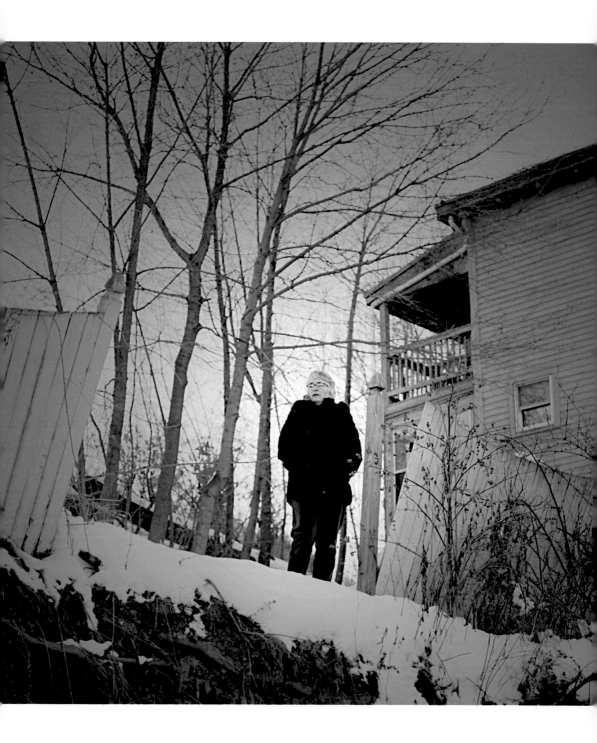

My father was an alcoholic, and so that always became the central problem in our family. It led pretty much to us not being nurtured as kids, you know, because the father was always the problem. For me as a kid, I thought it was great because no one paid attention to me so I could get away with a lot of stuff! As I look back, I see myself as this scruffy little ragamuffin who had a lot of curiosity.

I went to Catholic school. The local church was new, and we were the first first-Communion class, and there were nine of us. I have a picture of myself that day; I remember it so clearly, it was the day before my seventh birthday. And it was really one of the few times that I felt that I really shined. I used to love to just go in and sit in the church by myself. I think coming from a very chaotic family, the church offered me a peace that I really didn't find too many other places.

When I was about nine or ten, a priest came into our parish – Father G. He was from Ireland. At that time, coming from an Irish family, I had this incredibly romantic idea of Ireland. I wanted to live in Ireland, I loved all things Irish. And of course, when he came into the parish with his brogue, I instantly was attached to him. And he was really nice to the kids. I can always remember him always being available, you know, to talk to. He was there a couple years, and then he was reassigned. I was heartbroken when he got reassigned because, you know, he was so special to me. I'm sure I had a childish crush on him, in a sense, that later came back to haunt me.

When he left the parish, before he left, I went over to say goodbye to him. I was probably eleven, maybe twelve, it was in the winter, and I said, "Father, can I give you a hug goodbye," and we were standing in the vestibule of the parish house, and he pulled me in the door, and he gave me a French kiss that just absolutely paralyzed me. I had no frame of reference for anything like that ever happening to me. It absolutely, like, horrified me. It was so traumatic; I can remember my knees shaking so badly and all I could concentrate on was getting out the door and getting down the steps without falling down. I walked away from the parish house, and I kept saying to myself, "He's leaving, he's leaving, he's leaving." I just felt that something horrible had happened. I had no idea where it came from, what it was, but I knew it was bad, and it absolutely terrified me.

Then, soon after he had left the parish, I was going to school in the next town. We always had confessions on First Friday, and it would be in the auditorium, and there'd be like a chair and a screen and a place where you would kneel, and the priest would be behind a screen but you could see him. This one First Friday I walked into the auditorium with the rest of my class, and sitting there was Father G. And I was just horrified. I was like, "How the hell did he get there?"

I don't remember what I said in confession, but I knew he knew it was me. And then I went back with my group. And he came into the class, and he said, "Oh, I'm here to see Susan." And I was like, horrified. The nun was very impressed that the priest had come to see me, and she let me go out in the hallway with him. And he molested me in the hallway. He felt my breasts, and you know, I didn't have any, I really hadn't even reached puberty at that point. And he, you know, lifted up my skirt, and you know, went into my underpants, and I'm standing in the hallway saying, "Please don't, please don't," and just horrified, horrified, horrified. I remember him rubbing up against me, and looking both ways up and down the hall, to make sure no one was coming. There was nothing I could do!

I was walking home from the beach one day, and he pulled up in a car next to me, and I just knew I was in horrible trouble. I was only a couple blocks from my house, you know, a quiet, quiet neighborhood. And he said, "Come on, I'll give you a ride home." I said, "Oh no, it's OK, I only have a couple of blocks. I can walk." And he says, "No, no, come on, I insist, I insist." Well, I was in a bathing suit, and I got in the car. I remember the car, I remember the interior, it was a black car with red velvet interior, and I was terrified. I had a towel. I remember trying to wrap the towel around me as best I could. And he pulled up in front of my house, and in front of my house he sexually assaulted me. He didn't rape me, he mostly masturbated me. He had me masturbate him. He kept telling me that he loved me, God loved me, that it was all right. I kept saying, "Please no, Father," you know, very weak voice. I mean, you never said no to a priest, there was no frame of reference for saying no to a priest. I knew this was something horrible, but I knew I had absolutely no control over it.

From then on, I was in terror. I remember going into the house that day, and being in the shower, and just sobbing in the shower and scrubbing my body, and at that time making the decision not to tell my parents because I thought that it was such a horrible thing that my parents couldn't survive hearing it. And I also remember a layer of guilt, that it was my fault, that I had started it by asking him to give me a hug goodbye when he left the parish. So I really felt that it was my fault, you know, I did this and I was responsible for it. And it was such a mountain of shame that I just swore I would never tell my parents and I would never tell anyone.

So the summer went by, and the following fall I was back at school and I was twelve. He came once again, the First Friday confessions, and once again pulled me out in the hall and I had my period for the first time. I had a sanitary napkin and I was so embarrassed and horrified that I told him that. I said that I had my period and I have a sanitary napkin, you know, and I said "Please don't touch me there." And he ignored me. He pushed it aside with his hand, and sexually masturbated me.

And it became a pattern, First Fridays, until I finally just said, "That's it," and I started playing sick and not showing up for First Fridays, or I would just skip school. I would not get on the bus. I would go and hide out down at the beach. But he started finding me on the street. This was the fall of my eighth grade in grammar school. I was babysitting at the time. I remember one time – he just started stalking me. Whenever he would find me – in the car I was powerless to stop him. I got in the car. I didn't know how to say no! I remember one time I was babysitting and I had a baby, and he wanted me to bring the baby in the car and I just absolutely refused to do that. I said, "No, I've got the carriage. The mother is waiting." And I got out of it that time, but there were many instances where I just didn't get out of it. The shame was overpowering.

The way it stopped was…. Uh, it's just a miracle the way it stopped. The following year, I went to a girls school, a private school, a Catholic high school.

We took the train there. There was a group of six of us girls, and we commuted together. We used to hang out in this luncheonette across the street from the train station, waiting for the train. And one day we're in the luncheonette and he walks in the door. And I just – I mean, I was a pretty scrappy kid at that time, and I can remember thinking, "Where the hell did he come from?" and not really in terror, more like wonderment. And he said, "Hi," you know, and all the girls were like, "Oh, it's a priest! Father, Father!" and I'm standing there, and I'm thinking: No way. And he's going, "Come on, I've got a car and I can fit you all in, I'll give you all a ride home." And that's when I just said, "No, we can't do that, we have to get the train." And he sort of looked at the girls and said, "Girls, wouldn't you like to take a ride home? I've got this nice Cadillac, you know," and the girls were all like, "Wow, a priest giving us a ride." They all thought that was really cool.

And it was like this showdown, where the girls were standing behind me, and I was standing there, and I was looking right at him, and I stopped. They were like "Oh, OK" – and I just said, "We're not going." And I looked him right in the eyes, and I said, "We're not going." And he says, "Oh, well I can give you a ride. That's OK, it won't be any problem." And I said, "We're not going" a second time. And I looked at him for the first time, really looked at him in the eyes, and he knew that the [jig] was up. He knew. And then he tried to give us money. He said, "Oh, let me give the girls some money so you can get a soda pop," or whatever. And I said, "No! We don't want any money." And I said it in such a way that the place went silent. No one had ever seen a thirteen-year-old kid talk to a priest that way! The girls were like, what the hell's going on? And he and I were just staring each other down. And that was the last time I saw him. He walked out.

And I realized at that time that you can do what you want to me, but don't mess with my friends. A couple of years later, my mother was reading the Catholic paper. I was seventeen at the time. It was in our living room, and I remember I was lying on the floor by the fireplace and reading a book, and my mother said, "Oh, Susan, look at that, Father G. died." And I looked at my mother and I said, "Good!" I was seventeen at the time and he was probably in his early fifties when he died. My mother, I think, thought I was just being a sassy teenager, but I remember – it was so etched in my mind – that experience. And what it did for me was that I knew the bastard was gone, that he couldn't hurt anyone else. And it was the beginning of my recovery.

GREGORY VALVO

My name is Gregory Valvo; I'm thirty-two years old. I reside in Prospect Heights, Brooklyn. I grew up in a very nice household: two brothers, mother, father, what I would call, you know, a real dreamy life up until the age of ten years old, when I was abused. I was very active in grammar school with sports and whatnot, and I had a lot of friends.

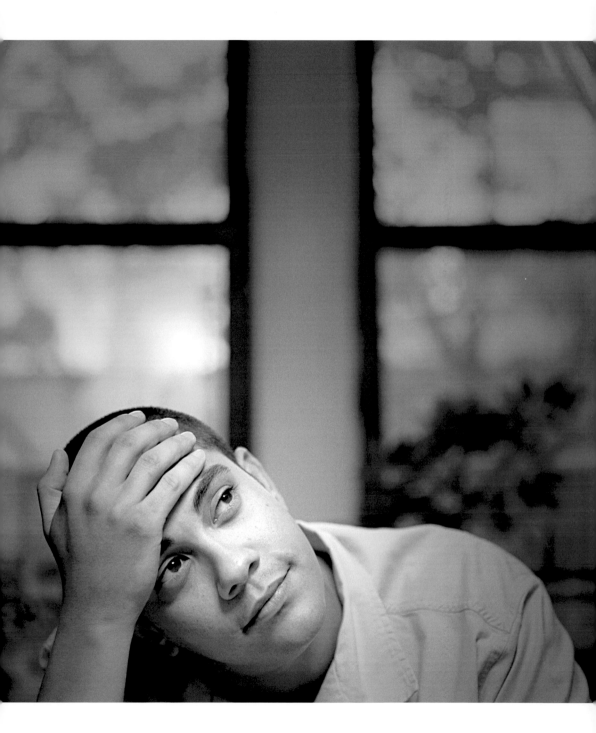

Altar boys going to a Catholic school in Brooklyn were a very special group. It was a gift to be able to serve up on the altar. And it made me feel, I remember, you know, very important and close to God. I remember going to church and feeling close-knit with, you know, other peers, and the parish itself, and priests, and even the nuns, which most of them were pretty mean. Catholic school was a great environment for me to grow up in, very supportive environment up until today, although I'm no longer a Catholic or consider myself one.

I guess … my abuse occurred at the age of ten. And this particular priest was in charge of the altar boys, and he had a house in Pennsylvania in which he took altar boys on weekend excursions. And this was well known; you always heard stories. Not necessarily of abuse, but going up partying and whatnot. And this was coming from the priest's mouth when myself and another boy were selected to go up. He started to get into stories about what went on up there. You know, cool things; you could smoke, you know, you can drink, things like that. And I remember being so special that I was chosen to go up there with the coolest priest in the parish. I know, not everybody went, and my brother was never asked to go. So that made me feel, you know, like, wow, he liked me more than my brother! But, you know, I found out shortly thereafter that he wasn't really the coolest guy.

The priest's story about this house and the property was it supposedly was built on an Indian burial ground. And part of his, I don't know, manipulation, and part of the whole scenario had to do with this Indian ghost, and as I found out, the abuse would unfold. We would have to do certain things to appease the ghost and keep him away so we'd be safe, etc. Very sick and twisted things!

We were, you know, given beer, and I remember specifically, rum and Coke. And my abuse just, you know, terrified me when it occurred 'cause I really…. I didn't really understand too much about what was going on. I mean I was ten years old! I wasn't raped or forced to have sex with this priest, but what he did have two of us do was strip down, and he took a lot of photos and stuff, which he said were going to be offerings to this Indian ghost, and we were going to burn these photos later in the backyard. These photos were of me holding shotguns to the other boy's head, and pointing them at him on the ground, and vice versa. I was told what to do. I was scared shitless. You know, there were shotguns involved! It was wicked and sinister. And I was a victim of someone's, you know, sick, distorted …you know, fantasies being played out.

And then he took pictures in the shower, and showed us pornography and, you know, made us jerk off in the shower.

I guess I'm lucky in terms of what could have happened and what I believe did happen to other kids that continually went up there. I think more or less he was feeling me and this other boy out to see how things were going to go. You know, the story itself can go on a lot longer but I guess, you know, you get the gist of it. It wound up being a very traumatizing experience. I remember trying to go to sleep that night, you know, just absolutely sweating and terrified; and after drinking and whatnot, really believing that I was going to see this ghost and this ghost was going to come after me. And, you know, to this day, when I get in a panic mode I still remember that was the first time I ever had that true feeling of fear. And in my life, anytime there was a confrontation – schoolyard fights, whatever, whenever – there was something that would make my heart race and really get me upset. It would…. It would always trigger back to that same feeling. So those feelings that were created that evening lasted me a lifetime, you know?

That car ride home being very, very quiet, obviously. I had nothing to say. My mother and father picked me up and asked me if everything was OK, and I just remember looking out the window. I can still see it today, and telling her, "Yeah, I'm fine, Mom, everything's OK." Which was still really not realizing how really sick it was, and how inappropriate and wrong and criminal it is.

After that, there were changes in myself. My grades started slipping in school. I just started … misbehaving. You know, never really understanding what had happened and if it was wrong, right or whatnot. I struggled with that for a couple of years, and when I was around twelve or early thirteen, I told my mother what had happened. And my mother and father had gotten divorced around this time, and it was obviously … it was a very emotional time for me. I was now losing…. My family was breaking up; two years ago I was, you know, abused by this priest in this way, and my whole foundation…. I just lost my entire, you know, faith in the Church, so to speak, and now my family unit was breaking up; it was a very tumultuous time for me.

My mother took me to the Monsignor and explained the situation to him. He sent us down ultimately to the Diocese of Brooklyn, which told us basically that they would take care of it; the priest would be taken care of, not to worry. We assumed that meant something. And that was pretty much it. I went down there with myself and another boy that was molested by the same priest, and this is how we, you know, wound up reporting it.

But you know, for me it was swept under the rug. I mean, I walked out of that office that day, and no one ever called me again to see if I was OK or needed any help. That priest was transferred a short time later to another parish. I thought when they said they were going to take care of this priest, I never would have thought that they

meant that they were just going to transfer him. Keep in mind this is probably 1985, and they would transfer him and allow him to work as a priest 'til 2001. So, you know, this is…. This is the same thing that's happened to hundreds of us, if not thousands and thousands.

And I'll be honest with you, I was confused about it for a couple of years; whether what was going on was right, whether what happened to me was normal. Was it wrong? Was it my fault? Did I do something wrong? I thought I was supposed to be special; is this what happened to all the kids that went up there?

Those are the questions that I lived with for the past fifteen years, you know? What has he done? You know, I know what he did to me, but what else has he done to other kids? That's what's been my torture, you know, for 15 years. Not how many kids did I let him abuse; but, had I come forward a little bit stronger, and maybe gone to the police instead of trusting the Church – that the Church was gonna take care of him – how many kids from 1985 to 2001 were molested by this man?

My heart hurts and has hurt every day since then!

My life up until this point has been very rocky. I've been in and out of counseling most of my life. I've had a good life, I'm not going to say it's been bad; I'm going to say bad things have happened to me. And although what happened to me was a horrible experience, far worse happens to people. So I have to be grateful that, you know, I am here today whereas there's a lot of survivors out there that live a lot longer than I have and are not able to deal with the situation. You know, they live into their fifties, into their sixties, keeping it a secret, not knowing what's going on, never truly dealing with it and realizing that it's the root of a lot of problems.

I was forced to deal with it. In my mind I knew that this wasn't something that was going to go away. And, if I didn't at least accept it, deal with it, and move on, and make myself a better person, I can't worry about what the Church is going to do in the future.. I resent the Church, I resent what happened. What they've done was wrong, it's criminal.

All these years I didn't know if my father knew, and it was almost better thinking, "I hope he didn't know." Because me as a man now, I can't even imagine thinking what I would do if I knew that that happened to my son. Even all this time later it kicks up so much emotion, you know, that I chose not to…. It upset me a lot. Because I'm saying, "Did this guy know?" He wasn't the best father, but you know, why didn't….

Why didn't he do something? Why didn't he go break his legs? That's what I'm into. I'm not gonna. I mean, who would want to? Who would let that happen to their kid? I love him; he did the best he could, you know. My mother, too.

I've been speaking to a woman recently who ironically comes from a neighborhood right next door to me where her son was molested, and he's going through hell! I feel for this woman, 'cause I hear the torment and the heartache that she's going through. And she recently received a letter from the head of the Catholic review board who totally attacked her and re-victimized the woman, blaming her for her actions, and you know, it's just…. It's just preposterous that, you know, what could still could go on in light of the fact that this is still…. That this is now public. You know, her son tells her, she's trying to reach out to her Church, and the Church just smacks her in the face again. And I can't do all that much to change that right now. But like I said, my goal, and what I'm there to do, is hopefully when her son needs to walk through that SNAP [Survivors' Network of those Abused by Priests] door, I'm there to hold it open. And like I said, if I can be an instrument for someone's healing, then, you know, I'm doing the right thing. I'm proud that I can sit here and talk because you know, a lot of victims of sexual abuse kill themselves, or kill themselves in many ways; suicide, drugs, whatever it might be. A lot of people don't make it to speak about this. And, you know, I feel it my obligation to hopefully be there someday, you know, when they need me.

LYNN WOOLFOLK

My name is Lynn Woolfolk, from St. Louis, Missouri. I'm forty-four years old.
We had a pony farm when I was young, and this priest's family had a horse farm.
That's how he and my dad had a connection; he tried to get that connection.

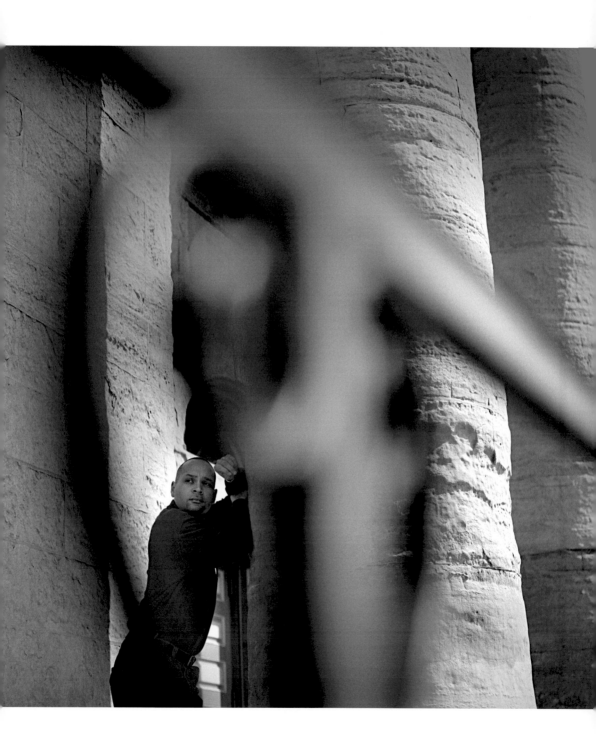

He would take me to his farm where the horses were, and we'd ride. During the course of those trips to the farm, he would ask me to slide over on his lap like he was teaching me to drive, and he would fondle me.

I told them in court, the old cathedral was where I lost my virginity.

This happened on quite a number of occasions, and that was the beginning of the abuse at the hands of the priest. He was transferred a couple of places, but ultimately he wound up at the old cathedral, down on the riverfront, downtown. He would still come out to the house and pick me up and take me back down to the old cathedral, and that's where the first case of sex took place.

At this time I was around twelve, but the touching started much younger. He would tell my parents he was going to the horse farm and I didn't realize that we were going to where he lived. He'd pull into the garage, and he'd close the door and we'd go through the inside door to the hallway and his room, which was on the left of that hallway. He closed his door, watched TV for a few minutes. Then he would come out and talk to me, and then he would take me to the bedroom and start caressing me, and that's where he started his sexual acts.

I didn't keep track, I didn't count, but it happened more than just a few times. He would pick me up, take me down to the old cathedral, have his way with me and then take me back home.

I felt numb. I guess shocked is a good word. And it hurt, physically hurt afterwards. This was all new to me; I had never experienced anything of that nature. The reason why I said it was hurtful was, he did it for so long and it was painful. And even the next day, I couldn't hardly walk because I was so sore. My dad even asked at one point what had happened, and I couldn't even tell him.

If I can back up, some of this is kind of complicated. I was adopted into my family and I've been told that he played a big role in that. My [adoptive] mother was a devout Catholic; she still covered her hair when she went in church. She didn't eat meat [on Fridays], and she just believed the priest was above anything, next to God. I think my mom wanted me to be a priest. When he would come to pick me up there were no questions asked. He could come whenever, and that was OK with them. It was like my family was sending me; my mother was giving me to him. So I didn't feel I could tell them.

It's hard to describe but they gain that trust, and then violate it.

As a child, and still to this day, I have a problem trusting people. I never allow anybody to get too close to me for fear that they will violate my trust.

During the trial, it was me and him; my word against his word. The court opens at 8.30. His people were there to fill the courtroom. My supporters were there; my family, a couple of friends of mine, and a lot of members from the SNAP [Survivors' Network of those Abused by Priests] group were there. But they tried to take up all the seats so that we couldn't get in. In that courtroom, you know, they brought in two nuns and placed them strategically right in front of the jury. But it was this whole, like I said, this intimidation, you know. The priest sat on my side, the nuns sat on my side.

My therapist worked with me and I'm, like, I need to do this, I need to do this. And it was scary! It was scary, it was painful, it was hurtful being in that same room with him, you know, seeing him deny it.

They tried to bring up during the trial that, like, at one point I sent them a letter demanding $30,000 from them. And again, the prosecutor did a good job, told them I didn't demand anything. That [the] letter strictly said for therapy: past, present and in the future. They tried to make a big deal in front of the jury that I was only out for money. I went to them in good faith. So how much more does a victim have to keep getting insulted and re-victimized over and over? Even in the trial, they kept trying to say again that it was about money and I was, like, I'm not getting anything, I'm a state's witness here. I'm not getting paid to be in trial. I don't want my life history out in front of... You know what I mean? I'm not getting anything out of this other than to give my story, and to see, finally, some justice and accountability, you know?

When the jury found him guilty there were two other victims that came forward for the penalty phase that were able to testify [and] that I'd never seen. One was from the same grade school as me, a year behind me. I didn't know this kid, I wouldn't have known him if he walked right by me, you know, and now it was thirty years later. The defense tried to make it seem like we knew each other, and that this was all set up. But I didn't. As God is my witness, I didn't. He didn't know me, and I didn't know him!

After the verdict, the people were saying that, you know, the jury was incompetent because there were seven blacks on the jury. They tried to say that it was a race thing, you know.

When I heard that he was found guilty of the criminal case, I did feel vindicated; I felt like

my voice had been heard and that somebody had listened, finally listened! I had always said that I've never forgot this abuse; it's just always been, like, in the back of my mind.

Now I'm unsettled, with him still being out of jail on appeal.

What happened to me was, it was like I was dirty; I always felt that I wasn't worth anything. I tried to counter that by trying really hard to be liked, being accepted. As I got older I started smoking cigarettes and drinking. Then I gave up the cigarettes after a couple of years and continued to drink. But the surprising thing is, people close to me didn't even know that. I would just go home and drink, you know? If I went out once in a while I would try to pick fights with people just to let out that anger and stuff, you know? At this point I was – well that was '94 – so between thirty, thirty-five. Then that kind of settled down and I just got engrossed in work I look back now, man, I think that's why I work so much: It's because it kept me busy, my mind occupied, and I was doing something, you know? I always felt angriness, but I thought as long as I was working I could direct that and control it. After '94 when it finally hit and I started bringing this all up, this anger started to surface. I thought all these years I'd controlled it. But then I even got real bad with drinking. It seemed like the more I drank, the anger just took me over.

I had to start therapy and it wasn't until after a couple of years of therapy that I started to release my anger. The therapy helped me. However, there's still some anger and it's with the diocese and the Church.

In the archdiocese, unfortunately, what I've learned is, they don't listen to people – regular everyday people like me. They listen to lawsuits and attorneys.

I've always told people I was raised Catholic and I probably always will be Catholic. A lot of friends of mine always told me during this whole process, especially during this trial and stuff, that, you know, there are other denominations out there and all. And this is true. I know there are. I've sang in choirs, I've sang in a choir that went to Rome, sang for Pope John Paul II, you know, had an audience with him. We've sang, you know, numerous things. I've done work in the Catholic Church more than some people do in their life. I used to give up a week's vacation; I did that for eight years with the youth camp and fifty teenagers. Who in their right mind would give up a week's vacation to spend with fifty teenagers, you know? But I did that for the diocese.

I've been active. You know, in that trial they tried to make it seem like I was just a disgruntled Catholic, and I'm not! You know, I love the Catholic Church. I love the

people that make up the Church. As I look back now, it's the hierarchy that's corrupt. It's just like a business. They run it like a business. But it's the people that make up the Church – the people that are sitting in pews.

I used to give an envelope faithfully, a Sunday envelope. I don't give now. I still have this guilty feeling that I've done something wrong. Taking this guy to court, you know, taking him to trial. When I don't go to church I feel guilty! But yet when I sit in church, my mind is just a total blank.

I'm fighting with this struggle now. Should that keep me out of church? I still believe in God; I've never lost my faith in God and that's probably what got me through to this point. Not the institution, but my faith in God. The people the Church enrolls are men just like me, they are human. They can dictate all these Church rules that are man-made rules, but when they wear that collar, that's the only thing that separates them from me. They're still a man, as I am! And I feel my faith is between me and my God.

The trust…. I think I've made some progress, but I still won't allow people to get so close to me. And I'll probably carry that 'til the day I die. I realize that if I do not do things like going to church, that the abuse, and abuser, are still controlling me.

I still have a way to go because, as I said, I have this trust issue. I have this spirituality thing, you know, to feel good about myself. Still, for so many years, to look in the mirror and not see anything or just feel like it was a disgrace or, you know, that it was my fault. But I've come to the realization at forty-four that I am somebody and can love myself, that I am worthy and, you know, what I did was right. And it's a good feeling! It's almost scary to try to feel good about myself because it's still that guilt that I did something wrong. But my therapist keeps telling me, "You didn't do anything wrong." I guess I've lived with it for so long, it's trying to reverse that and feel better about myself. And I'm getting there. I'm trying to. I'm getting there. So I got a little way to go, but I'm working on it.

JANE RODELL

My name is Jane Rodell, I'm seventy-three years old and I live in Indian Creek, Illinois. My father was killed in an accident when I was four years old. I was taken care of by my mother and my grandmother in Iowa.

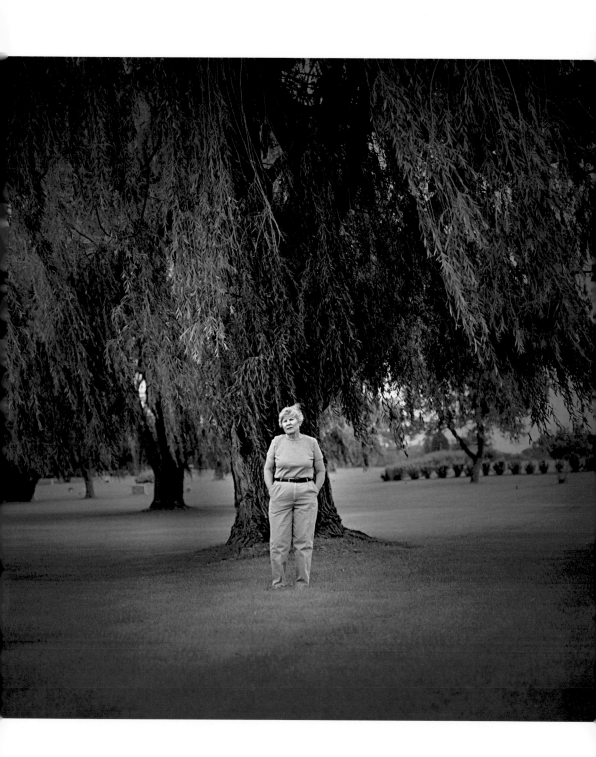

My dad's uncle was like a father to me. The first year after my dad died he would come to our house every evening after work and play with me, my sister and brother, so we didn't miss a dad coming home from work.

I went to Catholic school from kindergarten through high school and then I went on to a women's Catholic college. In high school, I was abused by our parish priest. He was my basketball coach, my volleyball coach, my religion teacher, and also the assistant pastor at school. My abuse started when I was fourteen years old. I was groomed between my freshman and sophomore year.

When I was taking my first year in Latin, I did not do well, and so they suggested that I go to summer school. I was the only one who was taking the class and the priest who abused me was the teacher. We would go up to this room and he would have me translate the Latin phrases, and then he would compliment me. It's difficult for me to call him a priest; he made me feel special.

In our sophomore year he called on the smartest boy to translate a paragraph but he couldn't do it. He called on me next and because I had that paragraph in the summertime I could translate it, and felt very proud that I was able to do that. And he mentioned, "You should all study like Jane, she's a good student." The kids probably hated me, but I felt good. He would sketch pictures of me in class, little cartoons, and I had, like, a turned-up nose which he called a "ski jump," and he drew a little skier on it. You were special; it was a male giving you attention – I didn't have a father.

When we played basketball, I remember we played different schools and our team was really not very good. Towards the end of this one game, I was given the ball and this one girl tried to take it from me but I didn't allow it and I shot from the center of the court and it went "swoosh," right in. I was the hero of the game! He complimented me on how strong I was.

In junior year, there were only nine people in our class and we sat at a long table. He said, "Jane, I want you to sit here." He was at the head of the table and I sat to his left. While I sat there, he would have me translate and would put his hand on my leg and then go up. He would unhook my garter, then he kept trying to go up farther and farther. Well I would hold my hand and push his hand down. I couldn't change my voice. I couldn't say, "Stop it!" I was totally under his control.

When class was over and it was time for lunch, we always walked home. The other kids would leave and I had to stay and pull up my stocking and hook it in the garter

and all that kind of stuff. So I was alone with him, but I knew I would have to get out of there fast. So many times I would just hook one garter instead of two, and then I'd say to him, "Barb's going to meet me for lunch and I have to walk home with her. She's waiting for me." And then I would dash out the door quickly. Well this went on the whole year. One time I tried to switch seats but he said, "What are you doing down there? You belong up here next to me." So I had to go back and sit there, and I had to go through this very, very often. I couldn't tell anybody because if I quit Latin class the principal would ask me why, my mother, my uncle, you know, everybody would ask me why. I was, like, stuck in Latin class.

In my senior year, again I had to sit in the same position, but I noticed that he was paying attention to this new girl. She had blond curly hair, very pretty, and it made me jealous because she was getting some attention. And I should have been thankful but I wasn't. I was jealous of her. It didn't dawn on me that she was being abused because during those times you didn't know what abuse was.

When I was in my senior year, all of my friends' dads were taking them out in the car and teaching them how to drive. I wanted to learn how to drive and this priest said that he would teach me. Anyway, when we were in high school we had these high school dances and it was in the basement of the church. We would just play records and dance and the nuns would be sitting all along the wall and the priests would talk to the boys. I was told by the priest [to leave] the dance early, and he told me what time to leave, and go up the steps and go through the room where the altar boys dressed. Well, I snuck in there and then went out this side door so that no one would see me. I was supposed to meet him at this little grocery store so I ran up there. His car came and I got in, and he said, "Put your head down." And I said, "Why do I have to put my head down?" He said, "I don't want anyone seeing you in the car because then I will have to teach too many other kids."

So that was the excuse. He said, "Here, just put your head on my lap because it's more comfortable." As I did that, he stroked my hair and he said, "Oh, you have such beautiful hair." He kept petting my hair. He said, "I wish I would have met you when I was in college." He was a mixed up man. I finally asked, "Well, where are we going?" And he said, "We'll just stay here for a while and then I'll tell you when you can put your head up."

So we drove, and it was really out of town into the country where this cemetery is, the same cemetery where my dad was buried. He stopped at the cemetery entrance and he was supposed to teach me how to shift. He started that, and he said,

"Well, you have to get a little closer so you can see." So I got a little bit closer and then he grabbed me and he was going to kiss me, and I put my hands over my face and I said, "I cannot kiss you because it would be a sin – because you are a priest!" Years later, when I knew about abuse and things, I should have said, "You can't do it to me!" He got furious at me and he was so mad that it really frightened me and I started to go back up towards the door. I thought if he makes a move towards me I'm going to jump out of this car. I knew places in the cemetery that I could hide because as kids we used to play hide and seek there all the time. He didn't do that. He started the car and I said, "I guess you're not going to teach me how to drive?" He didn't say anything, but he drove me back into town and he stopped and he said, "Open the door and get out, but you absolutely can never tell anybody that this happened, or otherwise I will either harm you, or your brother and sister, or your mother." And he just shouted this, he was just furious! I mean, to this day I can still hear him.

I got out of the car and I walked home, and then I had to compose myself because I had to be greeted by my mother and my grandmother, and I had to pretend nothing happened. I went in. They said, "How was the dance?" And I replied, "Oh, it was fine." I couldn't tell anybody.

In high school, even in college, I was going to the same church, you know, the same place to go to confession. And I didn't know what to do. I felt that I had committed a sin because why would this priest even want to kiss me? I might have done something to, I guess, lead him on, I thought. So, if I went to him I couldn't say anything because he was the one that was there, you know, in the car with me. And then I couldn't tell the pastor, because then he would have asked questions and I was told not to tell anybody. So I didn't! But I had this guilt feeling.

But when I was in college all this started coming up. One night, some of our college friends got together and we were sitting talking about all the crazy things that happened in high school. Somebody asked if this priest ever did anything, and I said, "Oh, do you mean something to us? Well, yeah." I mentioned very briefly what happened to me, and then this other person said, "The same thing happened to me!" And then they said the same thing happened to the girl I was so jealous of. I had no clue! There's a pattern there: her dad traveled a lot and the other girl's dad died at a very young age. It seemed that this person was hitting on young girls that were missing a father. Well, one of the classmates who didn't go to our high school – she was from Illinois – her eyes got so wide and she said, "That happened to you? That's wrong, that's abuse!" And we all went "Oh!" It didn't dawn on us at all. As I said, we were just naive people.

When all this hit the fan as far as priests abusing people from all over the United States, my friend called me and she said, "Jane, why don't we go and talk to the archbishop and tell him our story." She said, "Why don't we tell him that this happened to us years ago, and here we are, 60 years old, and we're still affected by it."

When we met with the archbishop, I said, "I think that you should do something before he meets his maker." I mentioned that I felt this priest should get some help, and he said, "I am just amazed that you can even say that."

I guess I would be called a "cafeteria Catholic." There are some ceremonies that I will not attend because it brings back bad memories. I am active as a volunteer in my church and I feel very strongly that because I was abused by a Catholic priest, he took a lot of stuff away from me. But I feel that he cannot take my faith away from me. I feel very strongly about that.

That the more I do to help people, it's so important, because I've been through the scary part of abuse. When I see either a young woman or a young man come to their first meeting, and they're shaking, I go up to them and I say, "You'll be okay. We've all been through this, and we're at a certain point farther than you, and you'll get there."

JOHN HARRIS

About $79,000. That's what a rape is worth!

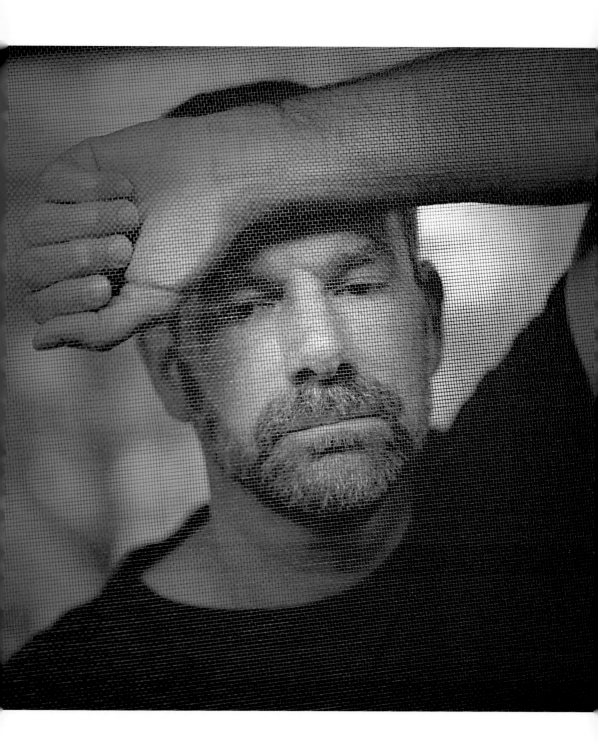

My name is John Harris. I'm forty-eight years old, and I'm living in Norwood, Massachusetts, the town I grew up in.

I was part of the global settlement of 552-plus people. We went through mediation, you know, to figure out how much my rape was worth. Some people have had the nerve to say, "How much did you get?" And I'll say, "Well, after the lawyer got done with me I wound up with about $79,000. That's what a rape is worth."

My first year of college, my father was murdered, and I think that created the need for me to be home on weekends from school. I would come home from college making sure my mother was OK. It wasn't until my senior year, when I was feeling pretty low and really wanting my life to be over, that I sought out some help. Over the course of a few months I was finally able to come to terms with the fact that I was gay. It was, like, sort of like an awakening.

As it turned out, there was a peer-counseling center at the university and I remember there was a telephone in my dorm, a pay phone, and it had a little sticker near it, and it said, "Do you think you're gay? Give us a call." So I did, and I often wondered if someone had put that sticker by the phone for my sake! I went down there during the week and I met some guy. He said to me, "I know a professor here who you could speak to." I got in touch with the professor, and he agreed to meet with me at his office. He was very cordial and considerate. I remember at one point he asked me what I thought about God, and how God felt about it. I remember saying to him, "Well, my feeling is that God loves everybody, and that he loves me." And I remember the professor saying to me that he thought I would do just fine.

We subsequently met in his office and I mentioned to him that I go home on weekends, and was there anyone or anyplace I could go to when I'm home? He gave me the name of this local priest he knew.

When I was home, I called and spoke to the priest. The following weekend I came home from college, and I was driving up and down the street looking for his address. I'm looking for a church-type building; I'm looking for a church. The address that I had matched this little Cape Cod-style house so I pulled in, but there was no real driveway.

I went up to the house and knocked on the door and a kid answered – he was about seventeen. When the priest finally came to the door, he was in street clothes; he wasn't in priest robes or anything. There was a kitchen to the right, and there was another kid there. They seemed standoffish and not well kempt; maybe they were street kids or on drugs.

We went into this little den and we talked about religion; he mentioned he was gay. We talked about celibacy, and for him it wasn't an issue, and I remember asking him about that. I thought that priests were celibate, but he had some excuse for it. That was one thing that bugged me after the crisis. I wish I could remember what his excuse was! At one point he left the room, and I remember there was soft porn lying around, and when he came back in, he encouraged me to look at it. He said, "Oh yeah, you can look at that stuff." We started talking more about sexuality, and to help me to relax he gave me a massage. I'm coming to him for help and counseling, and to meet people who might help me along the way. So I agreed to it and wound up with my shirt off, and he took his shirt off, and he's massaging me with oil.

Boy, was I naïve! Chronologically I was twenty-one. Emotionally, I was probably still a young teen. Now I see how vulnerable I was. I'm on the floor, I think on a mat, or a blanket. I remember he closed the doors and there was this little light with a red lampshade on the mantel. He was massaging me, and I was becoming aroused but I remember feeling somewhat embarrassed. He thought it would be a good idea for me to remove my pants, and next thing I know, he removed my underwear, and he was massaging my buttocks, and he had disrobed, too. I was still lying face down. And he said that he wanted to fuck me.

I said, "I don't think I can do that." And he said it would be OK, that he'll use baby oil. So that's what he did; he proceeded to anally penetrate me, and it was excruciatingly painful. It was the first time that had ever happened to me. It was not enjoyable at all. And I remember he said it had been a long time for him and it felt good. I said I couldn't continue with this, you know; it hurts! It continued for a little while longer.... I don't remember if he said "Thank you."

So here I am in this situation where I'm trying to get in touch with my sexuality. I'm thinking to myself: Why did I go along with that? Well, you know why? Because I thought this is what I need to do to be gay.

After that I got up and I put my clothes on, and I went into the bathroom, and I froze. I sat on the toilet and I was frozen in the bathroom for about twenty minutes. At one point he came to the bathroom door and knocked on it; he said, "Are you OK in there?" I said, "Yeah." I said, "I'm OK, I'll be out in a minute." I felt like leaving, and what was going through my mind was: What do I do next? And do I say goodbye?

I did finally manage to compose myself, and I went out and I said that I had to go back home, so it was somewhat a cordial goodbye. When I was driving home I thought to

myself that I can't tell anyone what happened. And so now that I look back at that, to me it was like going back into another closet. Something about me that I had to keep secret; I can't go home and say, "Oh, guess what, Ma, I just met this priest and he fucked me!"

Two weeks later, I was home again and I was so desperate to talk to somebody that I called him again. I agreed to meet him again, and we drove into Boston. He took me around and showed me where a couple of gay bars were, but we never went into them. He showed me where a gay porn cinema was and we went in. We sat for a little while, there was a porn show playing on the screen, and this was all a new experience for me. He said, "Let me show you down back." There were two bathrooms, and I remember we went to the one on the left and we went in, and there was an orgy going on. I would say about twenty-five men [were] in there, some watching, some doing things. It was hard to see because the lighting was dim. Being a shy person and everything, it was sort of like part of my body is saying, "You want the sex," but part of me is saying, "I'm in conflict, because of my shyness." At one point he said to me, "If the lights flicker, that means the police are coming in. So just be aware of that." And I'm thinking to myself, I've never been in trouble with the law.

I didn't want to be near him because something just didn't feel right. So here I am depending on [him] to try to understand where I'm coming from, and there is a power differential though I don't intellectually know it. I had a repulsion to it.

That was the last time I got in touch with him. Ever!

After that, things fell apart. By the summer of '95 I was still drinking. I started to see the signs, and the shakes. I just started going into a severe depression to the point where I started disassociating from the world in general, and had racing thoughts. I would say it was almost like a psychotic breakdown. Not that I was hearing voices and stuff like that, but it was just constant racing thoughts, and trying to make sense of everything. I stopped drinking, cold turkey, and that began my long progression back to mental health.

I had finally sought help and I had to be hospitalized a couple of times because my anxiety level would go up and down so dramatically that I felt like I was walking around in a dream world. The second time I had a full course treatment of ECT – shock treatments, the gold standard treatment for major depressive disorder, especially when medications aren't working well. And it saved my life; a month before I'd had a suicide attempt with sleeping pills. It was like I was coming out of the dream world.

At the end of January 2002, The Boston Globe ran a story about the priest I had met with. That was the beginning of my triggering moment, what they call this process where you start to realize what happened to you. I still hadn't considered myself a victim of rape, and I had minimized it because I was twenty-one years of age. Looking back on it, now, it was abusive. I can't say this enough to people, abuse and rape is not about sex, it's about power! Sex is the tool. There's a lot of ways to abuse people. You can abuse people physically, verbally, psychologically, or sexually; there's always a power differential there, or a perceived power differential.

And now that I'm older, I can start to put some of this together, and no one's going to minimize this or to tell me that this didn't happen. The silver lining in the black cloud was that this actually helped my depression a little bit because it became the impetus for me to get up off the couch and to become active, to start dealing with what I felt was a re-victimization by the Church against anyone who'd been abused. I was a nervous wreck going to the church to protest the first time. I went with a sign I had made up, and I wanted to hand out fliers. It was just something I had to do. I tell you, it was so anxiety- and shame-producing. I grew up in a family where you don't call attention to yourself. And here I am, you know, calling attention to myself, and what's the subject matter? "I was abused by a priest," you know?

I have long now separated spirituality from religion. I renounced my Catholicism in the summer of 2002 in a letter to Cardinal Law; got a letter from his secretary saying sorry to see you go, you're welcome back anytime. I've read the Gospels myself; I read them when I was severely depressed. I realized Jesus had a problem with the hierarchy back then too. He hated them for their hypocrisy. I have no problem separating my belief in Christ from the religious institution which I believe is just totally corrupt and criminal. I have no problem praying to God to show me the signs of what I'm supposed to be doing in life. Because sometimes I don't even have a damn clue!

BOBBIE SITTERDING

My name is Bobbie Sitterding. I'm fifty-five years old and live in a south suburb of Chicago. I'm one of seven children. I went to a Catholic grade school and an all-girls Catholic high school. And I met my husband when I was twenty-one. We married, and have a thirty-two year old daughter.

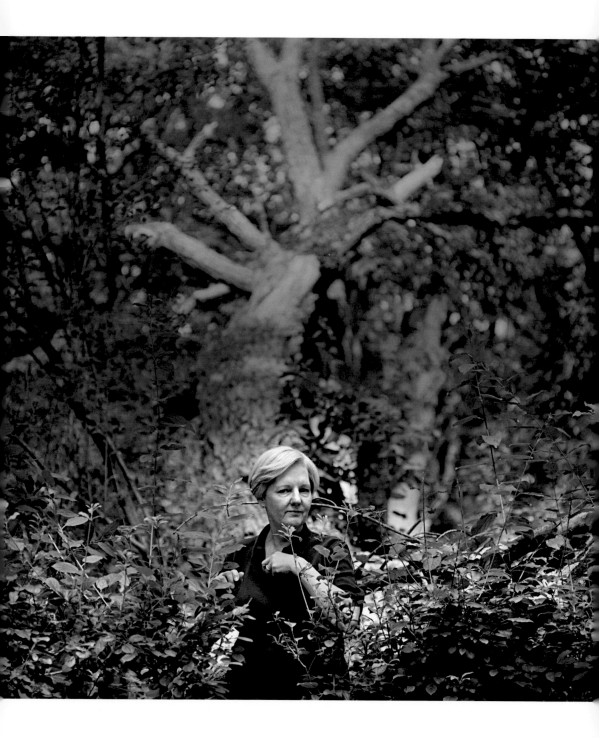

When I was eleven years old, a very young – I believe in his early thirties – priest came to our parish. The Monsignor was quite sick at the time, and Father So-and-So basically took over running the parish. He was just, you know, a regular guy.

Well, he was transferred to a parish that was on the south side of Chicago when I was fourteen. I would call him up and ask if I could come see him. He always said yes. I would go with a friend. Sometimes I would go by myself.

He would take me to the kitchen. I would have milk and cookies. Then he would check to see if the coast was clear, and then he would sneak me up to his room. And we would talk for a long time. Most of the time it ended up with me sitting – laying – on his lap, and we would listen to music. I remember specifically that we listened to "Man of La Mancha" all the time.

It was more than just sitting on his lap because I remember having my ear to his chest, and I could hear his heartbeat. And so, it was like laying on his lap a number of times. He had this big oversize chair and I remember listening to his heart, and then, um, I remember him hugging me and squeezing me. And I remember once that I was in his bed but I don't remember anything – if he was in the bed with me. I just remember that I was in that room, in his bed, and he was touching my bra strap and telling me not to tell anyone because they wouldn't understand. I remember watching him wrestle with my friend on the floor when we went together. Her blouse just happened to come unbuttoned and he said it was, like, "No big deal." And then he took me in a separate room. It was pitch dark and I was sitting on his lap, and I remember that once a priest came and opened the door, and he saw us, and he said, "Oh, excuse me," and closed the door.

Well, I also remember going to confession in the same dark room sitting on his lap. The reason I remember that is because he had the stole, and I remember him kissing it before he put it on.

That priest betrayed my trust when it became sexual. When he said and did those things to me, he changed my life forever. Because it happened when I was fifteen through nineteen, it changed the way I viewed men my whole life.

When I was sixteen, Father So-and-So wrote me a letter, which I still have today. He was always encouraging to me, and always talked to me about God. And I thought that he was the holiest man that I had ever met. He was the exact opposite of my father who was either sleeping or angry. My father was absent a lot of the time and was very strict. He used a lot of, uh, physical punishment. I know now that I had

a very strong attachment to Father So-and-So. He was always available and loving towards me. My mindset is that he cared for me. He loved me and, um, it wasn't violent. It was always in the context of "God loves you."

He gave me gifts and paid for part of my high school tuition. He gave me a necklace – a religious medal of Mary – that I wore for my high school graduation picture.

It fell apart!

The necklace I'm wearing in this picture was a gift. It's from Tiffany's. It's a silver image of Mary which means that I need to take care of it by polishing it. Today I'm very conscious of the need to tend to my faith life by looking at it periodically. It's more valuable to me because it was a gift from my husband.

This one will last forever!

In 1972, when my now husband came to Chicago to visit, I took him to the church in the south suburbs to meet Father So-and-So. It was more important to have his approval of my future husband than it was to have my father's because I depended on him for so much of my emotional support.

So in 1972 I get married, go to Hawaii for three years, live in California for a year, and then we come back to Chicago. And that's when I found out that So-and-So was an associate at the parish on the south side – in the south suburbs. My husband and I would go to Mass there sometimes.

In about 1988 I got a job downtown at a law firm. One of the attorneys I was working for was having personal problems. He was so young, right out of law school. And he was so depressed. I thought: Is there some way maybe he can go and see somebody? My friend told me that she had gone to a therapist who had offices downtown, so I said, "Maybe I should go to see the therapist before I can recommend him."

So I went and said that I was thinking about what happened with me and the priest. And I told him I wasn't sure exactly what some of the things that happened were! And I remember how difficult it was. When I started talking about it, I couldn't stop shaking. And then I would cry, and the words wouldn't come out. Like, I was choking on the words. It was such a physical thing.

And then in 1992, I saw an interview with some victims on TV, and I saw [a priest] in handcuffs and I said, "My God! You know, how can this priest do this?" And then, all the things about abuse started coming out.

When I told my therapist that I was having a hard time remembering, he said, "Well, why don't you write a letter to him. Find out what he has to say and maybe he can clear it up." And so I did. But my therapist was shocked when I told him I delivered it, too!

At this time Father So-and-So was a pastor of a parish. My friend and I went to have dinner with him after not seeing him for a number of years. I went back a couple of other times and I told him that I was in therapy, that I remembered going to visit him, and that there were certain things I couldn't remember. He said, "All we did was talk. I remember you coming to see me when you were upset, and we talked." And I said, "No, it was more than that! I remember sitting on your lap, and I know that if my fifteen-year-old daughter had gone to see a man who was in his thirties and he held her on his lap… that I would want to take a gun and shoot the guy! And his reaction was, "Oh…" That was around the same time that my friend went to the Archdiocese to report him. He was just livid with her for doing that. He would tell me, "I'm not the same as those monsters. I'm not like that." And he went ballistic!

I got married in '72, and all of this started happening in about '92, so it was about twenty years before I told my husband. And it was at that time that I started going to the support groups like The Linkup and SNAP [Survivors' Network of those Abused By Priests]. I went by myself because I didn't want my husband to know. He would drop me off and go to the mall, and then pick me up. And hearing these people talk about what had happened to them, I just cried and cried and cried. I thought, "Those poor people, I'm glad I'm not like that." But then, when I heard them talk, they were saying the same things that had happened to me. They had loving relationships with these priests that they trusted, who would give them gifts, and who made them feel special.

And then my husband and I started going to the support meetings together. One of the reasons I had a difficult time telling him is … he grew up Baptist and he converted to Catholicism when we got married. I didn't want him to feel horrible about the Catholic Church.

I was having problems in my work environment in 1991. I kept getting fired. And so, I went to see my therapist who was helping me try to understand how to hold onto a job. And so, I was at the train station, and I just froze. I didn't know what to do. I knew something happened and I couldn't go home. I called my therapist, and told him.

My husband was on the other line, and I put the two phones together and they talked and my therapist said, "You have to take her to the hospital. Don't take her home." That's when I had my first hospitalization.

I said to my husband, "Call Father So-and-So. I want to see him. I have to see him. They'll let him in because he's just like God. He can do anything he wants." So he came in, talked to me and visited me about three times when I was in the hospital.

And before going home I had this last session with a doctor who kept wanting to know what was wrong? And I didn't say it until the last, like, right before I was going to head out the door. And then I told him about Father So-and-So. And he ... said, "These men, they are not God!"

Well, now it's 2003, and it was the day after my daughter's wedding that I read the letter from the Archdiocese saying that the priest's actions may have been "inappropriate." His lawyer says: "Father So-and-So makes no claim to perfection..."

I want to put some type of closure to this very painful part of my life. I don't want money. I don't want anybody's name in the newspaper. I just want to be free from it! And I want the Church to know that they have to be part of it — that it's their responsibility. And this horrible F-word that people keep using all the time: Forgiveness. I don't know what to forgive, who should be forgiven, if I should do it, if they should do it. Because I live with it everyday, I feel that he has power over me! And it's up to him to say that he shouldn't have done it! He has no consequences; he's still saying Mass. I want him to know how much it's harmed me. I know that I am not the mother I feel I should have been. It breaks my heart to think that what happened to me those many years ago still affects my husband and daughter. And I'm trying not to see it that way, and I'm finally coming to the realization that the way I previously saw it — it ain't so!

I asked my therapist, "Why didn't you tell me in the beginning?" And he said, "I couldn't do that. You had to come to the realization by yourself." And I said, "But it wouldn't have been so painful." And he said, "It has to be like that for it to be from you, and for you to go on."

BILL GATELY

I've said consistently that the perpetrator wins. But in the case of a priest in the Catholic home, he has won the minute he puts his hand on your leg; boy or girl, you wouldn't tell a friend. You're not going to tell your parents. When he had entered my room he had already won.

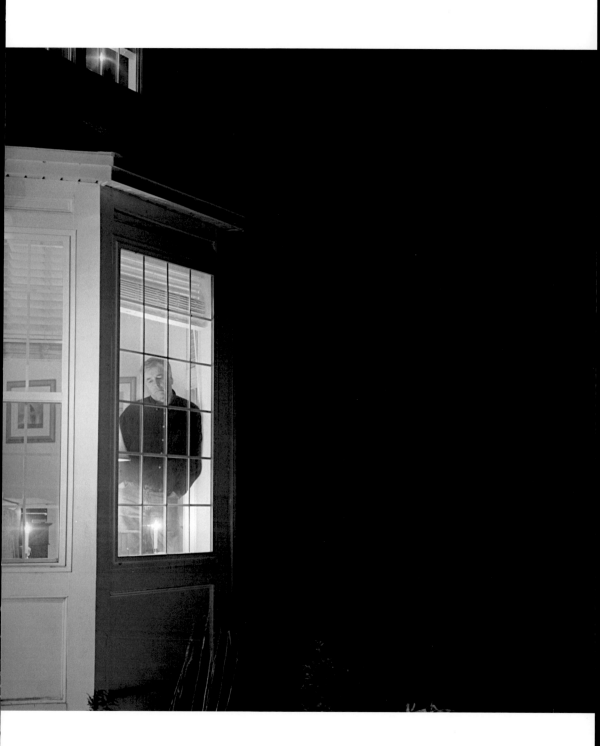

Bill Gately, age fifty-four, and currently we're in Plymouth, Massachussetts. My parents were extremely religious; in fact, my whole family was. My parents were the Catholics in the parish. At that time, one of the priests in that parish had asked my father if a visiting priest could stay with us for a week because there was no room at the rectory and he needed a place to stay.

My parents were very enthusiastic about him coming, because all my life they wanted me to be a priest. He stayed approximately one week. The night before he was to leave I had gone to bed, and shortly after that I became aware of this silhouette in the doorway. My initial instinct was that it was my father coming into the room. I automatically sat up in the bed and moved to the right. In the darkness, this silhouette sat down, and I remember smelling this cheap cologne and realizing that it wasn't my dad. He was in boxer shorts and a white t-shirt and he started to rub my left arm, telling me how much me was going to miss me. He told me how he enjoyed me more than the others, and that he thought that someday I would make a wonderful priest. He went on to tell me how lonely the priesthood was, and what a difficult life it was. He continued to rub my arm and then he started to pat my hair.

As he did that, I believe that he'd already won. First of all, he's in the dark and he's in my bedroom and everyone in the house is asleep, or at least had gone to bed. He'd already crossed boundaries that would have been difficult for me to explain, not the priest. So the awkwardness, the embarrassment, the shame, had already begun to culminate. He continued to talk, and in doing so he spoke in a manner that sort of projected the assumption that all of this was normal.

I remember that he lifted the covers and got into the bed. After that he started running his hand down my abdomen, and then around my back into the back of my underwear. He touched my penis at that particular point and then kissed me. I remember he just put his tongue in my mouth, which was extremely difficult for me to tolerate. I can remember detaching mentally, emotionally, from the experience, keeping my hands flat on the bed so that he wouldn't think that I wanted to be a part of this. I wanted to, like, melt into the mattress.

And then he went back to wherever he was sleeping.

The following morning my father said, "Father is leaving today to go back to Korea, so he asked me if he could drive you to school." And with that, I went down the hall and I got sick. I went to the bathroom and I threw up. I couldn't look in the mirror; I just couldn't face the shame and the guilt.

It was at that point that I realized that I was going to have to carry this secret for however long. Philosophically it's rape. It's sex against.... It's a violation of.... It's against your will. You're not consenting. I just knew that this was the beginning of the wall between my parents and I. In my house, sexual expression was shameful and a homosexual act with a priest would have been unheard of. They would have assumed that it somehow was my responsibility. I think that at first they would have blamed me. You know, who's gonna question the priest? So many of them use that excuse. The priest has that cover. When I did tell, my father asked me thirty years later, "Why didn't you tell me?" and I said, "Because you never would have believed me." And he said, "You're right. I wouldn't have believed you."

And so, he drove me to school that day. He said he hoped that I wasn't shocked by what we did. And I remember thinking at that time very clearly, "We didn't. You did!" But I listened, and of course I agreed with him. But how could I not be shocked? You know, you're living a healthy existence, in a family where there are appropriate boundaries, and all of a sudden, somebody, against your will, twice as old as you, gets into your bed and has sex with you! Who wouldn't be shocked? But the polite response was, "Oh, no, no, that didn't shock me."

When I got out of the car, I turned around and looked at him and he made the sign of the cross. It was like he anointed this bond that we somehow had, that I was reluctantly a part of. And if that doesn't seal you in silence, nothing's going to.

He came back every six months for about two and a half years to visit and stay with my parents, do fundraising, and he molested me each time. It happened about four or five times that I can recall. I remember his arrival into my bedroom. I remember hearing the door, I remember the smell of the cologne. It ended December 29th, which is my birthday, so, that's how I know. From when I was fourteen to seventeen – until my seventeenth birthday.

The truth of it is, though, you can't remember everything. You disconnect, and you have to! I had mentally left the room, you know, Elvis has left the building. It wasn't until my therapist suggested that I obtain that cologne that many of my memories came back. I remember opening it and fearfully smelling it. It was as if it was some sort of memory drug. It confirmed and strengthened my visual memories. This time, the visuals also included him being on top of me.

At the age of seventeen I wondered what it would be like to be dead, if being dead would be better. At twenty-two, I was a cop. I remember being at my parents' house at

my supper break and taking my gun out of the holster and pointing it at my face and thinking, "I wonder, if I pulled this trigger, if I would even be dead before the noise, if I would hear the noise." I didn't consider suicide beyond that, but it was as if my life was a second job. The abuse was the greatest shame; that if I was gay, or as I realized, that my first sexual thing was with a priest. And so sex to me was vile, it was disgusting. It wasn't pleasurable, it was against my will, and it was with a male.

The night of my birthday was the last time I saw him until 1993. I tracked him down and found him in Arizona; he had left the priesthood, and got married. So, I got on a plane and I went to Phoenix. I wanted to see what he looked like on my terms. I called him and said I had found an envelope in the gutter that had his name on it and it looked like they were important papers. When I saw him looking around from the car, I went out to meet him. I did have an envelope, but it was an envelope that I had in my car. I wrote my name, the name of the priest that introduced me to him, the name of the parish that I was in, his old name, and the name of the priest in Massachusetts on the envelope. I said to him, "Do any of these names ring a bell with you?" He looked at my name and he said to me, "That's you, isn't it?"

He started acting like he was going to pull away, so I reached into the car and I turned the key. And he says to me, "I was just going to park." I said, "I've tracked you down for two years. I know everything about your children, your wife, and when you came back from Korea." We talked for about two or three hours in a park, and the strange thing was he acted as if it was a social visit. He said to me, "How are your parents?" I know that even when I left him that day, I don't think he had any sense of how much damage he had done. I said, "Here's the deal: I ask the questions, you answer them. Never mind my parents, or anybody else. This isn't a social visit." He asked, "Are you going to put me in jail?" I said, "I'm here to work my stuff out. I've spent thousands of dollars and thousands of hours for this moment. If I find that you lie, I will probably pursue your going to jail."

I asked him a number of questions. They confirmed my recollection of the events. I asked if I was the only kid, and he said yes. I said to him, "Remember what I told you." And he said to me, "There were several, a lot of them were in Korea." As we parted he said, "I have to ask you again, are you going to send me to jail?" I said, "I don't care whether you live or die or go to jail or not." And he said, "Well, please think of my family and what that would do to them." I remember thinking, "Think of your.... You ruined mine – the integrity and honesty that existed between my parents and me!"

I was thirty-two when I found him. It was prior to anything happening in Boston, like, by ten years. After Boston broke, I went back and confronted him again. I wanted

answers to other questions I had. What did the order of priests know? Why did he leave the order? What was his sexual orientation? More intimate things like that. He was very upset. He said to me, "I thought you were going to let me live my life?" And I said, "Well you can go on and live your life, but I'm going to take care of mine now, and we'll do it on my terms."

I was able to leave him and my issues in Phoenix.

The confrontation that I had with him allowed me to begin the process of forgiveness. I was no longer investing energy in the event. And it has nothing to do with some sort of acquittal on the part of the perpetrator. Before this, I was so Catholic that I believed that God somehow had picked me to be able to keep a secret. That God had picked me for this guy to be able to act out his sexual needs with and still keep my mouth shut. No longer could his existence alter my life in any way. The damage that had been done to my soul and my psyche is permanent, but it would no longer be controlled by the thought of him.

That captures very well what my life was. That captures what my life experiences were. I had handpicked the people I told. And it's the first time that I had ever felt it viscerally, not in darkness. The analogy that I've used is that I lived sort of on the periphery of life, meaning that if you take your life as a pond or a lake, that all of the people you love in your life are in that pond, and they're all enmeshed and immersed in your life, enjoying life in general and I would always be on the edge with my feet in the water saying, "This is nice."

BETH McCABE

My name is Beth McCabe. I'm fifty-six years old. Born in the Bronx, grew up on Long Island, New York – a typical large Irish Catholic family, very much involved with the Catholic Church. We're in Canton, Connecticut, where I live.

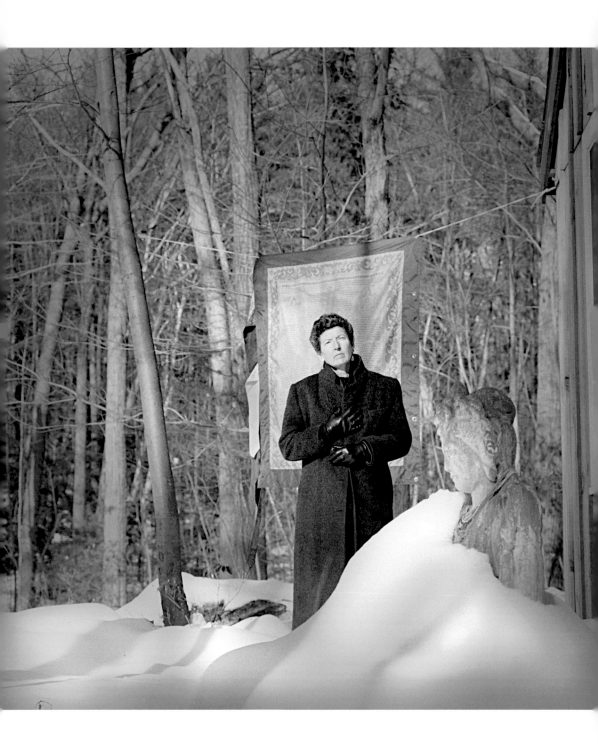

I started screaming, "What about the victims?" It was at that moment that I kind of really lost it. I was sitting in traffic, absolutely screaming, just hysterically crying. Got to work, and I didn't know what I was going to do.

In 2002, after hearing stories – one after the other on the radio – about the scandal in the Church and the cover-up, I think there was a story about Cardinal Law. And he said something like, "Maybe we need to do a study about why priests are pedophiles."

It all still feels surreal at times. But the sad truth is that it did happen and it is something that has changed my life.

I was the one that was abused, but in a way our whole family was. We were emotionally abused; we were betrayed in an incredible way. Someone that we trusted would come into our home and take advantage of me.

Our whole life kind of revolved around the Church. We knew all the priests in the parish. My brothers were altar boys, my mother was actually president of the mothers of the altar boys, my father was in the Knights of Columbus, and one of my aunts actually worked in the rectory. She was a great cook, so she was a cook for the priests.

There was one particular priest who would come to our house. He was a tall man. I would say he was in his fifties. He smelled old and musty. He drove this big Buick, and he was bald. He had dark glasses, like black glasses, and this big red face. He always had a Scotch, or several Scotches when he came to the house, and I remember the smell – the smell of Scotch. To this day I can't stomach the smell of Scotch. It just repulses me!

He always had his camera with him, this thirty-five millimeter camera that he skillfully used to lure me. He was always taking pictures of us. Meanwhile, my parents would be in the kitchen cooking, and it was during these times when we'd be sitting on the couch in my parents' living room that he molested me.

While he would sit on the couch, he had this…. I call it the "vise grip." He would put his arms over my shoulder and just hold me in this grip, so tight that I just froze. And he would bring his very large hands around and rub my breasts. I couldn't move, I felt like I was in a vise.

And he, this guy, this bastard, this pervert just had all kinds of freedom from having his arm around me. And that's the part – that's all that I remember. I must have

known that there was something wrong in this because I didn't tell my parents. But I repressed it for so many years that I don't remember a lot.

This priest would come several times a year because he was not one of our regular parish priests. He was like the substitute. The perfect opportunity! He would come to our house and stand at the door until he would be invited in; and every time he was invited in, I would be molested. I found out years later that they never invited him to the house; that he would just appear at the door.

The abuse happened when I was eleven and twelve years old. There were times that he would appear at the door and my brother would say, "My parents aren't here." And he would say, "That's OK, I'll come in and sit down and have a drink." And again, another opportunity to molest. I think the abuse ended because he stopped coming to our parish to take over when the other priests were on vacation.

I think the most important thing for me was that I did not remember this for a good thirty-five years. I never told anyone. The secret was hidden even from me. It was totally repressed. I began having flashbacks when I was helping a friend deal with some sexual abuse that had happened to her. In helping her, I had my first flashback of sitting on that couch and being molested by this priest. At first I didn't think it really happened; I pretended it didn't happen and pretty much put it back in my head and didn't want to think about it.

I didn't really deal with all of the emotions. I don't think it was a conscious thing. I think it was just too painful to go there. I used to say, "Yeah, I was abused by a priest," totally detached. There was no emotion connected to it; there was just this kind of very stoic, strong, "Yeah, it happened, but that was years ago." It was pushed so far back. The only thing that I consciously knew was this incredible distrust of anyone religious – no matter what religion. Anyone with a collar, anyone that wore their religion on their sleeve I would withdraw from totally. I didn't want to have anything to do with them. And I didn't understand that, but I was aware of it.

But it was that moment when I was in the car. That was the realization that not only was I abused, but the pain of the abuse was multiplied by the enormity of the abuse of power and the subsequent silence and cover-up by those in authority. I was enraged at the abuse, not only caused by this one priest but by a Church that preached about love and caring for children yet let so many accused priests be moved from one parish to another continuing to abuse children.

I didn't remember the abuse happening until the late eighties. Actually, I was having dinner with my parents and we were talking about the Church. I became really angry and I told my dad that I didn't like the priest that used to come to our house, and he asked, "Why?" I said, "Well, he hurt me. He molested me." They were horrified! I believe the first words out of my mother's mouth were, "I'm glad the bastard's dead!"

They asked me why I didn't tell them at the time. We were raised to believe that priests were God; they were God's messenger. So, why would an adult believe a child? Or that maybe in some way it was my fault!

The most painful thing for me is that he took away my innocence; he took away my dignity. He touched my body before I had the opportunity to allow someone to do it the way I would have liked. Even more important than that, he took away my sense of spirituality, my religion; that was the greatest loss, and it was also the greatest betrayal.

When it was the anniversary of my grandmother's death – also the Feast of the Immaculate Conception – my parents were going to church, and my mother said, "Well, maybe you should go to church and pray for Nana," and I said, "No way, Mom! Light a candle for me, for her, for my grandmother."

But I have no intention ever to be a practicing Catholic. I just stopped going.... It was actually more that – just not agreeing with a lot of the Church's stances on, say, abortion, homosexuality, you know. It was not this embracing Church that I had believed in, you know.

In 2002, when I realized that I had come to the critical point in my life where I needed to deal with this 'cause my life was literally falling apart, I entered therapy. There's been a lot of ways that I've learned to cope … by holding everything in. And it's been hard to break that pattern because it took so much energy to hold that in for so many years. I'll never get over it! It's part of who I am. It's part of my life story.

I think that the biggest effect was certainly on my spirituality, and feeling a real loss of that. I had this epiphany three years ago, and I realized that, except for my own sense of attachment in a really profound way with the natural world, I had no spiritual community. I realized that my greater power was Mother Earth, and I always felt the most spiritual when I was walking in the woods, sitting on top of a mountain, sitting in a kayak in the middle of a river or a lake. To me, that was church.

Luckily, I found a community called "The Women's Temple" and started going to their gatherings on Sunday mornings and found what I had been missing for a long time. I finally felt connected to a group of women who felt the same about the earth – Mother Earth. Now we worship the female deities that the Catholic Church would never acknowledge. We honor goddesses, and it has made a difference in my life. It's something that I embrace now, similar to when I was growing up embracing the teachings of Christ.

There's a lot of Native American in it, there's a lot of Buddhism…. I mean it just incorporates a lot. And then, after we call in the grandmothers and ancient ones and goddesses, we'll be just, like, "Come on in!"

There'll be a reading, and it can be anything. You know, it can be Alice Walker talking about "The Color Purple" or, you know, if someone has a particular reading they found they want to share. And then we sit, usually for about a half hour, and just meditate, just sit in quiet.

You know, I'm the soft-spoken, together one, where, like, everything is cool. Everyone likes Beth, you know? Don't confront, you know, stay silent. And now it's, like, I'm speaking out!

And I feel like one of the reasons I agreed to do this is that, you know, nothing ever changes in this world unless people tell their story.

'Cause silence is how they kept it. That's how they deal. They count on your silence. They count on your silence! The Catholic Church banks on and counts on people keeping silent.

SANDRA GRAVES

My dad, an Air Force pilot, was killed in a plane crash in December of 1952,
and I was born in July of 1953. My mother converted to Catholicism because my dad
had been Catholic and she wanted to raise his children in that religion.
My grandmother also lived with us and she had been Protestant.
She also converted to Catholicism.

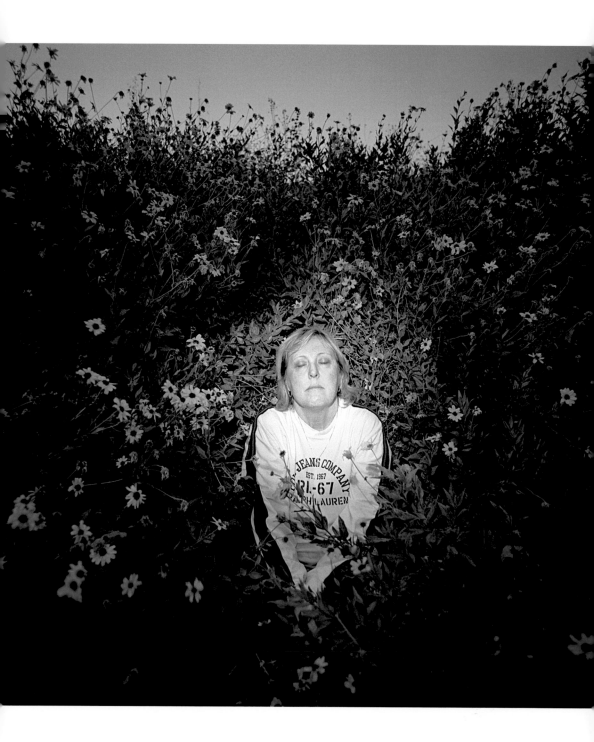

In 1957, the priest that molested me was transferred to our parish. He seemed to be a very warm and loving man. We always considered him, sort of, part of the family in that he would come to our home for Sunday dinner, sometimes for holidays, and he was always there for Christmas. I grew up with him just being there, and never having a dad of my own, I guess I really looked up to him especially since when you're raised within the Catholic Church, you're raised to believe that a priest is truly just one step below God. He's the right hand and you know he basically holds your salvation in his hands. So I was in awe, as most kids were back then.

If I think about what's now known as grooming behaviors, they probably started when I was about four years old, and that was with the hugs, the kisses, and putting me on his lap. Well, even though I studied about grooming behaviors that perpetrators use to get the trust and faith of their victims, there's grooming behaviors that are also done with families. And our family was very well groomed. We wanted the priest to be part of our life, and we felt so special when he would sit down at our dinner table. Everybody stopped and waited for the priest to say grace, and to bless the house, and to bless the people there at the table.

That's grooming. I guess I hadn't put that together when I was really young.

So I dug out a bunch of old eight-millimeter movie film and did a really stupid thing. I went ahead and sat and went through all of it. And sure enough at the tail end of one of the big spliced reels was the priest, and I'm walking up to him in my little fur-trimmed Christmas dress and I'm handing him a box with a cardigan sweater, gray. And he goes and he gives me a hug and he kisses me on the lips. I was so disgusted watching this as an adult. And I guess that's the whole point, that as a child you just don't know and, ironically, one of the first things I always remembered were the sloppy kisses. In fact I'm phobic about having lipstick or anything else on my lips still.

So when the new school opened, there was more access to children. And what happened was, in trying to be helpful and wanting to have the attention of the priest or the nuns, and wanting to be thought of as a very devout Catholic, we would volunteer for different things. Like I could remember going in the back of the schoolyard and clapping the erasers and inhaling lots of chalk dust. But one of the other things we would do is go over to the rectory to help the priest to stuff envelopes or fold bulletins. Now, it was always just one of us at a time but as far as I remember there were five other victims besides myself. And they all seemed to have a specific vulnerability. Either a parent was dead, or a parent was an alcoholic or emotionally not there, but there was always some sort of vulnerability that they were more likely to be drawn

in and need that attention. Also, they would not tell because these were all families right at the center of the Catholic community.

So in fourth grade I was sent over to a little office in the back of the rectory, and the priest would have you come in and he'd make a big fuss over you. As many times as I've talked about this, it's still really hard. He would pick me up and hold me on his lap and tell me how special I was; what a great kid I was, and God will bless me. And at the same time he's taking his hands and putting them down your panties and inserting his finger in you. And I had no clue what that was. All I knew was I didn't like it. And having to be in school the rest of the day with wet panties, the humiliation! That went on for about a year. I don't know how many times. My memories are sort of a consolidation. And the really interesting thing or, I don't know, maybe "interesting" isn't the right word, but he never acknowledged what he was doing. It was as if we were just sitting there and having a chat. And I think in some ways that I felt like an object. I didn't even count for him to even acknowledge what he was doing. I was just sort of like a toy or a plaything. And then when he was done you'd get sent back to the classroom feeling kind of shamed. And I had no clue what that was. I lived with a lot of shame and a lot of anxiety. And then the most shameful part was after he was done. He would just sort of set you aside and it was time to walk back to the school, which wasn't a very far walk, with wet panties.

About a year after the abuse started, one of the other girls actually informed an adult about what was going on. So that started off several different events which eventually led to him being transferred back to where he came from.

In my family we never talked about problems. We never even talked about my dad being dead because I learned real early that if I talked about Dad, Mommy would cry. So I just stopped bringing it up. Well this was sort of the same thing. You didn't talk about it. We basically just pretended it didn't happen. And that was our secret, and we weren't going to tell anybody, and the priest was gone so everything was just fine.

About a year or two later, my mom married. She'd been a widow for thirteen years. And she married another very devout Catholic man who was a widower and had been for thirteen years. His daughter had also been a victim of the same priest.

I graduated from Cal State University in 1975 with a bachelor of arts in home economics. I guess at that time being a home economist was a little bit more lucrative than it is now. But I ended up actually being a management trainee for Sears, and I

started there in 1976 and I stayed there until 1998, when I left Sears to embark on a new career as a social worker for Child Protective Services. I had gone back to school and I'm actually kind of skipping back, but I'd gone back to school in 1993 to work on learning more about psychology and working towards a degree.

I guess the part I did forget, ironically, is how I had to address the issues from childhood. My husband and I had been trying to have a baby. I was a late bloomer, didn't get married until I was thirty, so I was, like, thirty-two when I started trying to get pregnant. We'd gone through all of the wonderful infertility things, and you know, poking and prodding and there was no such thing as romance. It was just sort of a mechanical thing to try to have a baby. So, after trying that for maybe three and a half, four years, I decided I just really needed to relax. That was it. I always remember hearing stories about people who adopt children and then all of a sudden the wife gets pregnant. So I thought I could just cut out the adoption part and go to the wife-gets-pregnant part.

I went to see a therapist who I knew through a friend, and I was aware that he used hypnotherapy. So I thought, all he needs to do is hypnotize me into being relaxed. He would go ahead and see if he could put me in a trance, and if he was successful with that, then he would ask if there was anything regarding motherhood or pregnancy that was emotional or had a high emotional contact. I didn't have any problem going into a hypnotic trance, and he asked the questions, and it was truly as if someone had either opened a window or opened a door, and while I had never forgotten what had happened to me as a child I had managed to disconnect any kinds of emotions and feelings from it. So all of a sudden I was overwhelmed with all of these terrible emotions and fears and anxiety and shame, all the things that I had kept tucked away so well for so many years but here it was, and it was triggered by, you know, "Do you have any concerns about being pregnant or being a mother?"

And what came up ... was two things. One, I was afraid of having my husband die and leave me with children to raise on my own, just like my dad, and the other was, I was afraid I couldn't protect my children from being molested, which is where all of the [molestation] issues started coming up. So, like Pandora's box, there was no stuffing that trauma, memories, whatever you want to call it, back into the box, so I didn't really have a choice, I had to address it. So I addressed it with the same therapist for three years, sometimes twice a week if it was a bad week. Many times I came out of a session feeling much worse than going in, but I also recognized that that's how you go through the healing process; you have to look at a lot of pain and ugliness first.

During this time I met an attorney and he did take my case, but because of the statute of limitations, that case was dismissed. I thought, "OK, that's fine." I never expected anything, and I continued on with school and got my master's degree in counseling psychology. When I had finally gotten my master's I made that transition into being a social worker at Children's Protective Services working with abused and neglected kids. So I did that for roughly the last seven years, which brings us up to today. In June of last year I actually started a private practice while I continued to work full-time, and in November I went ahead and transitioned to just full-time private practice. And for the first time in all my life I was without employment, gainful employment, which was pretty scary since I'd only had two jobs in roughly thirty years.

I am now a licensed marriage family therapist. I'm a play therapist, and work with abused kids – work with adults, couples, marriages, and I know this is where I'm supposed to be. For whatever the journey was about, or whatever the reason that I got singled out to be abused, I know this is where I'm supposed to be.

ROBERT COSTELLO

My name is Robert Costello, my age is forty-four, and we are in Norwood, Massachusetts. I was born and raised in West Roxbury, Massachusetts. The abuse started around the age of seven, and continued 'til the age of thirteen or fourteen.

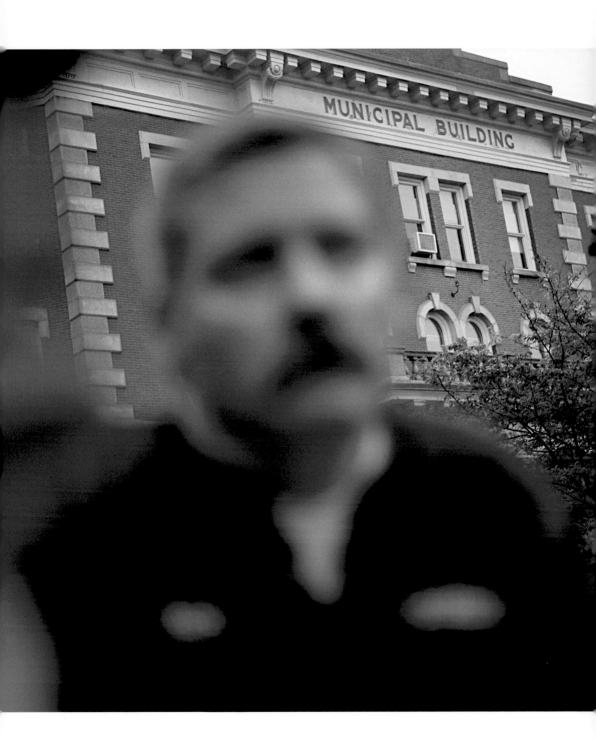

Being a kid, there was no escaping the influence or the hands of Father C. He was in charge of the Boy Scouts, in charge of the altar boys, and in charge of the CYO [Catholic Youth Organization] sports.

He had tremendous power and charisma, you know. He was a charming, good-looking man – and he was a priest so you wanted to do stuff to please him. Whether it was stuffing as many envelopes as you can or, you know, sexual acts; it was just like you wanted to make sure you pleased him.

He represented God on earth. That's drilled into your head when you start first grade. It's just part of your makeup. I mean, the community that I grew up in, the highest member of society is the priest. At school, the nuns would go, "Ooh, here comes Father so-and-so. Clean your desks, and clap the erasers 'cause Father's coming."

Father's the one who, you know, changes the bread and wine into the body and blood of Christ, and Father's the one who decides if he will forgive you your sins or not. Therefore he's the one who decides whether you will go to heaven or hell. And to a little kid, that's a heavy decision. And you're not going to do anything to risk having to go to hell! So if he says, you know, you're going to go down on me or your parents are going to hell, what do you do? But for the most part, kids don't even know that that's sex. They just know that they're protecting their parents from having to go to hell. Or having to, you know, save their dog from becoming hamburger or whatever. They use their power to create a sexual act but it's not necessarily the sex that they're looking for. It's just the power that they want over somebody.

So if it was a Scouting activity in the basement, he would bring me to either the bathroom or to the Scouting room in the lower rectory and he would abuse me there.

It's kind of hard when people ask you when the abuse ended because the physical abuse becomes mental abuse – psychological abuse. How many years were you abused? How many times did it happen? You know, how many times did you wake up screaming in the middle of the night? Twelve? Twelve hundred? I mean, there are those kind of numbers that you cannot … you can never justify those kinds of numbers. And you can never say how many times it'll happen in the future; you can't guess. So even if the physical abuse ends, the mental and the psychological abuse continues.

I think the incidents at the swimming pool happened at the time when I was about ten or eleven, maybe twelve; about a three-year period. I think Father C. was like, you know, get 'em as young as you can. He allowed my brother to bring me swimming.

And under the guise of teaching basically how to float on my back, he would digitally penetrate me in the pool – and it hurt! He was brutal. And he would again in the shower in front of everybody, and there were stalls of showers [with] three or four boys in one and he would just go right in there with them. I felt trapped, I would try to hide in one of the big dressing lockers.

There was no escape!

I can remember after swimming, hurrying to get dressed. We would run across the street to get to the bus, and being so sore that I couldn't run, I barely made the bus. And I couldn't even sit. You know, I'd have to stand on the bus and joke with everybody on the way home. I couldn't tell my mother.

Those were days of hell!

I never finished Scouting. I just stopped going because there was also sexual abuse on camping trips. There was one incident at the camp where I was very ill. I had swimmer's ear in both ears and I was very sick, and he took me into the doctor's and the doctor gave me pain medicine and said, take this child to the Massachusetts Eye and Ear [Infirmary]. And he didn't. He took me back to the camp. And he came back later that night after everybody had gone to bed, took me to his tent [and] raped me that night, twice. And then he drove me back to Massachusetts. He made me pull my pants down around my knees the whole way home. And then he brought me to the house, and I remember my mother was there, and a friend of hers [who] said, "He looks a lot more upset than for just an ear infection." But they didn't…. Nobody went any further with it, you know, and I was too scared and too afraid, and too sick.

[Later] he came to the house to make sure how I was doing, and he fondled me at home while my mother was making him, like, a ham and cheese sandwich in the kitchen. Up to that point, I couldn't go anywhere to escape him but home. And now home was not safe!

I used to have fantasies coming home from school, from that age up through high school, and was disappointed every day when I turned the corner to see my house still standing. I used to pray to God [on the way home from school] that my house had burned down. And it wasn't 'til, you know, several years ago that I realized that he had made that an unsafe place for me, and I wanted it burned to the ground, oftentimes with everybody in it – with my family in it. Because I did not want the life I had. I just wanted out. I wanted to get out of where I was. The only safe place I had was gone!

There are a lot of people who have questions as to whether homosexuality is born or learned, and all that sort of stuff. I consider myself a homosexual. Unfortunately, I never had the normal chance of being able to discover who I am. I'd been abused by men from before I even knew what sex was. And that becomes something of a habit. One of the other things that a lot of people don't understand is that occasionally, like, it feels good. I mean, it's sensual, it's touch. We all … everybody, craves that.

In eighth grade, my mind is already, like, you know, sex equals friendship. I moved up to an eighth grade kid being promiscuous.

I go to high school, I meet friends; I meet some nice friends, some so-so friends, you know? Once I happen to meet a bad friend, OK? High school graduation, I'm partying in a gay bar in Boston. I'm fed Mickeys, or Roofies, by a gentleman who I thought was my friend. I go stumbling into the bathroom, two young men decide that they'll rob me because I'm stumbling around.

And the gentleman that fed me the Roofies comes in to see what's taking me so long, finds the two kids robbing me, and decides to invite the two kids back to his house so that they can all party and do whatever they want with me. I wake up in the morning covered in blood; I've been screwed by every household object in the house. I spend the next two days in bed – have internal tears. And I end up in the emergency room like three times within a week. I mean, it was brutal! They were wondering what I was doing alive because of the blood loss and all. I mean there were broomsticks, and they're begging me to tell them who did it – who the hell did this to you? – you know? The guy who … my supposed friend.

And the reason I mention that is, if I didn't have the abuse and the grooming and all of that sort of stuff, I wouldn't have been as easily trusting of older men. And the other thing was, it was like, screw me first, be my friend next. I mean that's what I learned. I had low self-esteem, extremely low self-esteem. And that's a direct result of the abuse. So the more you abused me, the more you liked me.

So that was 1980. That's when it all comes out because I had to go to court. I mean, I had to lean on my parents because I couldn't do this alone. So my parents had to find out. And when they found out, they found out everything! I was eighteen. They blamed me because I didn't tell them the truth when I was a kid. I mean that went on for years, that my parents said it was my fault, and I was, like, how can you blame a seven-year-old kid, you know? That was how me and my parents dealt with it.

I get my nurturing from my friends. They're my chi, I guess you would say. They bring me back to my center. Yeah, they bring me back to the center, you know, not to take things so seriously. I mean, there is nothing like a good laugh.

Spirituality. I guess the quick answer would be: I'm at a loss for words. I guess I'm discovering what spirituality actually is, what the word even means and, you know, I've said that I've been either ignoring it, or angry. I'm just angry. I mean I get pissed off when the word "God" is even mentioned, and it's because I automatically go to the God of the Catholic Church. I automatically go to the God that's in my head. And I guess that goes to the intensity of which I'm doing survivor work. I just get so angry at the Church, it's like, how could God do this?

I don't know if this is, I want to say, humbling. I'm not sure how to say this, but you know, I don't do any of what I do for, like, public notoriety or anything else like that. But when my mom was dying, she said to me, "I'm so sorry that you had to do this alone." You know, when I was growing up I had to go through that alone. And I said to her, I said, "Well, maybe I had to go through that alone so I could be the person that I am now, in order to be able to do what I'm doing. So that I can help somebody else." And she just said, you know, she just wanted to make all of that hurt and stuff go away. And she knows that [she] can't. She knows that I have all of those memories.

I think the thing to remember is that we're all humans, all human beings. And … we give people the power over us, and we can take it back.

You know, people are going to start realizing that we're not lying, and there are thousands of us, and that these bastards in black are terrorists, you know, from a foreign nation – over there in the Vatican. I mean. I may be taking it a little bit too far but the one part that absolutely kills me is the extent to which the Church will go to lie, cheat, and cover up.

MICHAEL JOHNSON

My name is Michael Johnson and I'm fifty-five years old. We're in Lincoln,
the northern part of Michigan, right off of Lake Huron. My mother bought a place
up here before she retired from the Detroit Police Department. And then, when she
passed away, I was going through a divorce and I ended up moving here. I had a severe
alcohol and drug problem, and I decided to live up here and just drink my life away.

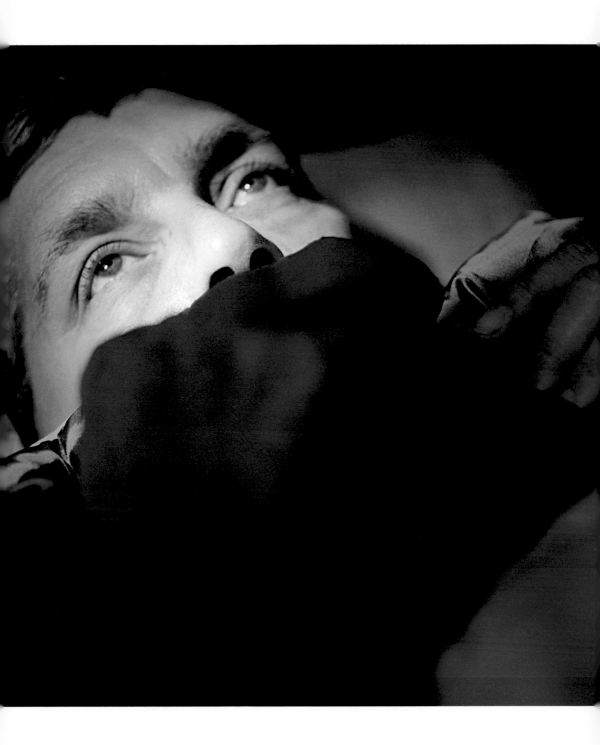

I 'd been in and out of Alcoholics Anonymous. I'd go to meetings. They'd talk about different steps that we need to take. I'd stay sober for a while and I'd drink some more.

And through those steps I was able to see that I was abused when I was younger, while attending this Catholic military school in Michigan. It was a school where I lived about nine months out of the year. Then I came home for summer vacation.

The first day of school, we went to our homerooms and Sister was standing up at the blackboard – you know. At that time they wore their habits.

The abuse that I remember started when I was in fifth grade, by this [same] nun. I'd say I was about ten-years-old. But it started [that] first day. While she was introducing herself, she was writing her name on the board, and then she turned around with just an evil look in her eyes and she said, "And I like to hit you." From then on, it didn't make any difference what you were doing. You could be marching down the hall. You could be in the classroom. It made no difference if there were people around; she'd come right up and slap you in the face. She slapped me in the face so hard she knocked me right off my feet!

I started getting interested in reading, and so I had picked out a science fiction book from the library. I was telling a friend that I was enjoying reading the book, and this nun overheard me. And that night, she came into my room and she's slapping me in the face, and saying, "You're gonna give me that book! You can't read that book!" She would say while hitting me, "Little boys don't cry, little boys don't cry!"

My scariest recollection is an area down in the basement. I started calling the place "the dungeon," where we had a swimming pool. We took baths [after swimming]. They had all these bathtubs in little wooden closed-off areas in a row, and each one had a door to it. The nun would come in and she would start washing my back and stuff, and then, uh, you know, almost like caressing me. Like, something that's going to feel good. And then she started grabbing my penis and my testicles and squeezing them. And it was excruciating pain for me! And then she'd say, "Little boys don't cry!" She'd say that quite often.

All's I know is, there's so many things that I try not to think of. She would come into my room at night and do the same damn thing, squeezing my … slapping me in the face, and saying, "Little boys don't cry!" Two o'clock, three o'clock in the morning … "Little boys don't cry." I would try not to cry. And I'm sure that I got to the point that I didn't cry.

I was embarrassed to talk about this to anyone at school. I was starting to tell my mother and father that there were things going on at the school; I was telling [them] that this one nun in particular kept hitting me. It was always that nun. Not the sexual abuse – I wouldn't bring up anything like that back then – just that she was hitting me. My mother and father were go-to-church-every-Sunday-type-Catholics. They didn't want to believe it. My mother's older sister is a nun! It was just unheard of that a nun or a priest would abuse a little kid, especially like what we're talking about. You'd put these people up on a pedestal. They are just below God, as far as I was concerned. So anything that this nun did to me, I must have deserved it. Otherwise she wouldn't have been doing this to me. It was my fault.

And so, my mother and myself approached her one weekend when my mom came to pick me up.

I can't believe that this nun – when my mother said, "I understand that you are hitting my son" – was so out of control that she slapped me in the face right while my mother was standing there.

I remember us going into the Mother Superior's office, and my mother saying to her, "This will cease and desist." That nun, that woman, will never touch my child again. And it did cease and desist – while I was in fifth grade. The school year was almost over, and then I went home for the summer.

So, here I am back at home in Detroit, and everything's going fine and dandy, and of course I'm thinking, "I'm going back to school there, but I don't have to worry about Sister anymore because she teaches fifth grade."

So I come back to school, and I'm in my room with my roommate, and I said to him, "Who's our homeroom teacher?" And he says to me, "Well, it's Sister...." and I says, "No, it can't be her! Oh, no! She's our homeroom teacher?" And it turned out she was.

She had all summer to think about being reprimanded for slapping me in front of my mother.

And so the abuse resumed with a vengeance.

I would say it happened fifty times over the fifth grade and sixth grade. It's hard to say because sometimes it was twice in a day. It was, like, almost every night she was

coming in saying, "Little boys don't cry, little boys don't cry," slapping me, knocking me down, doing all this kind of stuff.

At that point I thought, "She is going to kill me, I have to get out of here." And then I ran away from the school, me and two other guys. And I'm a little tiny kid then, and there's a big world out there. It was drummed into our head that you don't leave the grounds because they were so concerned about [the wealthy students] being kidnapped. You just don't leave the grounds. But I had to leave because it was either leave, or she's going to kill me. We took off!

At the last moment one kid wouldn't go. He went to the Mother Superior and told on us. They immediately had the police out looking for us, and that evening at about three o'clock in the morning, the police caught us. We went the wrong way. We thought we were going towards Detroit. I remember seeing the Ohio border sign. So, the next thing you know, we're being driven up to the military school.

We pull up in the police car, the door swings open, here's Mother Superior and she says, "You boys go to bed now. Your parents will be here in the morning to pick you up." And that was it. We were expelled right then.

I know that I got to the point that I didn't cry. I've been able to train myself [not to cry] in many situations where you might. Even through my mother's funeral and my father's funeral I didn't cry. I have developed a way of not feeling. I just don't feel anything. And alcohol and drugs really helped me with that. And today, being sober sixteen years, I can still turn on and off that switch of not feeling.

This program that I've been involved with at AA has taught me to look into my past, evaluate it, and see what I've done in my lifetime. You know, I got into some real trouble a little over sixteen years ago; I got into a fight and darn near killed a guy. We were both drunk, and I was defending myself. And so they took me to court and said I had to see a psychologist. I'm going through therapy as we speak.

I have approached the nuns – the perpetrators. I've even written a letter to the nun that abused me – with no response. I can't sue them because of the statute of limitations in Michigan.

The nuns at this particular time are paying for my therapy. And they're paying for medication that I take for anxiety attacks and all this kind of stuff. They've agreed to pay at least until the year 2007, and then it's sort of up to my therapist. But they

will not admit that anything ever happened. It's pretty funny that they pay for this, but nothing happened. You know.

I just wanted an apology. I wanted them to say, "I'm sorry," and admit that this kind of stuff goes on. And I'm not trying to imply that it just goes on with nuns and priests. There's a lot of pedophiles out there. [But] what we're talking about right now [is] Catholic nuns at a military school. This is what's happened to me, and it's devastated my life in so many ways with relationships; I don't trust people to this day. You know, I don't have a problem with drinking and drugging and all that kind of stuff, but I still have other problems that I need to work out. It stems from the abuse that I went through as a child. I'm an authority [on that] abuse.

My life changed when I was in sixth grade, until 1988, '89. All those years I abused alcohol or drugs, any drugs that you can imagine. Heroin, cocaine, LSD, mescaline. I took them all in large quantities for years and years and years. You know, to escape that feeling of the abuse.

I believe that there's a God, some kind of a higher power. Otherwise I wouldn't be here. One time I'm in a hospital, there's a drug treatment center connected to it, and I was on death's door. I was on life support. And I recall people were coming into my room from the drug treatment center. And the counselors told them, "We want to show you this guy that's not going to make it through the night." I'd been in and out of hospitals and jails, but they were bringing these people in to use me as an example of how somebody dies from drinking. I came out of it. You know, it was like I was trying to kill myself without even knowing it. You know, my wife had left me – we were married nine years. I had such low self-esteem.

The last time that I drank, well, I beat [someone] up bad with my fists and I hit him with a golf club. I went into a blackout, alcohol-induced amnesia. You don't realize exactly what you're doing. I almost beat the guy to death. Of course, the police [were called] and arrested me for attempted murder.

I can't hardly believe that another human being would do that to a little kid. I think of how I looked up to the nuns and the priests and stuff. They're on their pedestal, and they can't do anything wrong. So what they're doing to me must be because I'm doing something wrong.

I believe in God, but I don't believe in Jesus Christ. They beat Jesus Christ out of me.

BETTY AND JOE ROBRECHT

My name is Betty; my husband is Joe Robrecht. We're married fifty-nine years, which is longer than Methuselah.

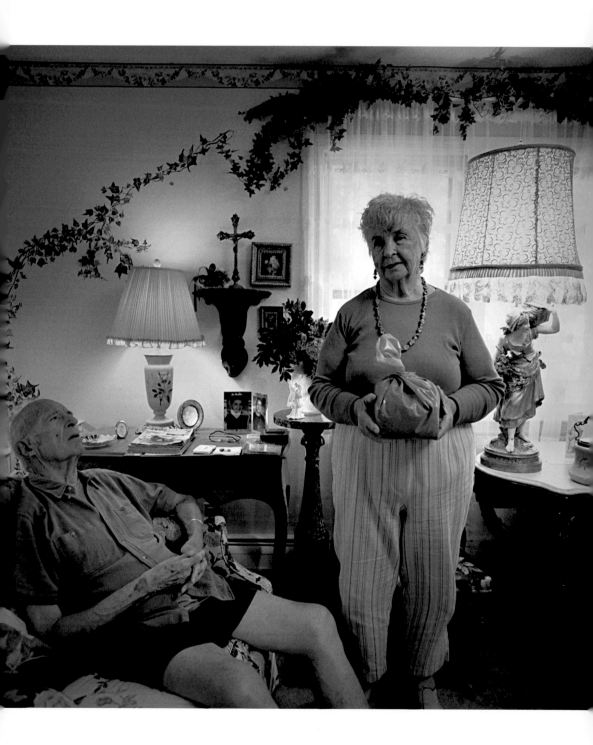

The phone rang. Bill our son answered and listened, but just hung up the phone and stood there. I remember he said, "Mary was found dead." And I understand when it's suicide, they always say no sign of – I forget the word – but she wasn't hurt or anything. She was going to come home, but she didn't come. She didn't come. She was living in Ithaca, New York. And she had been dead for about a week when she was found. It was planned because everything was neat.

Our names are Betty and Joe Robrecht speaking on behalf of our daughter, Mary. We were both raised Catholic, and we really were devout Catholics because of our families. We had many priest and nun friends all of our lives. We even lived right across the street from the church while our children were growing up.

And we had seven children that I delivered; we lost triplets, and we had two miscarriages so we would have had a dozen children. Mary was a beautiful child. I remember an aunt of mine had lunch with us one day, and she said, "Aren't you afraid to have such a pretty child?" And I said, "Why?" And, you know, she said, "Oh, I would just… I would never let her out of my sight." I guess she was a pretty little girl, you know?

The nun who abused her, she kept journals. She wrote about the day she came to our parish. It was a Saturday and she decided to see what the church looked like and she saw Mary come out of confession. She wrote, "You were beautiful, and that was the day I picked you!"

That nun was demonic, really. She was undermining anything that we might have tried to teach Mary. She told Mary the reason that we were having all these children was because we really didn't love Mary. She was giving her liquor; we know that. This nun was giving my daughter liquor, and pills.

I would say the abuse took place over three years. I think that Mary was abused for the entire three years that Sister was there. I only came to this conclusion about three months ago. That was the beginning of – I guess – the serious part of our life. There were – I can't remember them all now – but there were varying different things that happened.

There was a time when Mary was eleven years old, and we noticed she had begun to change. You know, this pretty little curly-haired girl looked frightened. She was not as outgoing anymore, and didn't seem to have many of her friends hanging in the house like they always did. At this time, a new nun had come to our parish. She didn't teach girls, she only taught boys. But she took to Mary, and Mary took to her.

She was always asking her to come over and help her do this, or help her to do that. And that was fine with us. You know, why not?

The change in Mary was so startling that I think both of us didn't want to say it, but we felt like something was wrong.

The nun became her friend and was there three years before being transferred to an out-of-state parish. Mary had graduated and was going to go to the high school, which was down the street. The nun seemed to call a lot of times that summer and right before she was to leave, maybe a week before, she showed up at our house one night. I remember she was driving a car and I didn't know she could drive. She had on civilian clothes and I didn't know she had that, or was allowed to wear them. I mean I'm talking about a long time ago; this was thirty-nine years ago.

When she came that night, she said that she had a sister who lived in Point Pleasant who had children about Mary's age, and she was going down for the weekend. She asked if she could take Mary with her, and we were proud to say yes. So proud in fact that we asked, "Do you need some money?" and told Mary to get her clothes packed. And off she went.

The next day we were walking home from Mass, and I don't know why, but I turned around and there was Mary walking behind us. She was looking worse than ever. I don't honestly remember what she said, but it was something like, "We had to come back early" or "Sister had to come back" or something like that. And you know, I might have said to her, "Are you all right?" We accepted whatever her reason was for coming home early and didn't give it a second thought. I honestly don't remember her going over to see the nun again; I assume she did but the nun was gone shortly after that night.

Then there was something new. Every day when she came home from high school she went for the mail, and there was always a letter. One day there were five letters. I remember saying to her, "Mary, isn't Sister teaching?" She said, "Why?" And I said, "Well, where in the world does she get the time to write you five letters?" And she just stopped and she said, "Mom, do you want to read them?" And I, thinking I'm this modern mother with this new baby and stuff, I said, "Oh, not unless you want me to."

The next day – Mary had her own room and the bed was always made neatly – she left a letter lying on her bed. And I read it. It was November. And it had such a terrible effect, I still didn't know why. I had never heard the word lesbian. I had never heard so many

words but it was a cold day, and my feeling was – and I've said this to our lawyer – had she still been across the street, I would have taken my bread knife and gone after her.

Whether I really would have or not, I don't know. I had this nice big warm house, and I had to get out of it. I had this baby who was not very old and I wrapped her in blankets, and I went out and sat on my back steps and I cried all day. I didn't know why, but I knew that something was very wrong.

I didn't say anything to Mary when she came home that day. We had all these kids coming in at once and she usually would go up to her room, so when Joe came home I showed it to him. We went upstairs to see Mary and she was sitting in her room doing her homework. I remember Joe said to her, "Honey, your friend is sick." And Mary said, "I know that!" He went to kiss her and she said, "Don't you touch me!" We didn't really get a chance to talk.

The letters were not as frequent after that. I started to change, too; I was panicky and didn't tell anybody about what had happened. My husband and I just kept it quiet. Every time I went out to a store, or went to something, I thought I saw her. I thought I saw the nun. We went to see a priest who was a friend and we brought the letter. I remember that he started to cry, and he looked like he was going to throw up. He said, "This woman is diabolical." Before we left, though, he said, "Now I think it would be best if you keep this quiet. You can't go around telling all the bad things you know about people." This irritated me; he was our good friend! I fooled myself that day. I thought that we had taken care of her problem.

A couple of months later I told my younger brother, who was then a Christian Brother, and he said, "We're going to see the Mother Superior." And he said, "I called up there and said I'm coming with my sister." And the nun said, "But you can't come! It's a Sunday, it's snowing and everything." He said, "Like hell I can't!"

We were told, "You must be mistaken, she's such a good nun. In fact, this is her third order!" If I heard that now, I'd say, Bingo! "In her last order … she took care of sick children. Your daughter must be making things up."

On Tuesday afternoon, the head of the whole order called me and said, "[The nun is] leaving! She'll be gone by the end of the week. I just cleaned out her room." And Joe brought home the worst filth that either one of us had ever seen. It was not only about our daughter, but was about the men in the parish that she was going out with. [Letters] would say, "If you want more money.…" It was obvious she'd been getting money from different men. You know, I can't believe that we still kept quiet.

I think I began to change religiously long before Joe, you know. I smelled the rat in different places. I don't believe there's a hell. I don't have the terrible anger I always had. I believe in God, and I believe in all the little people, but I absolutely hate some of the bishops because there's been so much phoniness.

Mary was just fourteen at this time. She felt that it was her fault, you know? She began counseling, and one day the woman she was going to see called up and said, "Do you know Mary hasn't been coming? She came two or three times and she really didn't know what she came for."

Later I had gotten the names of a couple of psychiatrists, and I remember taking her to one in particular. When she came out she just looked so happy and she gets in the car and says, "Well, at least I know I'm not a lesbian!" She just seemed to be so relieved. And I – you know – filed it in my head.

She was in three rehabs – that's the reason we're poor. When she was probably about nineteen or twenty she had to go to rehab for drinking. She did stay a week and then left of her own design, walked home, got into bed and slept for about two days.

She was an artist; Mary was very bright, a beautiful artist. She had the smallest room, and she had gone out one day and measured a stop sign, and [painted] that in the middle of her bedroom wall and then she painted black and white concentric figures. Her wall looked like a floor when you went up the stairs, and was very attractive, it was beautiful! Come along one day, the hall is painted white, and she was starting to paint over her room. Sister said, "You have no artistic talent..." Today I would say I'd kick her ass!

We skipped all the good years; all the years that she wasn't drinking. She was dry for ten years. You know, so many times in Mary's story, you'd think, "Well, it's all right now, everything's going to be all right."

She OD'd on a pill. Whatever the pill was, the label said, "Do not take with alcohol." I guess she took too many of them. I guess that's what she chose to do. She probably had a lot of pain. She wrote different things in this booklet; there was a little, maybe a couple of drops of blood. I don't know whether she sneezed, or what. And she wrote a sort of a note, you know, and she prayed. She thought of everybody, even apologized to whoever would find her.

PHILIP YOUNG

My name is Philip Thomas Young. We're in Wilmington, Delaware.
I am thirty-nine years old, one of six children. We grew up Roman Catholic with
my mom and my dad. We were a pretty normal family. You know, white picket
fence and everything like that, you know, dinner on the table, go to church
every Sunday, said the rosary a lot.

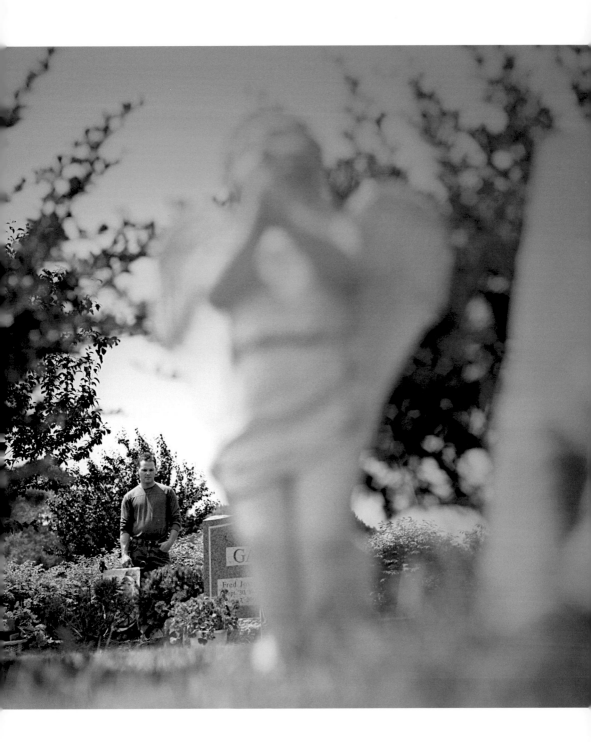

My dad's best friend was a monsignor in New Jersey. I was named after him. I always knew him. He baptized all of us, um, gave us our first Holy Communion. When we went on vacation, he always went with us. You know, we went off to Canada. We went down to Florida, to Disney World. He would go, you know, wherever we went. We went to Tennessee one year. He had a place at the beach that we always went to. I mean everything was all right, I guess, until I was twelve. They took us up to church and we stayed over, like, at the rectory like a couple of days if we were going on trips or anything like that. We went up there for a carnival, and during that time that's when the monsignor started molesting me. I was about twelve, he was around sixty.

Monsignor, I'd say, was about six feet something, six-five maybe, and he was intimidating. He was the priest you'd pay attention to because in the lifestyle you were brought up in you always respect the priests and nuns. Always respect, you know, because if you don't, you go to Hell!

Monsignor would hang out with a bunch of the younger altar boys. And what would happen is, he'd become close with them and he'd bring 'em into the – you know, have 'em stay over – and he would molest them. And I think that's how it happened with my father. And my dad married my mom, you know. They had kids. My dad, you know, didn't deal with anything that happened to him and he just didn't think it would happen to his children.

So you know, he didn't think anything of leaving his kids there – not there with the monsignor – at the rectory, at his beach house, anywhere.

It started out one night with the drinking. He got us – me and my brother – to drink and then, you know, I got into bed. He got into bed with me and he started, you know, fondling me and, um, taking my underwear off and started masturbating me, and then he went down on me.

It just kept on going for five years. You know, I don't really remember a lot of it, but I mean the things I do remember were just terrible and it's, like, I think it's affected my life pretty decently. I still have major holes in my memory and my mind hasn't processed most of the memories that happened. I think it just filed them incorrectly, that's what it feels like. And it's, like, I have to say about a year ago I started having nightmares about being anally raped and it's, like, I couldn't get any sleep, and this went on for months. And I kept on bringing it up with my psychiatrist and she was, like, "Well you know, in other people.... Well, you might have been." And I was, like,

"I don't remember it." I remember that one time – where he was like choking me and trying to force himself on me – but it's like I don't remember anything other than that, anything going any farther than that. It is difficult to talk to men about what happened because they are probably thinking that they would have fought him off or that I liked it because it went on for so long. But basically the truth is that most straight men are afraid because they really don't know what they would have done.

When I was seventeen I went out to Phoenix, Arizona. I dropped out of school when I was sixteen because I'd been having problems. I think my parents didn't know what to do with me. They split up at that point. I was out there with my uncle talking to him one night when I was drunk and I said something to him about it, and he was, like, you have to tell your parents when you get home. So I came back home and I said something, like, screaming at my dad. My dad believed me because that's when he came out and said, yeah, well, it happened to him too. The next day my mom stopped over. She was living with my grandmother, and he told my mom that I had something to tell her. I explained to her what happened and she asked me why I didn't tell anybody, and I said, well I didn't think anyone was gonna believe me. You know, he was my dad's best friend, a priest. The priests weren't considered like normal people, if that makes any sense, they were supposed to be more "Godly."

My mom said that we had to do something about this. So she contacted a local priest and he said that he didn't want to hear anything about it. My mom contacted [another local] monsignor in New Jersey, and he set something up for my mom and me to meet with the bishop. So we went and met with the bishop and explained to him what happened, and he wanted me to go into detail of what actually happened. So I told him. And then he said, "We really don't want you to go to the authorities. We'll handle this internally," and so we said OK. We thought that was the end of it.

We left and thought the bishop was going to handle whatever they need to do to get him help. So then we hear from people in New Jersey that they just transferred him to another parish up there. We went back again and my mom was trying to figure out what was going on and they said they were going to try to "handle the problem." They said that this is what they usually do before they move 'em down to a facility in Florida. So we just went away and basically that's about it.

When we went to the bishop, the impression he left with me was: Don't talk about this because you could hurt the Church just by talking about it to counselors or anybody like that. So when I went into counseling I didn't talk about it, you know? It's, like, be silent. And that's the way I was, because for one, it's really hard to talk about, and

for two, if somebody's telling you not to, of course you're going to agree with them. I'm reflecting on it now, but you know, if someone's telling me not to talk about it, and I really don't want to deal with this anyway, I'm not going to talk about it.

Then we saw in one of the newspapers my grandfather sent that some people were suing – taking the diocese to court. So my mom was, like, "We need to do something about this." My mom discussed it with us about contacting these lawyers to see if we can do something about the problem. So that's what we did and we entered into the lawsuit. I think it was in court for like five or six years. But we lost that case.

After that we didn't talk about it as a family. The lawyers had us talk about it. And that's the only way I found out that my brother Bob had been molested. It started with him when he was ten. So I mean I didn't even know any of that. He's dead now. He was thirty-nine. He hadn't gotten to the point where he could talk about it when he was sober. I have closure with my brother and was thinking at his grave that I hope he is happy now since he didn't seem happy in life. It seemed like a struggle to him.

The abuse affected my life greatly. I haven't been in a serious relationship most of my life. I'm still single, living at home with my mom. I started doing drugs when I was twelve. I did some marijuana, some opium, hash, speed. Then I drank. By the time I was sixteen, seventeen years old, I was drinking with thirty-year old people. [The drugs and alcohol] just gave me the "out" to not get any help because, you know, doing all the therapy and everything like that is really difficult to do.

When I was seventeen, I was more off-the-wall than anything with the drinking and the drugs and getting into trouble with the police. I used to get into bar fights every other week, so it was like I wasn't thinking. I was molested. It damaged me so bad that I couldn't process any of my feelings, and I didn't know any of the damage was done. It was just, I didn't know what normal was, if that makes any sense. So I'm just running around freakin' half crazy and, you know, that's the type of people I hung around with anyway. So it was "normal." I don't know why this has happened to us, you know? We both my brother and I acted out the same way with the violence, a lot of drinking, doing drugs.

When I was eighteen, I was put in prison for knifing some guy who I got in a little fight with. We'd got in a confrontation about drugs, someone else's drugs, and he'd moved towards me and I cut him. Then I was committed to a mental hospital for attempted suicide when I was nineteen, I think. I had just gotten done drinking about two six-packs and I'd say about half a fifth of rum, and attempted to cut my wrists.

My mom came home, she called the paramedics. One of her friends got the knife away from me. The paramedics were taking my blood pressure. I turned around and tried to jump out a window to get away. They grabbed me, the county police grabbed me, my dad…. I think it was another big dude grabbed me, and they strapped me down to one of those gurneys, wheeled me out of the house and took me to the hospital.

I've been in therapy since probably 1998. I feel personally as a human being I've made a lot of progress. I mean, I don't drink, I don't do drugs, I don't go off the wall anymore. So that aspect of my life is a lot better now because of therapy. But my personal life, you know, is worse. Because, you know, how I always ended up with women is I'd go out to a bar and get drunk and just end up with one, and I don't do that anymore. So getting into a relationship is a lot more difficult now. Because all that happened to me, because of the sexual abuse I became very reclusive and I don't really talk to people. I don't trust people. I'm not an outgoing person. I keep people just on the outside. I don't let anyone in because I don't want to get hurt again.

My belief in the Church is like non-existent. I have no belief in the world. I think I was raped very strongly, spiritually. People don't want to hear about the ugly drama that is your life. They don't want to hear about going to court, and about people beating up on you. This is not Hollywood. This is, you know, my life. I mean it's not a secret anymore.

PATRICK McSORLEY

July 6, 1974 – Feb. 23, 2004

While my guitar gently weeps…

"Polysubstance abuse…manner of death undetermined."
-Office of the Chief Medical Examiner, Boston, MA.

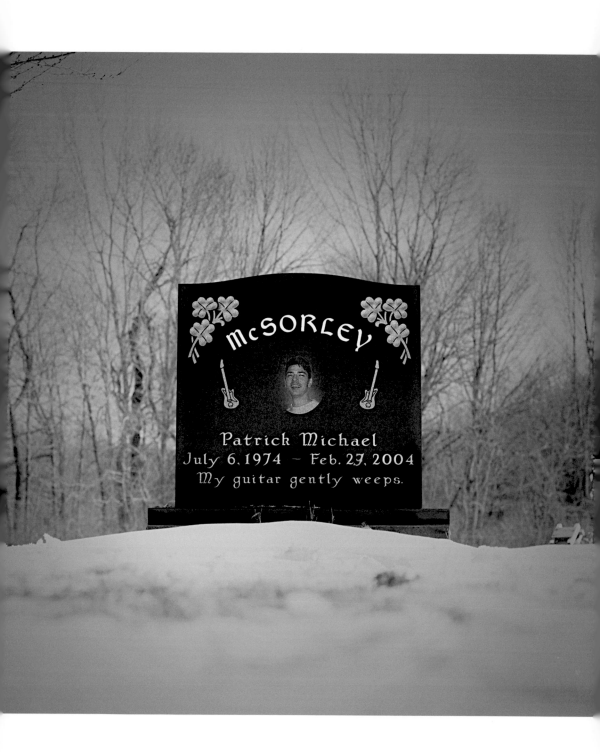

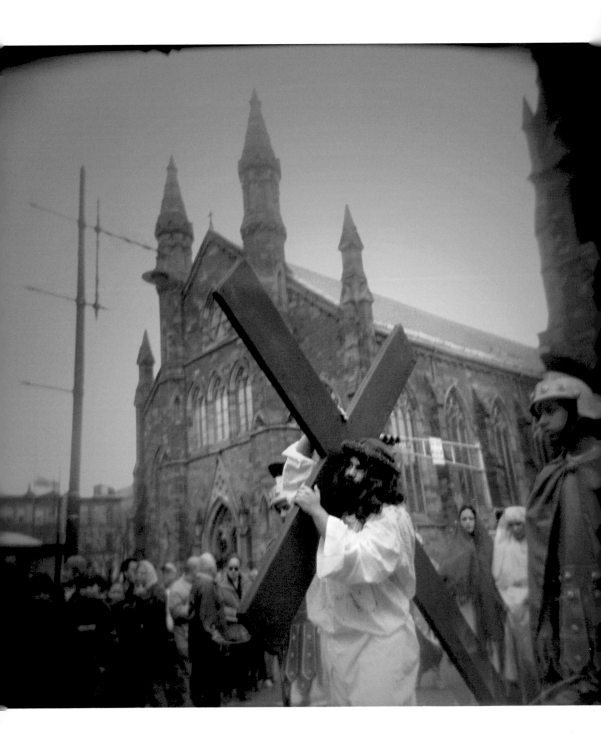

THE EYE OF THE BEHOLDER

A. W. Richard Sipe

Millions of people have long admired photographic art and the artists who share
their vision of the world—reality—with the rest of us. Photography can document
action, events, and especially emotion, beyond words. The photographer's vision of
people, events, feelings, and nature opens eyes - it is a means of enlightenment.
The photographer's vision of a world can reveal what is familiar, even known,
but not easily "seen." Visual records can move one beyond insight, to awe or
breathless discovery.

The sexual abuse of children by Catholic priests, and bishops is a topic that many
people have heard about, read about, or even talked about. In fact, the news
media talks about "reader fatigue" when it comes to this subject. That is not a result
of understanding - only hearing.

Carmine Galasso assigned himself a daunting task—to bring attention, human under-
standing, and empathy to a most painful subject only reluctantly faced.

Courage is needed to penetrate the realities of suffering beyond headlines to come
face to face with the outrage of the sexual abuse of minors by religious authorities.

Photography is an appropriate medium to delve into the reality of this problem
because abuse by priests, and nuns is *unspeakable*.

A room full of Church insurance lawyers was moved to tears when survivors of abuse
illustrated their stories with photographs of themselves at the time they were abused
and in subsequent photos.

The scene, a sealed, packed Los Angeles courtroom, could have been staged for a
Hollywood movie. It held several dozen men and women involved in the litigation
over sexual abuse of minors by Catholic priests and bishops. Present were lawyers,
experts and consultants, bailiffs and a judge presiding over the mediation investigation.
The focus was on twenty insurance company representatives who had come with
scores of cartons filled with documents that were piled like barricades at the side of
the room. The atmosphere was more like a medieval joust than a trial on Court TV.
The attorneys for the Church defined themselves by their stance at the front right
hand side of the room. They formed a regal phalanx. The lawyers for victims and

their experts were scattered throughout the room as the audience—the rabble in the drama of medieval power.

The cool—or rather hot—clinical atmosphere of legal constraint and precision literally dissolved as one after the other insurance lawyers began to tear as five victims showed photos of themselves as they were at the age of abuse. Not just the thought, but the vision and transformation, the picture of these happy, smiling youngsters who were violated became real.

The discussion of money, claims, limits of coverage, and institutional vulnerability took on an entirely different tone. The focus changed from business to persons—from institutions, religious and legal power, to people—real children who had been hurt and scarred, personally and spiritually. The stories each had to tell were meaningful, but the power, the punch, and the memories incarnated in those moments were a creation of the photographs. Professionals used to dealing with words were given a vision of the reality beyond words.

Carmine Galasso's photographic essay demonstrates this power. His vision and the survivors' words evoke the pain, poignancy, anger, and passion the victims of sexual abuse by Roman Catholic clergy feel, suffer and endure for a lifetime. He captures a reality that defies words.

A photograph also proved pivotal and crucial in the psychological treatment of a priest after he admitted sexually abusing minors.

For months this man insisted that his crime had no victim because he always picked up young hustlers from the street who were eager to have sex with him for money. He protested that he was blameless and did no harm because there were no victims willing to complain to the police.

After months of stalemate and unproductive therapy he came in one day ashen and shaking. He had seen a photo of a teenage boy being sexually assaulted by a man in the manner he had so often done. For the first time he could see in the boy's face what he had frequently seen on the faces of the street boys he had had sex with.

The spectre of that face in the photo evoked in him for the first time empathy for the boys he had abused. The experience - that photograph - made therapy and change possible. He could finally deal with his addiction. The photograph, and the truth it told, literally changed his life.

Galasso's photographs and the stories the survivors tell is not a dour and hopeless portrayal. Juxtaposed with painful accounts are familiar religious scenes and icons that place the stories in the context both of betrayal and possible healing. He records a delicate interplay between beauty and pathos, between symbol and portraiture. He presents us eyes to see with a depth of understanding we miss by word alone.

This book is a triumph of making sexual abuse by religion understandable.

AWRS

A. W. Richard Sipe has spent his life searching for the origins, meanings, and dynamics of religious celibacy. He spent eighteen years serving the Church as a Benedictine monk and Catholic priest. He has been married for thirty-five years and has one son. Both as a priest and married man he has practiced psychotherapy, taught on the faculties of major Catholic seminaries and colleges, lectured in medical schools, and served as a consultant and expert witness in both civil and criminal cases involving the sexual abuse of minors by Catholic priests. His six books including his now classic, "A Secret World", and, "Celibacy in Crisis", explore various aspects of the questions about pattern and practice of religious celibacy.

Published in Great Britain in 2007
By Trolley Ltd
www.trolleybooks.com

Photographs © Carmine Galasso 2007
Texts © Carmine Galasso, Mike Kelly, A. W. Richard Sipe

Design: www.fruitmachinedesign.com
Editing: Carmine Galasso, Joe Galasso, Nina Berman
Copyediting: Jeffrey Page, Hannah Watson

A catalogue record for this book is available from the British Library.

ISBN 978-1-904563-59-4

Printed in Italy 2007 by Grafiche Antiga

ACKNOWLEDGMENTS

Sincere thanks to all who have helped and participated in,

"CROSSES: PORTRAITS OF CLERGY ABUSE".

To survivors and their families. SNAP, The Linkup, VOTF, and representatives from these organizations. To Gigi Giannuzzi at Trolley Books for his passion, commitment, and support on this project from the very beginning; Hannah Watson, and all those at Trolley Books. Richard Sipe and Mike Kelly for their poignant writing. Joseph Galasso, Psy.D., M.A. for editing. Jeffrey Page for copyediting. Ken Horowitz Digital Services: Ken, Bob Cattan, and Aria Newton for scanning and printing these images. Father Robert Hoatson. Anna Lopriore. Mitchell Garabedian, Esq. Kathy Halvorson, Katie Rietman and Nancy Pascarella for transcribing so many pages of interviews and notes. Rich Gigli and friends at The Record. Photographers Melchior DiGiacomo, James Salzano, and Stephen Ferry, for enlightenment and encouragement. I am particularly grateful to Sue Brisk at Magnum Photos, friend and advisor. Of course, I'd like to especially thank my family for always loving and supporting me. My children; Joe, Anthony, and Carla. Nina Berman for editing, guidance and love

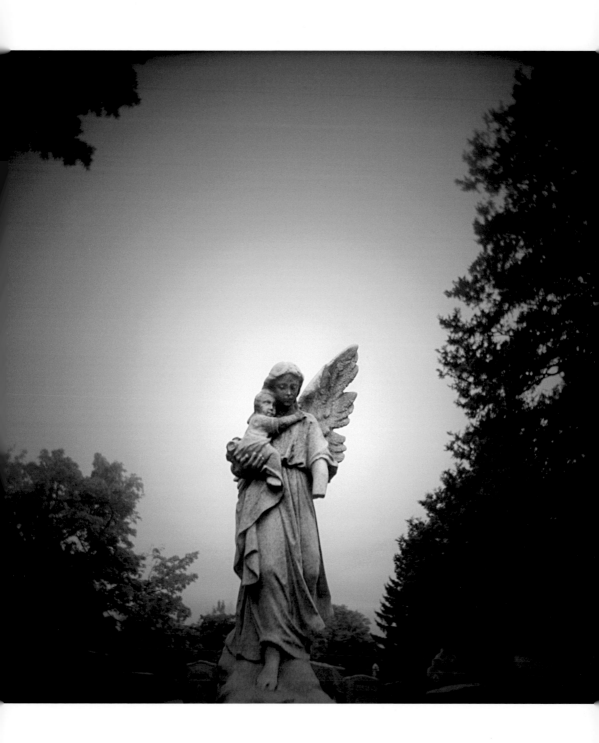